Martin Ridley

Deer

ARTISTS' IMPRESSIONS

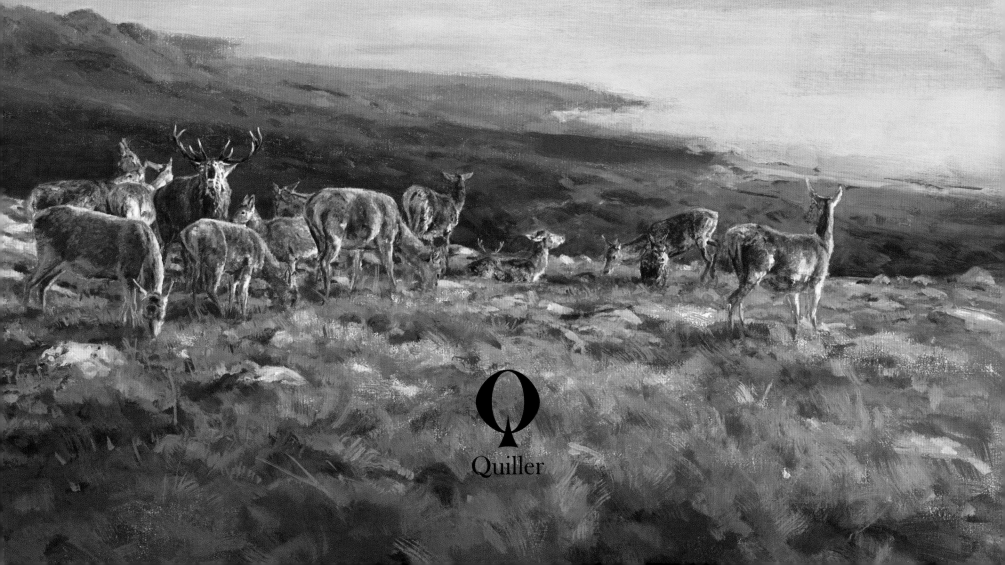

Deer

ARTISTS' IMPRESSIONS

Quiller

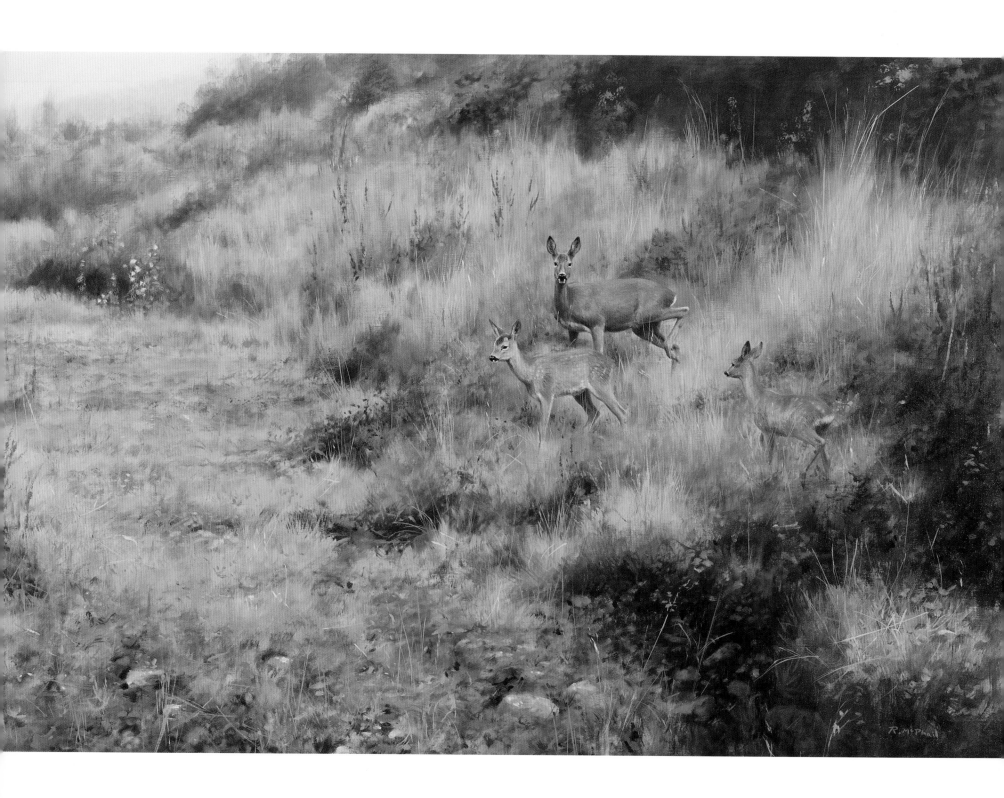

CLARENCE HOUSE
LONDON SW1A 1BA

I was delighted to be asked to contribute this foreword to such a wonderful collection of paintings celebrating fifty years of The British Deer Society. I was somewhat amazed to be reminded that I have, in fact, been Patron of The B.D.S. for some thirty-five years, which has given me a wonderful opportunity to see the excellent work you have done across the United Kingdom for this most noble of beasts.

To see a Red Deer on the hill, or a Fallow Deer in the woodland, is certain to stir the soul of anyone who appreciates our natural environment. But this wonderful sight can only be guaranteed if we understand the importance of the deer's place within a managed environment. Not only must deer numbers be controlled in some parts of the country, but we must also concentrate on managing the habitat in those places where deer are less prevalent, so that we can enjoy seeing deer in the wild for many generations to come.

I would like to thank all the staff and supporters of The British Deer Society for all that they do and I hope that these wonderful pictures will encourage you to do what you can to help their work.

Title page
A YEAR ON THE HILL IN FOUR SEASONS (AUTUMN)
Ian MacGillivray
Oil

Previous page
ROE AND KIDS (detail)
Rodger McPhail
Oil

Right
STALKING PONIES AND ROWAN
Jonathan Sainsbury
Watercolour

Copyright ©2013 Graham Downing, Martin Ridley, Owen Williams,
Jonathan Sainsbury, Keith Sykes, Rodger McPhail, Ian MacGillivray,
Ben Hoskyns, Ashley Boon

First published in the UK in 2013 by
Quiller, an imprint of Quiller Publishing Ltd

British Library Cataloguing-in-Publication Data
A catalogue record for this book is available from the British Library

ISBN 978 1 84689 184 7

Printed in China

Book design by Guy Callaby

Quiller
An imprint of Quiller Publishing Ltd
Wykey House, Wykey, Shrewsbury SY4 1JA
Tel: 01939 261616 Fax: 01939 261606
E-mail: info@quillerbooks.com
Website: www.countrybooksdirect.com

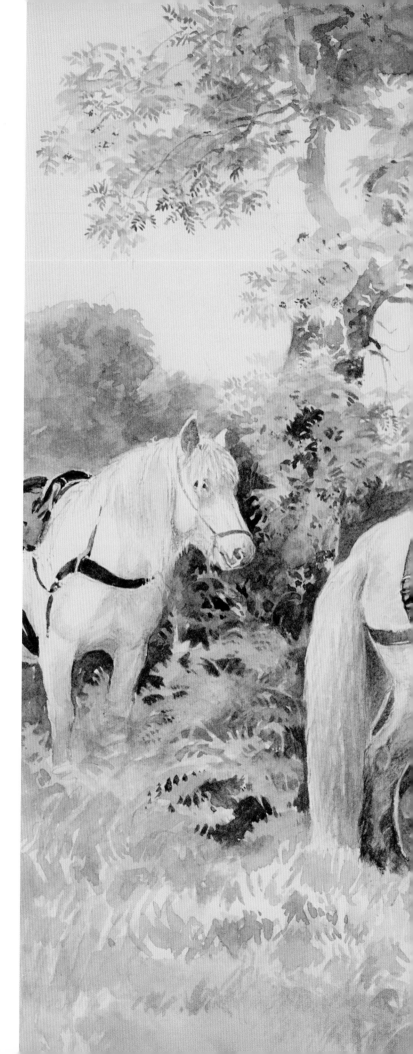

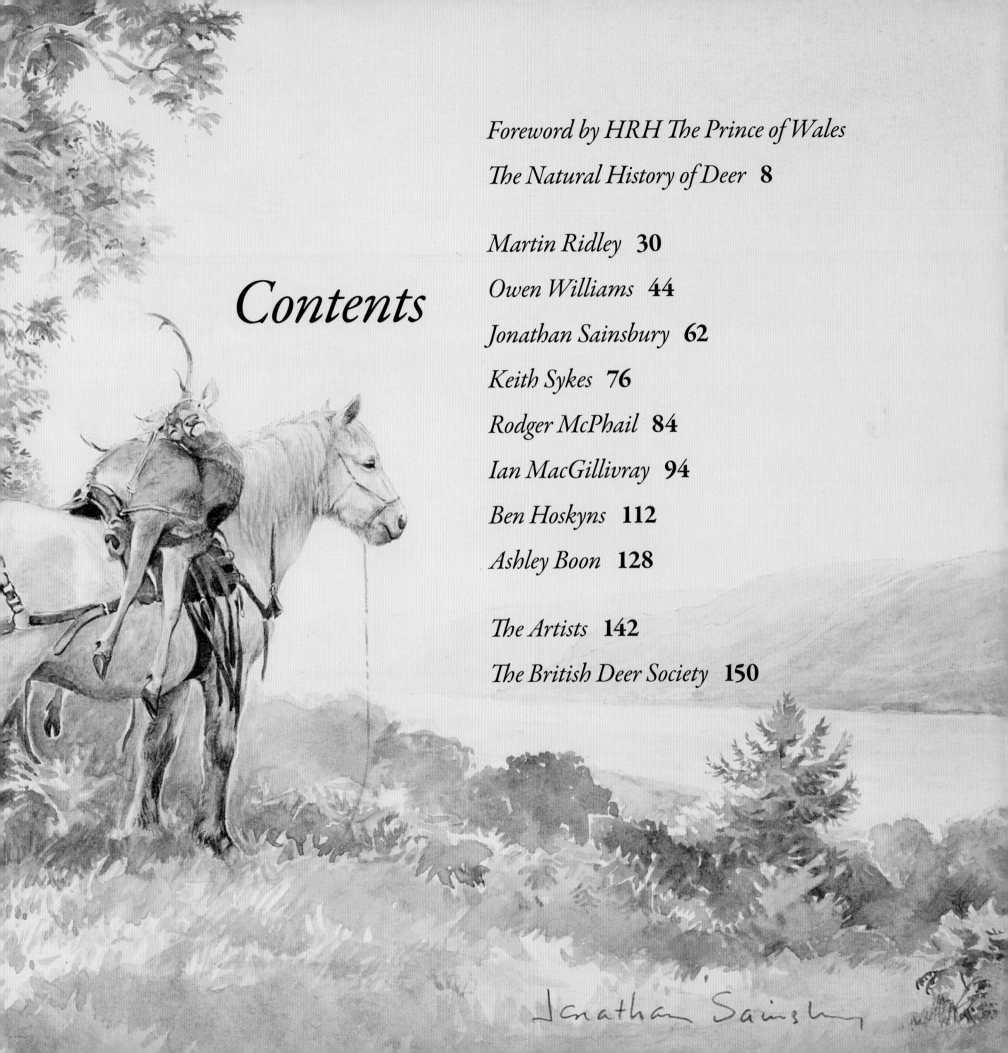

Contents

Jonathan Sainsbury

The Natural History of Deer
by Graham Downing

Introduction

Shrouded by autumnal mist in a forest clearing, their breath hanging in the dawn air and their branching antlers silhouetted against the pink sky; stepping daintily from the edge of a wheat field at harvest time with russet coats glowing in the August sunshine; or gathered in a highland corrie beneath the snow-clad mountain tops and the soaring eagle, deer are emphatically the most imposing and magnificent of Britain's wild creatures.

Their form is instantly recognisable even by those who will never see a wild deer in their lives, for the handsome headgear of the mature stag or buck is unique in the animal world. Even the females of the species could barely be confused with any other creature. The casual observer will most probably be unable to spot the subtle differences between a red and sika hind or to distinguish between an early winter roebuck and a mature roe doe. Such skills take knowledge, understanding and years of practice. But he or she will certainly recognise all of these animals as deer, for pictures of deer are everywhere in our daily lives. Their image is present on road signs and shop fronts, on the signboard outside the local pub and on a thousand Scottish holiday postcards. Everybody knows what deer look like.

For most people it goes no further than that. Deer are large, imposing creatures with antlers on their heads, which inhabit wild places and which somehow embrace the spirit of freedom and wilderness. To those who know, deer are of course rather more complicated, and far more fascinating. There are actually six species of deer wild in Britain, two of which – the red and roe – are native to these islands and shared our

Left
ROE DEER STUDIES
Rodger McPhail
Oil

Above
ROE DEER SKETCH (detail)
Martin Ridley
Pencil

ancient forests with prehistoric man. The fallow, though of Mediterranean origin, has been here on and off for two thousand years, quite long enough for it to be regarded as an honorary native, while the sika, Chinese water deer and the little muntjac are newcomers from the Far East, hitchhikers of Empire.

All, however, are on the increase. Every one of the six species is flourishing both in population and range, with parts of lowland Britain that have not had a resident deer herd since the middle ages once again hearing the spine-tingling roar of the rutting red stag upon their heaths or echoing through their October woodlands. It is truly a remarkable story of recovery, and one which may perhaps be laid at the door of the steady increase in afforestation and woodland planting which has taken place over the last century, boosted more recently by the welcome greening that has taken place in British agriculture. Quite simply, deer now have more habitat in which to thrive.

Certainly increased numbers have brought with them the need for better management, for deer in the wrong place and at the wrong time will inevitably come into conflict with human priorities. They can even upset the carefully-tuned balance of semi-natural habitats: an ancient woodland which has developed for 500 years in the absence of deer can change surprisingly quickly when an influx of hungry browsing mouths arrives upon the scene. The same conflict can arise upon the Scottish hill where the ever-changing political agenda now calls for the re-establishment of native broadleaved woods.

Management is our responsibility. We humans long ago eliminated the wolf, lynx and brown bear from our countryside, so once they have survived infancy, deer have no natural predators, and with some populations capable of increasing at 30% per annum, a measure of control is a necessity. By and large we do it well. The management of deer in Britain is conducted according to strict guidelines which have at their heart the maintenance of deer welfare and the long-term sustainability of the herd. Its principles have long been established in Scotland, where deer stalking has been an integral part of the highland culture for over 150 years. In England, responsible deer management is of more recent vintage, having been championed in the post-war years by a few passionate enthusiasts who brought over from continental Europe the ethic of modern, science-based deer population management and who in 1963 founded the British Deer Society.

Their legacy remains with us. It is enshrined in the legislation which protects deer in Britain and it is reflected in the enthusiasm and love of deer which can be seen amongst those charged with their management in these islands.

That enthusiasm and love now exists amongst a much wider public. This is due in part to the current generation of TV natural history presenters, but it also comes down to the fact that those who do walk quietly in the countryside

Left
RED DEER SKETCH
Martin Ridley
Pencil

Opposite
RED DEER STAG STUDY
Ashley Boon
Watercolour

can now have a reasonable expectation of observing wild deer, whether it be the advertised autumn set-piece of the rutting stags on a nature reserve or simply the bobbing white tail of the muntjac which darts unexpectedly across a forest ride during the course of a family ramble.

This book, a celebration of deer by some of our best-known and most-loved wildlife artists, is for the casual observer of wildlife as much as it is for the dedicated deer enthusiast, be he deer stalker or deer watcher. With brush and pencil the contributors to this volume have captured the essence of wild deer and the places in which they live, from the remote grandeur of the highlands to the dappled shade of our ancient forests. Open and enjoy it whenever you need a deer fix, and maybe it will encourage you to set the alarm clock and get out into deer country in that quiet hour before sunrise to experience the real thing.

Red deer

Of all the six species of deer which may be found living wild in the British Isles, the red deer, *Cervus elaphus*, is without doubt the most magnificent. It is our largest land mammal and was established here before Britain and the European mainland became separated in the aftermath of the last Ice Age.

Red deer thus have a long shared history with man in these islands. Such a huge animal is a very obvious and ready source of meat, and the species was certainly hunted by early man. However, as human culture developed, our ancestors also used red deer in other ways. One of the more important of these was the production of antler picks both for the mining of flint, the raw material for tool making and for the building of huge earthworks in the landscape. It has been calculated that Silbury Hill, the largest prehistoric mound in Europe, required the use of between 50,000 and 140,000 red deer antler picks in its construction. Clearly there must have been a well-organised and established trade to supply such a quantity of antler, some

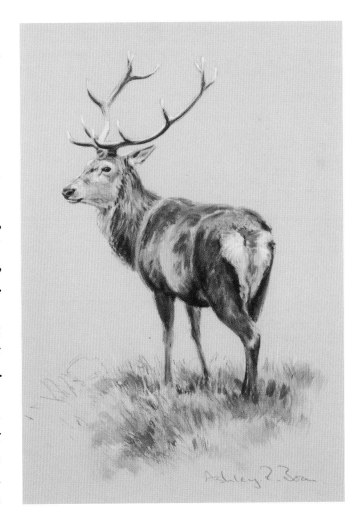

of it removed from hunted animals but much of it naturally shed, indicating how important red deer were to the Neolithic culture between 4000BC and 2000BC.

Indeed, there is a suggestion that Neolithic people may have regulated the killing of red deer so as to ensure the preservation of the largest possible number of mature stags, while the apparent deposition of antlers as votive offerings suggests that from the most ancient times the red stag was imbued with some form of spiritual symbolism. That mystical intertwining of association between red deer and man has lasted down the centuries. It may be seen in the esteem in which red deer are held by the rural communities of Exmoor, where the hunting of red deer with hounds was and to some extent remains a strong local tradition, and even in the truly iconic status which the red stag has assumed in the culture of the Scottish Highlands.

The fact that the red deer became the preferred hunting quarry of the early medieval nobility undoubtedly lent it a high degree of protection both in the Royal Forests and the network of Chases and other hunting reserves which the nobility were permitted to create. Statutes to protect deer came thick and fast from the fifteenth to the seventeenth centuries; even in 1661 a fine of £20, six months hard labour or a year's imprisonment was fixed as the punishment for the poaching of red or fallow deer.

But perhaps the urgency with which the governing classes evidently sought to protect them from unregulated destruction is in itself an indication of the extent to which red deer were on the decline. From the early middle ages onwards, their natural habitat in England and Wales had been progressively reduced as woodland was felled for timber and, more importantly, in order to make more land available for agriculture. Then from the fifteenth century the old Forests and Chases, which had formerly covered up to two thirds of the area of some historic counties, were gradually disafforested, the process accelerating during and after the Commonwealth. Thus in the lowlands of England and Wales, wild red deer had virtually disappeared by the mid eighteenth century, though the native population hung on in a few places, notably Exmoor where they were sustained by the local protection afforded by staghunting.

In Scotland, however, although red deer diminished, they never left the south west or the Highlands, even at a time when their numbers in England dwindled away. Instead they adapted to the huge changes that were wrought on the Scottish landscape by man. Firstly the secretive deer of the old Caledonian forests of pine and juniper adjusted to life on the open hill as the timber was progressively cleared. Then they adjusted once more to the changes in habitat and land use which occurred in the late eighteenth and early nineteenth centuries when the small scale crofting economy which centred around seasonal cattle grazing and the cultivation of tiny arable plots was succeeded by the establishment of huge upland estates, the income of which was based around extensive sheep grazing, shooting and red deer stalking. Red deer were once more prized as a sporting asset. They thrived in consequence and continue to do so.

Red deer were present in Ireland before the last glacial maximum, but disappeared at that point from Ireland along with reindeer and the giant Irish deer. Recent research by scientists working on the red deer of the Killarney National Park suggests that the species was reintroduced

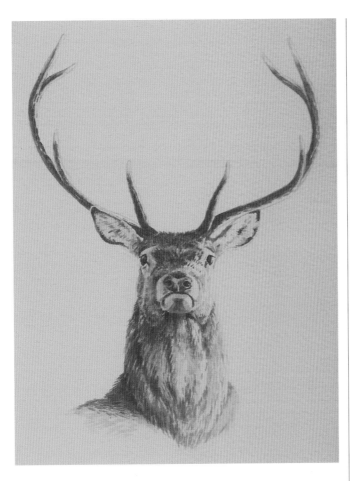

to Ireland from Britain by Mesolithic man around 5,000 years ago, with several subsequent reintroductions occurring thereafter. While there are widespread populations of wild red deer in Ireland, usually associated with more recent introductions to deer parks, it seems that the population in Co Kerry remains the most ancient body of red deer in Ireland.

The recent history of red deer in Britain has been a constantly improving picture. Over the last century the species has benefited from large scale afforestation, such as occurred in the Breckland area of Norfolk and Suffolk after the establishment of the Forestry Commission in 1919. A small population of red deer, possibly associated with escapees from the former Norwich Staghounds, established itself and spread out from there to colonise woodlands all

over the east of England. Or rather recolonise, for many of the veteran oaks of Epping Forest or Staverton Park in Suffolk will remember having seen red deer beneath their youthful branches when the Normans and Plantagenets were on the throne. In these places, and many others like them, red deer have made a welcome return to reclaim a land that is rightly theirs.

Red deer may today be found throughout the south west of England from north Somerset to Cornwall, in the New Forest, Hampshire and Sussex, across East Anglia from Norfolk to Essex, in the north Midlands, Yorkshire, the Lake District and of course Scotland. Here there is one concentration in the south west, while the main red deer range occupies the whole of the Highlands and islands.

Standing at between 40 and 48 inches (1 and 1.2m) high at the shoulder, dark russet in colour with a creamy underside and a magnificent rack of pointed antlers, the red stag is unmistakable. Indeed, thanks to pictures such as Landseer's famous 'Monarch of the Glen' and more recently its appearance on numerous 'deer watch' wildlife programmes, it is instantly recognised by millions. The red hind stands considerably smaller in stature than her partner, and weighs between 125 and 250 pounds (56 and 115kg) as against the stag's 200 to 420 pounds (95 to 190kg). The wide range in weight is a function of the availability and quality of food in the habitats where red deer live. A Highland stag weighing 300 pounds (135kg) is a huge beast for such a harsh and rugged environment, though a very few have even exceeded 365 pounds (165kg). On the other hand, the body weight of a forest stag which is able either to shelter amongst the trees where it can find more nutritious forage, or to raid the crops on neighbouring farmland, will far outstrip that of his Highland cousin who has

nothing to sustain him apart from poor quality heather grazing.

Nutritional differences between hill and forest stags also show up in the antlers. A mature Highland stag of good quality might be expected to achieve 12 points, that is to say two each of brow, bez and trez points plus three on top of each beam. Such an animal would be called a 'Royal' stag, and would delight any guest stalker in the Scottish Highlands. However, such a beast would not compare with the animals in many established woodland herds in England, where the size and weight of antler can be much greater. Even a relatively youthful woodland stag can be expected to have a dozen points or more, and a more mature head can easily have well in excess of 20. It is true to say that in certain cases new blood introduced into wild herds from park deer may arm some stags with the genetic ability to produce larger antlers and body weight, but essentially it is better nutrition which is responsible.

The daily movement of red deer is governed by a balance between the availability of food and the threat of disturbance by man, who is the animal's only predator once it has survived infancy. Low ground deer tend to be crepuscular in nature and will remain within secure woodland during the day, emerging only at dusk in order to feed. Hill beasts will tend to spend the day at higher altitude where they have a commanding view over any possible approaching danger. A further factor which affects the movement of red deer on the hill in summer is the presence of midges, which will make deer seek higher ground where there is more breeze to keep insects away. Likewise in winter, when there is snow on the hill, red deer will move to lower altitude or, if possible, into woodland in order to seek food and shelter.

During the early autumn, red deer enter the rut, a period of turmoil and social upheaval in the herd. The stags, which are by now in hard antler that is clean of velvet, the soft membrane which covers the antlers while they are growing, develop a thick, shaggy mane and set about the task of seeking hinds. Groups of stags split up as rival animals face each other down for possession of 'harems' of hinds which they herd together and guard jealously. At this time of year the stags can be heard to roar. This testosterone-charged noise, which can be anything from a grunting cough to a full-blooded bellow, continues for as long as the hinds are in oestrus and is a sure sign that the rut is underway. Late evening is a particularly exciting time to search for rutting red deer, as it is possible to locate a stag by his roaring and then quietly approach him as he stands, perhaps in some forest clearing with steam rising from his body. At this time of year the stags will also wallow in black, peaty water laced with their own urine, their antlers adorned with bracken or other shreds of vegetation. Younger stags will challenge the master stags for possession of the hinds and on occasions they

Below
WALLOWING
Owen Williams
Watercolour

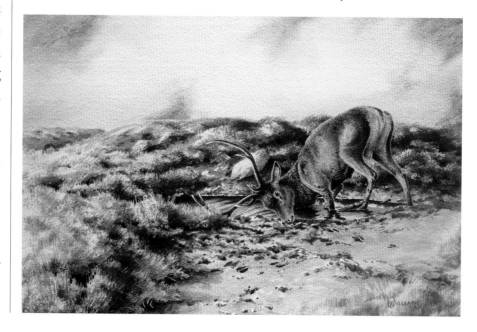

will lock antlers in a brief but violent fight, the clatter of antler against antler adding another sound effect to the repertoire of the rut. Usually these contests involve a good deal of bluff and more chasing than actual combat, the heavier and more powerful stag invariably seeing off his rival. Even so, injuries do occasionally occur and these can be serious, especially when inflicted by a 'switch', a stag with long rapier-like antlers that have no branching tines to impede any thrust that is made with them.

When the rut is over, the stags are said to be 'run'. Exhausted, their energy spent, they return briefly to the territory they vacated before the rut until they are forced to retreat to sheltered ground by the snows of winter. The hinds meanwhile occupy the best feeding areas, grouping together into herds on their home range. On the open hill, such herds can be substantial in size, while in woodland, hinds band together in much smaller 'parcels' of maybe a dozen animals. Each group of hinds has a distinct pecking order, with an older and more experienced hind operating as the lead animal who selects the feeding areas and who will alert her colleagues to potential danger with a bark or a stamp of the foot. If there is a threat to the safety of the herd, it is she who will lead the retreat. Like stags, the hinds too will challenge for the dominant position.

Late winter is the most difficult time for the red deer herds, especially those on the hill. Red deer can withstand prolonged cold weather, and they are well able to scrape away frozen snow in order to reach the grazing beneath. Prolonged wet weather in late winter, however, saps their strength and energy and in these conditions hill deer that are unable to find shelter or some form of supplementary nutrition will die, sometimes in substantial numbers. Particularly susceptible are any orphaned calves which do not have the support of an experienced dam to help them through the winter.

Hinds usually calve during the first half of June, although the exact timing will depend upon geography. They will select a sheltered and secluded place to drop their calves, and those hinds which were in the best condition at the time of the rut will usually give birth first. New-born calves have a spotted coat which helps them blend in well with the early summer vegetation. They carry virtually no scent which might attract predators, and are hard to spot. At first a calf will remain motionless and hidden while its mother goes off to feed, but as soon as she is able to do so, the hind will move her calf from its place of birth. The calf will be fully weaned and physically independent after around six months, but even so, it will still remain with its mother for many months longer, during which the calf will learn about its home range and how to survive in a sometimes hostile environment. A hind calf will usually remain in her mother's family group even when she reaches adulthood. Stag calves, however, normally follow their mothers into their second year, after which they join separate stag herds.

Antlers are shed and re-grown every year, the process of antler growth being one of the wonders of nature. In red deer it has been calculated that antlers may represent around 20% of the total weight of a stag's skeleton. Antler growth is capable of reaching a staggering 4cm a day, and as the flow of nutrients required for this growth cannot be maintained through feeding alone, the stag must transfer minerals to the developing antlers from elsewhere in his skeleton. This deficiency is rectified when antler growth is complete. Antlers start growing in early spring, and in late August or early

September the soft covering or 'velvet' which protects the growing antlers is rubbed off or 'frayed' to expose the bony antler beneath. The antler itself is subsequently stained dark brown through contact with tannin from tree bark and

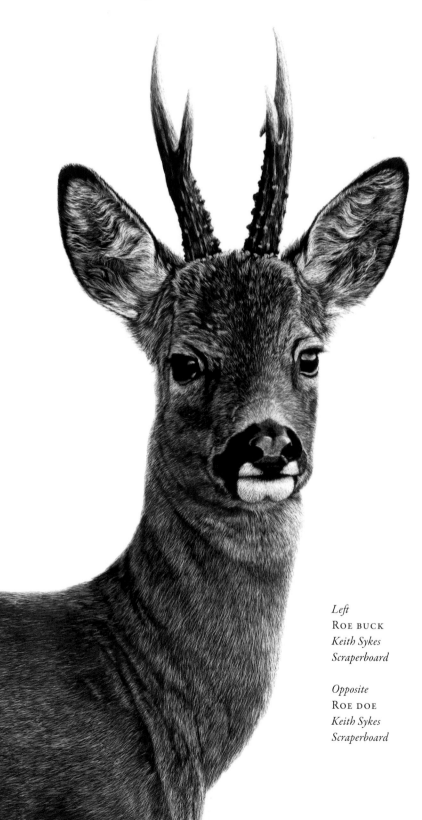

Left
ROE BUCK
Keith Sykes
Scraperboard

Opposite
ROE DOE
Keith Sykes
Scraperboard

other plant material, or from peat. Stags carry their antlers through the winter and shed them early the following spring. In his first year, a young stag will develop small bony knobs and is known as a 'knobber'. The second head usually consists of long, single spikes, and at this stage a stag is referred to as a 'spiker'. Thereafter in successive years the stag will grow antlers with increasing weight and numbers of tines until between the seventh and ninth year the fully mature set of antlers will be achieved. In his latter years, a stag's antlers will start to become shorter and the tines will decrease in number with successive heads. At this stage of his life, a stag is said to be 'going back'.

Roe deer

The European roe (*Capreolus capreolus*) is, along with the red deer, one of two cervid species which is native to the British Isles. Roe appear in the fossil record during the Cromerian interglacial 780,000 to 450,000 years ago, but along with other fauna they retreated south during subsequent glacial advances before recolonising their former range when conditions became more temperate. The first postglacial evidence for roe in Britain is a bone that has been radiocarbon dated to 9,430 years before present, at which time roe would most likely have been spread widely across the whole of England, Scotland and Wales. Initially, the slow increase in the human population would not have adversely affected the roe. Indeed it is possible that the opposite was true, for not only would the development of livestock farming by

Neolithic man have reduced hunting pressure on wild quarry like deer, but the steady elimination by man of large natural predators would also have helped to ensure greater fawn survival.

Clearance of woodland for agriculture and, from the eleventh century, much greater organised hunting pressure started to have a significant impact, and as a result the medieval picture is one of steady decline in population. The number of roe bones found in archaeological sites decreases from the twelfth century onwards and in 1338 the roe was relegated from a 'beast of the forest' to a 'beast of the warren', reducing legal protection on the species and giving commoners the right to hunt it. Royal foresters were, at the same time, ordered to eradicate roe from the Royal hunting preserves on the basis that it displaced other more favoured species.

By the late middle ages, roe were scarce in the midlands and southern Britain and in the eighteenth century they were considered by some to be extinct south of the Scottish Highlands, although small residual populations probably existed in southern Scotland and the Borders.

From the nineteenth century, however, roe numbers started a slow increase. In the north of England this probably resulted from a natural expansion of the remnant Scottish population. In the south, however, the roe was reintroduced. The first recorded reintroduction was at Milton Abbas, Dorset, in 1800 and was of four or five animals from Perthshire. Subsequent reintroductions

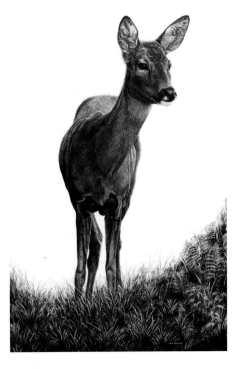

from this successful population were made into Windsor Park and Epping Forest, and then in 1884, twelve animals from Württemberg, Germany, were introduced near Thetford by Sir William Dalziel Mackenzie. It seems that this German introduction was the origin of present populations in East Anglia. Subsequently in 1915 a further twelve Austrian roe were introduced into Windermere. Recent research has focused on the extent to which modern roe deer are genetically identified with the remnant native British roe as opposed to the different strains introduced from continental Europe.

One thing is for certain, however: the roe deer has become very successful over the past forty years. From its strongholds in the southern half of Scotland, in Dorset, Hampshire, West Sussex and on the borders of Norfolk and Suffolk, it has since 1970 colonised the whole of the south and south west of England, the east of England as far west as the Chilterns, and from the Scottish border as far south as Lincolnshire. It seems that the species is also starting to establish itself in Wales and the west Midlands, with newly recorded populations in Shropshire, Gloucestershire and Staffordshire.

Roe are an adaptable species and while they may prefer small, mixed woodlands, they are perfectly at home in the large coniferous forests of Scotland, northern England, East Anglia and elsewhere. They are a browsing species, and the damage which they cause to woody shoots can have an impact upon the establishment of new

woodland and on the traditional management of lowland coppice, a fact which brings them into conflict with commercial foresters and the managers of conservation woodland. Other foods include herbs, grasses, fungi, ivy and cultivated roses, which does not serve to endear them to gardeners or nurserymen. Although roe are not regarded as a herding species and tend to live in small family parties, larger groups may sometimes be found feeding together in favourable locations, especially during the winter months.

Adult roe stand between 24 and 30 inches (60 and 76cm) at the shoulder and bucks weigh from 53 to 65 pounds (24 to 29kg) with does up to 13 pounds (6kg) lighter. Their summer coat is a striking chestnut red, and it is at this time of year that roe appear at their most dainty, slender and delicate. In late autumn they develop a much thicker coat of browny-grey, the dense pelage making them appear fat and even dumpy in appearance. In the spring, the shedding of this grey overcoat makes them look tatty and moth-eaten. At all times of the year, however, a distinguishing feature of the roe deer is its prominent white caudal (rump) patch. This is particularly evident in winter, when the white hairs stand erect as the alarmed deer flees from potential danger. In the female, there is an 'anal tush', a downward projecting tuft of hair below the caudal patch, the presence of which is an important identification mark of the doe during the period when the buck is without his antlers. With advancing age, the muzzle becomes grey and the head shape changes with a subtle lengthening of the nose and forehead.

Like other deer, roe have a highly developed sense of smell, and with their large and very mobile ears they are able to detect the slightest sound that may signal danger. Their eyesight, on the other hand is less acute, and roe will often disregard the human form provided that it remains absolutely still. Indeed, provided that the wind is in your favour and you remain motionless, it is possible to have roe approach you to within just a few feet.

Spring is a time of social upheaval as the roe bucks establish or re-establish their territories, the prime animals generally occupying the best feeding areas within a given block of woodland and forcing out any lesser rivals. Bucks which have failed to find a territory may sometimes travel considerable distances in search of suitable habitat, a process which assists the gradual spread of the species into new locations. Occasionally, a younger buck that has been driven from the territory carved out by one of his more mature and dominant colleagues will linger on the edge of that territory as a 'satellite' buck, making brief incursions into it when the dominant buck is otherwise engaged. In doing so, he will learn the geography of the territory and he may in due course inherit it.

Towards the end of July the does come into oestrus and the rut begins. Rutting behaviour is often associated with hot, close, thundery weather, but its timing is also affected by latitude, as it starts first in the south of England and progresses north, with the height of the rut normally arriving in the Scottish Highlands about the beginning of the second week in August. Fighting may occur between bucks, but it is the doe that is the dominant partner when it comes to seeking a mate. When she comes into oestrus she will go off and seek a buck in an adjacent territory, leading him back to a mating ground of her choosing. During this process there may be much leading-on by the doe and chasing by the buck, and sometimes the two will repeatedly run around in a circle, beating

the vegetation down into a circular track known as a 'roe ring'. Occasionally one is privileged to get a glimpse of this behaviour, and it is quite enthralling to watch as buck and doe chase each other, sometimes around a central tree or bush until, as if by magic, the spell is broken and the deer depart.

Mating will occur as soon as the doe is satisfied that her partner is sufficiently strong and powerful, and copulation may be repeated on a number of occasions. What occurs then is unique within the deer world, and is the reason for such a long delay between the rut and the birth of the fawn. When the egg is released from the ovary and is fertilized, it travels to the uterus where it remains free-floating for a period of five months before implantation finally occurs and the embryo – or embryos – start developing. The process is known as embryonic diapause or 'delayed implantation' and benefits the doe, as she has no developing foetus to sap her bodily system during autumn and early winter. She can thus maintain her condition and lay down reserves of fat, ensuring that she is better able to survive the much more difficult days of late winter and thereafter to nurture her young when they are born in late May. Twins are commonplace whilst triplets are regularly encountered in some areas. They may be left alone by their mother for long periods and are particularly vulnerable at this time. Young roe often remain with their mothers in small family groups of two or three until the end of their first year and sometimes beyond.

Like the cycle of reproduction, the antler cycle of the buck is phased differently from that of other deer species. Bucks shed their antlers in winter, and re-growth is complete by March, when the velvet is frayed. Most of the older bucks are in hard antler by early April and they are closely followed by the younger ones. Fraying is often combined with the establishment of breeding territories, and considerable damage may be done to young saplings during the process. In his first year a buck will usually develop two short spikes, but as he matures he will go on to develop the classic six pointed head with two forward facing brow tines and two rearward facing points at the top of the beam. Heavier antlers and additional points may form where the geology and soil is favourable.

Muntjac deer

Reeves's muntjac (*Muntiacus reevesi*), the muntjac species which can be found wild in Britain, belongs to a very ancient group of deer. The fossilised remains of the Muntiacinae family have been found in

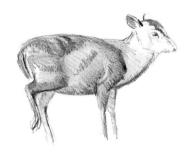

geological deposits dating back 35 million years. In prehistoric times, muntjac occurred in what is now western Europe, but today they are endemic to south east Asia. The Reeves' muntjac, named after John Reeves, an Assistant

Inspector of Tea with the British East India Company, occurs naturally in eastern China and Taiwan.

There were several introductions to both the Zoological Society of London and various private collections from 1838 onwards, including one to Tring Park, Hertfordshire, by Lord Rothschild in 1881. However, it is believed that the introduction from which most of the present British population originates was that of six animals which was made into the deer park at Woburn Abbey by the 11th Duke of Bedford in 1894. By 1906 a total of 28 Reeves's muntjac had arrived at Woburn.

A local feral population started to build up as a result of escapes, although by 1938 this was spread no more than 10km from Woburn itself. Between 1947 and 1949 deliberate releases were made in Oxfordshire, Northamptonshire, Kent and on the borders of Norfolk and Suffolk, and muntjac started to increase more rapidly. By the 1980s muntjac had spread across central southern England and the midlands, with odd peripheral reports from Cumbria, Yorkshire, Denbighshire, Gloucestershire and Cornwall. The past thirty years have seen a very substantial increase in range and population, and muntjac are now well established throughout England south of a line from the Humber to the Dee with the exception of east Kent and parts of Devon and Cornwall. They are present in south Wales and there are sporadic occurrences as far north as Northumberland, Cumbria and south west Scotland. In 2011 muntjac were recorded in Northern Ireland.

The muntjac has proved itself to be phenomenally successful. An animal of dense woodland, it quickly colonises small woods, spinneys, thickets and hedgerows. It is quite comfortable living in close proximity to humans and is frequently found to inhabit suburban gardens, shrubberies and roadside plantings close to large cities. Its diet includes ivy and bramble, plus succulent young herbaceous shoots, coppice re-growth and wild flowers like bluebells and orchids. A high density of muntjac can cause considerable damage by browsing the low-growing forest floor vegetation. Muntjac are also adept at stripping the leaves from quite tall saplings, which they do by walking over the stems and bending them to the ground, whereupon the upper foliage can be removed. Over time, continued browsing by muntjac will change the structure of the woodland habitat quite considerably and this in turn has been shown to have an impact on the presence of important woodland birds like the nightingale. It is because of this that conservation bodies are particularly concerned about muntjac. This concern is shared by foresters and gardeners, giving the species an unfortunate and to some extent undeserved reputation as a pest.

As creatures of dense undergrowth, muntjac tend to avoid crossing open ground except when they are in transit between adjacent woods, and they much prefer to creep along a hedgerow or through a standing crop or grass margin that will provide them with cover. They are

Below and Previous Page
Muntjac sketch
Ben Hoskyns
Pencil

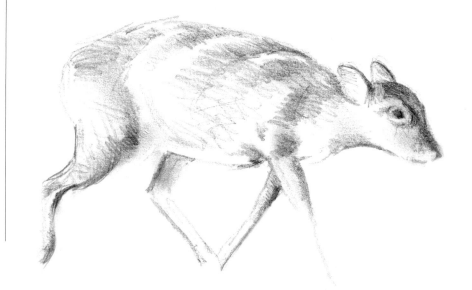

less crepuscular in their habits than other deer and are active for about 70% of the day. Recent research using camera traps has shown peaks of activity around dawn and dusk, with more observations occurring in the evening than in the morning. There is also a considerable amount of activity during the hours of darkness. Their small size means that muntjac are quickly hidden in early summer by tall grass, crops and other vegetation and this makes them difficult to observe during the summer months, even though their presence may still be confirmed by their slot marks and tracks.

A mature muntjac buck stands about 18 inches (45cm) at the shoulder and weighs up to about 33 pounds (15kg), about the same size as a large labrador. The doe tends to be somewhat lighter in weight than her partner. Both sexes have a chestnut brown coat and a rich creamy underside. The tail is also white on the underside, and held erect in alarm when the animal is disturbed and takes flight. The buck has antlers which project from pedicles that extend from bony ridges on the skull. These are accentuated by black facial markings in the form of a large V running from below the eyes to the pedicles. The tips of the antlers curve to a length of up to 4 inches (10cm), and in the mature buck there is a secondary brow point which in an exceptional animal can reach about half an inch (1cm). Bucks have long, curved tusks which project downwards from the upper jaw and have a razor sharp rear edge. In older animals, these are often found to be broken, possibly through fraying of saplings which is carried out in order to mark territories, or possibly during the territorial fights which occur between bucks. Tusks can inflict severe injuries. Older animals are frequently found to have facial scars, torn ears or even blindness. Occasionally muntjac

will attack other animals such as dogs, and a deep cut from the tusks of an aggressive muntjac can be very serious.

Quite apart from their small size, muntjac are easily distinguishable from other deer from their curiously hunched appearance, their haunches being high and shoulders low. They are constantly on the move, feeding as they walk and hesitating only long enough to take a bite before continuing on their way. When alarmed, however, they can move very quickly, usually with their tail held erect to show the white underside.

Muntjac usually live alone, but they can sometimes be found in small family groups, perhaps with a buck and a doe together. Bucks are territorial and mark their territories both by fraying and by scent marking. They have a distinctive bark, like that of a terrier. Both sexes bark in alarm, and sometimes if they have identified a potential but as yet unconfirmed threat they may retreat into heavy cover and bark repeatedly for a period of time. Bucks will also bark to defend their territory, sometimes walking round in a small circle while they do so. In an area where there are muntjac present, they may often be heard on a still night, perhaps from a considerable distance. Another sound made by muntjac fawns is a short squeak or bleat, not unlike that of a roe doe. It is usually made when a fawn is threatened by a predator, and in the right circumstances, imitating this sound with an artificial call can be a very effective way of bringing an adult muntjac quickly into view, the adult believing that it is rushing to the aid of a distressed youngster.

Uniquely amongst British deer, the muntjac doe has no defined breeding season, and may produce her fawn at any time of the year. A single buck may serve several does and gestation is

around 210 days. The single fawn is light brown in colour, heavily spotted with large creamy spots arranged in lines. It is weaned from the age of around 6 to 8 weeks, when it starts to lose its spotted coat. However, it may remain with the doe for up to about 6 months. The doe will come into oestrus within a day or so of giving birth and is immediately ready to mate. If she does not conceive straight away, then she will come into oestrus again every two weeks until

she does so. As a result, the mature doe is almost constantly pregnant.

Because of the lack of any seasonality in its reproductive cycle, the muntjac has no close season. If the deer manager wishes to shoot females but wants to avoid orphaning dependent fawns, then he can only do so by shooting does that are visibly pregnant and at a stage when their previous fawn is no longer feeding from them.

Fallow deer

Although they are regarded as an 'honorary' part of our native fauna as they have been present in the British Isles for such a great length of time, the European fallow (*Dama dama dama*) was actually introduced – or more accurately reintroduced – by man. In prehistory, fallow were present in the British Isles until the last glacial advance, when they retreated south and became confined to the eastern Mediterranean.

Until quite recently it was believed that the species was reintroduced to Britain by the Normans in the eleventh century. However, archaeologists working at the Roman palace of Fishbourne in Sussex identified a number of fallow bones including two jaw bones that contained teeth. These were subjected to strontium isotope analysis which proved conclusively that one of the animals had been brought to Fishbourne, probably from southern Europe. It is clear, therefore, that fallow were introduced to Britain by the Romans a thousand years earlier than had been previously suspected.

Furthermore, there is also some evidence that the Romans actually kept them in deer parks, though whether or not any relict population survived in post-Roman Britain is quite another question, as no archaeological evidence of fallow has been found to date from between the fifth and eleventh centuries.

Norman reintroductions are likely to have come from Sicily, which was under Norman control from the end of the eleventh century and where wild fallow were present. At any rate, the fallow was a prized sporting quarry, and as a Beast of the Forest it was afforded protection within the hunting reserves of early medieval royalty. Its subsequent history was bound up with hunting, and hundreds of parks stocked with fallow became established by the nobility and gentry. However, there can be no doubt that from an early date deer escaped into the wider countryside and that feral populations became established.

Many of the old deer parks fell into disrepair during the English Civil War and the

Commonwealth, while others were abandoned during the nineteenth century and the two World Wars, and in consequence the feral population increased. Even so, a number of great houses still retain their deer parks and their captive herds, and a herd of fallow grazing contentedly beneath the parkland oaks in front of some splendid country house remains a timeless scene. Equally, the fallow buck on pub signs up and down the country demonstrates the extent to which the species is linked to local history and tradition.

Fallow deer are well distributed across the south of England, with their heartland south of a line from the Bristol Channel to Cambridge, including such historic areas as the New Forest, Ashdown Forest and Epping Forest. Fallow are present throughout the south west midlands, in Wales, the east midlands, Staffordshire, Derbyshire, Lincolnshire and Yorkshire. In the north of England and Scotland they are more sparsely distributed, but there are concentrations in south west Scotland, Argyll and the Southern Highlands.

The species is most at home in well-wooded farmland, where arable crops and grass are interspersed with blocks of deciduous woodland which provide safe cover, and a fallow herd may occupy a range of several thousand acres. Most feral populations are situated close to

Below
FALLOW
Keith Sykes
Scraperboard

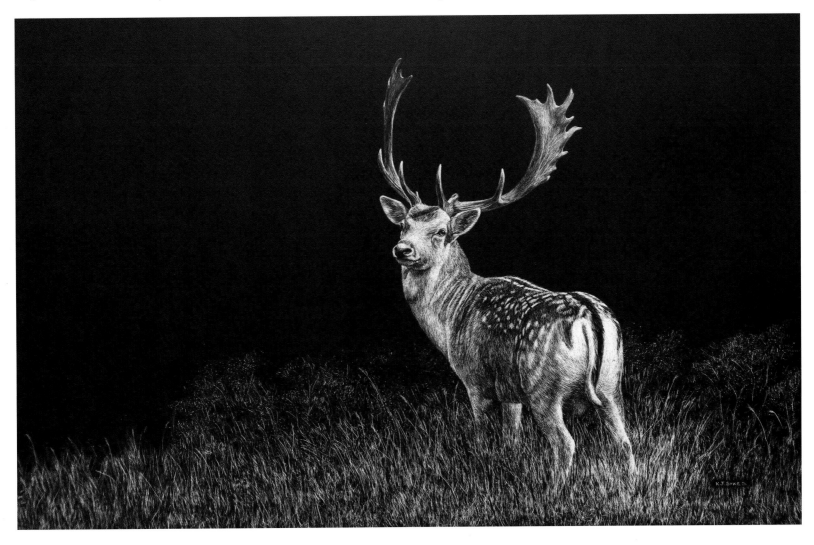

the old deer forests or parks from which their ancestors escaped, and very often the core of a herd's territory will be the ancient woods which once formed part of some great estate. However, beyond this central area will be found interconnected satellite herds of does and little groups of bucks, perhaps using adjacent small woodlands for feeding or shelter. Deer will range between these woods and the herd's principal territory along deer paths and routes which may well have been used for centuries. Fallow feed at dawn, and during the hours of darkness, though in the absence of any hunting pressure they will feed at four-hourly intervals throughout the day. They graze upon grass and herbage which forms the bulk of their diet from spring to autumn. At other times of the year fallow will take advantage of whatever food is available, such as acorns, beech mast, crab apples and a wide range of browse, including coppice re-growth. In winter, fallow will indulge in bark stripping. Where numbers are high there may be significant impact upon both forestry and agriculture. During the day fallow tend to lie up in the densest, thickest areas of woodland, but individual bucks may be found well away from the main herd, lying up in rough cover. Agri-environment schemes such as Higher Level Stewardship have created a new patchwork of lightly managed grass strips and small-scale tree plantings that are perfect to the requirements of fallow bucks

Fallow may coexist with other species, particularly muntjac, with which they do not compete for food to a significant degree. In some areas, such as the New Forest, they live alongside red and sika, but recent research has found that there can be competition between fallow and roe that will occasionally amount to outright aggression. The fallow is invariably dominant and in such encounters the roe will usually move away. It has been suggested that this determination to dominate available habitat was born out of the sheer need to survive when the range of their ancestors was confined to the relatively hostile environment of what is now Turkey and Iran.

A mature buck stands up to about 38 inches (97cm) in height and may weigh upwards of 155 pounds (70kg), depending on the time of year. In advance of the October rut, bucks will put on a thick layer of dense, white subcutaneous fat that can in some instances take them over the 200 pound (90kg) mark. Ancient hunting texts describe a buck in this state as being 'in his grease'. Does are rather smaller than bucks, standing about 34 inches (85cm) at maturity and weighing some 90 to 110 pounds (40 to 50kg) at maturity. Fallow are well known for the wide colour variation which they exhibit, and the same herd may sometimes contain animals that have coats in several different shades. Essentially, however, there are four basic variants. Common fallow have a chestnut brown summer coat, dappled with white spots, a superb camouflage when they are hiding in the dense foliage of a deciduous woodland. In winter the coat turns grey and the spots fade. They have a long and well-defined tail which is white with a strong, broad black stripe running down it. The white rump patch is also bordered in black. The menil fallow is similar in colouration, except that the coat has more spots which do not disappear in winter. Its rump patch is surrounded by a brown border. Black fallow may range from a dark chocolate brown to a dense black, the underside of the animal being a dusky grey, while white fallow start life a sandy colour, becoming progressively lighter with each moult. Occasionally, a park herd has been selectively

managed over a long period of time to favour one particular colour variant, and the results can be very impressive, as will be confirmed by anyone who has visited the magnificent herd of white fallow at Houghton Hall in Norfolk.

Fallow have a distinctive gait. Most of the time they walk or trot, although they are capable of a fast gallop when there is an urgent need to escape from danger. When they are alarmed, however, fallow have an unusual 'pronking' or 'stotting' gait in which the legs are held stiffly, all four of them leaving the ground at the same moment in a rapid bouncing motion. Fallow will also 'pronk' for no obvious reason except high spirits, like young lambs freshly turned out in spring pasture.

For most of the year bucks and does tend to live separately, the does in larger mixed-age herds and the bucks in smaller batchelor groups with the older bucks living singly or in association with two or three other larger males. Sexual segregation is not set in stone, however, and in some populations there can be quite a degree of mixing, with bucks remaining amongst the does after the rut for several months.

Social behaviour changes in the autumn with the onset of the rut, which normally reaches its peak around mid October, when there is a palpable degree of commotion and excitement within the fallow herd and the master bucks occupy their 'rutting stands'. Often these are traditional and time-hallowed features like a particular tree in the middle of the wood which will be rubbed and thrashed, scented with urine, and the ground around it churned up with hoof prints, but temporary stands or scrapes are also a feature of the fallow herd's rutting geography. The bucks will emit a repeated belching groan during the evening and throughout the night when much of the rutting behaviour takes place.

Naturally the does gather at the rutting stand to observe the proceedings, and a master buck may also permit a young buck to attend. If he is challenged by a buck of equivalent size, however, there will be a contest which may involve much strutting and posturing and occasionally an all-out clash of antlers. Just a small number of bucks will be successful in mating the majority of does, which they will examine for signs of oestrus and then cover. Fawns are generally born in May and June in a secure place within the wood such as a bracken bank or bramble bed. Most does produce a single fawn, although on rare occasions twins might be born. Fawns become independent at an early age and can both run and feed upon herbage when only a few days old. Fawns will continue to suckle from their mothers until the age of six months or more.

The antlers of the mature fallow buck are unlike those of any other British species. They are 'palmate' in shape, consisting of a beam that broadens out into a broad, flattened blade that is scalloped at the back into a series of projecting points or 'spellers'. Beneath the palmate top, the mature head will bear brow and trez points not unlike those of the red stag. Antlers are shed annually in spring and are fully regrown by August, when the velvet dries and withers. With a thousand years of hunting tradition surrounding the fallow deer, it is not surprising that there is a name for each stage of antler development. A first season buck has only a single spike and is known as a 'pricket', while animals with the succeeding heads are known as a sorel, sore, bare buck, buck and great buck, though these stages do not necessarily occur in consecutive years and antler growth is controlled by the condition of the animal which in turn depends upon the quality of the available food supply.

Sika deer

Sika deer (*Cervus nippon*) occur in a number of different races, which are indigenous to China, Taiwan, Korea, the Russian far east and to the Japanese islands. At least two races have been introduced to the British Isles but only the Japanese sika has become successfully naturalised.

Sika were first brought to Britain in 1860 when a pair was presented to the London Zoological Society. In due course sika were established in a number of parks in England, Scotland and Ireland from which releases or escapes occurred. In southern England, the main feral populations are in Dorset, arising from deer that escaped from introductions to Brownsea Island and Hyde House Park, Wareham in the 1890s. By the 1930s sika were established in the Dorset countryside, and they remain so to this day. A further population in the New Forest originated from escapees from Beaulieu. In northern England, sika are to be found in Lancashire and Yorkshire, while in Scotland they have rapidly expanded their range throughout Argyll, northwards from Inverness to Sutherland and eastwards into Aberdeenshire, with a further colony in Peebles that has extended eastwards across the Scottish Borders. Sika are also well established in Ireland, where they may be found in the Wicklow mountains and counties Kerry, Fermanagh, Londonderry, Antrim and Tyrone.

The fact that sika are so closely related to Britain's native red deer means that where the distribution of sika and red overlaps, the two species may hybridise, and it is this issue that is the one which is of greatest concern to conservationists and deer managers alike. Hybridisation is most likely to occur when colonising sika stags come into contact with red hinds, and in the Kintyre peninsula of Argyll, red-sika hybrids have been detected. A recent genetic study of fourteen estates across the Central Highlands, however, showed no presence of sika DNA, while new research undertaken by the University of Edinburgh in the Cairngorm National Park found only one out of 108 red deer samples with evidence of sika genes.

Sika are smaller than red deer, the stags standing at around 32 inches (80cm) and weighing between 155 and 200 pounds (70 and 90kg). Hinds are slightly smaller, around 30 inches (76cm) at the shoulder and 120 pounds (55kg) in weight. Their summer coat is a bright chestnut red with a dark dorsal stripe. It is attractively dappled with white spots, a row of which is arranged parallel to that stripe. In winter, the coat is a uniform grey, sometimes with the spotting still visible. In the field, sika in winter can appear almost black. The tail is similar to that of the fallow but considerably shorter, while the caudal patch is white. Both stag and hind have a pale 'U' shaped marking over the eyes, running back to the ears, and this distinctive feature of the sika gives the face a peculiarly 'pinched' appearance that makes it quite distinct from other British species.

Sika have a preference for dense coniferous forest and acid heathland habitat such as heather, gorse and rhododendron, though they are adaptable and on the Arne peninsula in Dorset they live comfortably in coastal

reedbeds. Damage may be caused to agricultural crops, but more significant impact may be felt in commercial forests, where sika browse conifer shoots and indulge in bark stripping and bole scoring. This involves the scarring of mature trees with deep vertical grooves made with the antlers of the adult stags, usually during the time of the rut. Sika lurk deep in the forest during the day and feed largely at night, travelling to their feeding grounds at twilight, just before dark. During the early part of the year, stags and hinds live together, and it is only in late summer that the stags separate out into their own groups. Then, as the rut approaches, the principal stags mark out a territory by fraying trees and other vegetation, scent marking and making scrapes in the ground. A stag's territory will be fiercely defended against the incursion of rival stags. Rutting stags will wallow, coating themselves with filthy black mud and urine. Often a master stag will be shadowed by one or more younger ones, which he will tolerate and which may be able to cover hinds whilst the master stag's back is turned. The presence of other mature stags which have ventured into his territory, however, will prompt vicious fights that can result in broken antlers and serious injury.

During the rut, the stag has a weird vocabulary of calls, the main one being a loud piercing whistle or shriek designed to attract hinds to a territory. This can be quite startling if it is not expected, especially on a

Right
Sika stag
Keith Sykes
Scraperboard

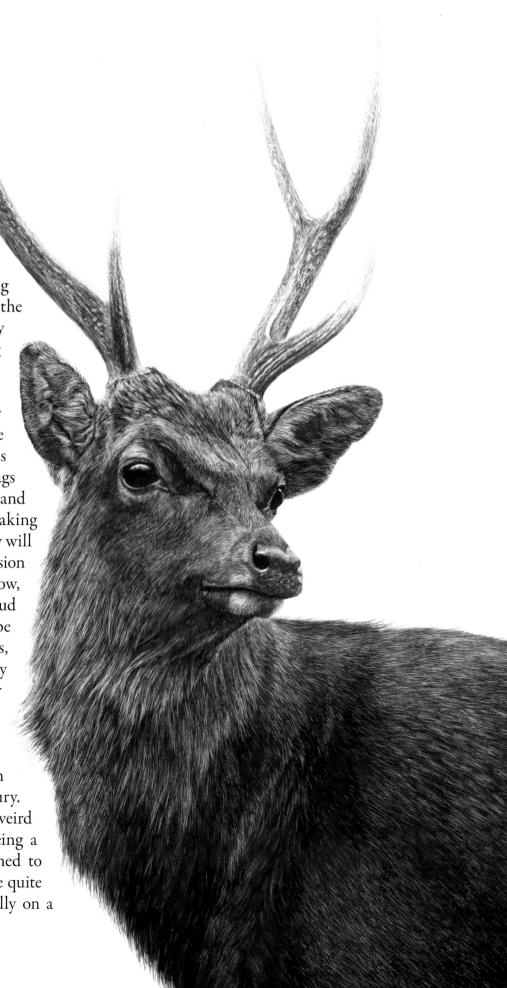

dark evening, deep in some gloomy coniferous forest. If there is competition for a hind from younger stags, the territorial stag will make a hoarse bellow, while there is also a cackling note which a stag uses to challenge another stag intruding upon his territory. Both stags and hinds in addition have an alarm whistle that may be heard at any time of the year when deer are alerted to danger.

Most calves are born in May and June. Studies have shown that mature sika hinds have a remarkably high productivity, with over 90% producing a single calf each year. Calves grow quickly and remain with their mothers until March, when the stag calves join other parties of adult stags. Hind calves are driven away in late spring before calving.

Stags grow their antlers in the spring, fraying them in August prior to the rut. The first year stag has only a single spike, and this may vary in length up to about 10 inches (25cm). In his third year a stag will usually have 6 points and at full maturity he will become an 8 pointer which is the classic sika head, though exceptional animals with 10 or even 12 points are occasionally encountered. The spread of a sika stag's antlers is considerably narrower than that of a red stag, and the architecture is quite distinctive, with the tines leaving the main beam at an angle of less than 90 degrees.

Chinese water deer

Least known amongst the deer species which occur wild in Britain, the Chinese water deer (*Hydropotes inermis*) is native to the reedbeds and riverine grasslands of eastern China from the lower Yangtze basin northwards to Korea. With the gathering pace of industrialisation, the Chinese water deer has declined substantially throughout much of its native range, where numbers are estimated to be as low as 10,000. As a result, the species is listed as 'threatened', making the growing British population of international importance.

The first Chinese water deer was imported to the London Zoo in 1873 and in 1896 a single doe was acquired by the 11th Duke of Bedford and introduced to Woburn Abbey, Bedfordshire. By 1913 a total of 19 had been introduced and, with successful breeding, a population of 126 was recorded. Numbers fluctuated back and forth over the years and it is believed that during the Second World War, when the abbey was occupied by Government staff, a significant number escaped and became established in the surrounding countryside. Also during the 1940s, a number of deer were sent from Woburn to other collections in England and Wales, from which some escaped and temporarily established themselves in the wild. By the 1960s, Chinese water deer had colonised parts of Bedfordshire, while further populations later became established in Huntingdonshire following a release from Woburn and in Norfolk after an escape from a private collection at Catfield. The Norfolk Broads proved ideal habitat for Chinese water deer and they soon became well established there, spreading along

the river valleys of Norfolk and Suffolk before, in more recent years, moving into open farmland between the river catchments. Chinese water deer may now be found almost anywhere in suitable habitat throughout Norfolk and Suffolk, as well as in their former core territory of Bedfordshire, where they may occur at quite high densities. More recently they have expanded into Buckinghamshire.

A small deer, Chinese water deer are larger than muntjac but smaller than roe, both bucks and does standing about 20 inches (50cm) at the shoulder and weighing some 26 to 33 pounds (12 to 15kg). The coat is a foxy ginger red, turning pale gingery grey in winter. They have button eyes, round ears that are well lined with soft hair, and squat, round heads. Neither sex has antlers, but both the buck and the doe carry tusks, and those of the buck can extend over 2 inches (5cm) below the jaw line. These tusks are used both for gathering food and for fighting.

The main food source is grass, herbs and wetland sedges, with bramble shoots also being a favourite. Some minor damage to commercial carrots and sugar beet has been recorded, but Chinese water deer do not presently, at any rate, pose a significant threat to agriculture or forestry. While they are largely solitary, deer may be found in particularly favoured areas at quite high densities of between 2 and 3.5 per hectare. Though its natural habitat is dense grass and reeds, the species appears quite at home in open fields, and when alarmed will sometimes run off before dropping down and lying flat on the ground until the danger has passed.

There is an annual breeding cycle, with the rut occurring during November and December, when the bucks become aggressively territorial, marking their territories with piles of droppings, scrapes and scent rubbings. Any intruder will be challenged, confronted and chased, the chasing buck making a clicking sound. A further sound is the bark, which is a slightly hoarser version of that made by the muntjac, with which it may well be confused. Both sexes will bark in alarm, while a repeated bark may also be given to defend a territory against another deer.

Young are born in May or June and weigh around 2¼ pounds (1kg), which is a substantial weight given the relatively small size of the animal at maturity. Chinese water deer are capable of producing a litter of as many as five or six young, though a litter size of one or two is more usual. Nevertheless, the potential remains for the Chinese water deer to increase quite rapidly in both population and range within lowland Britain.

Above
CHINESE WATER DEER
Rodger McPhail
Oil

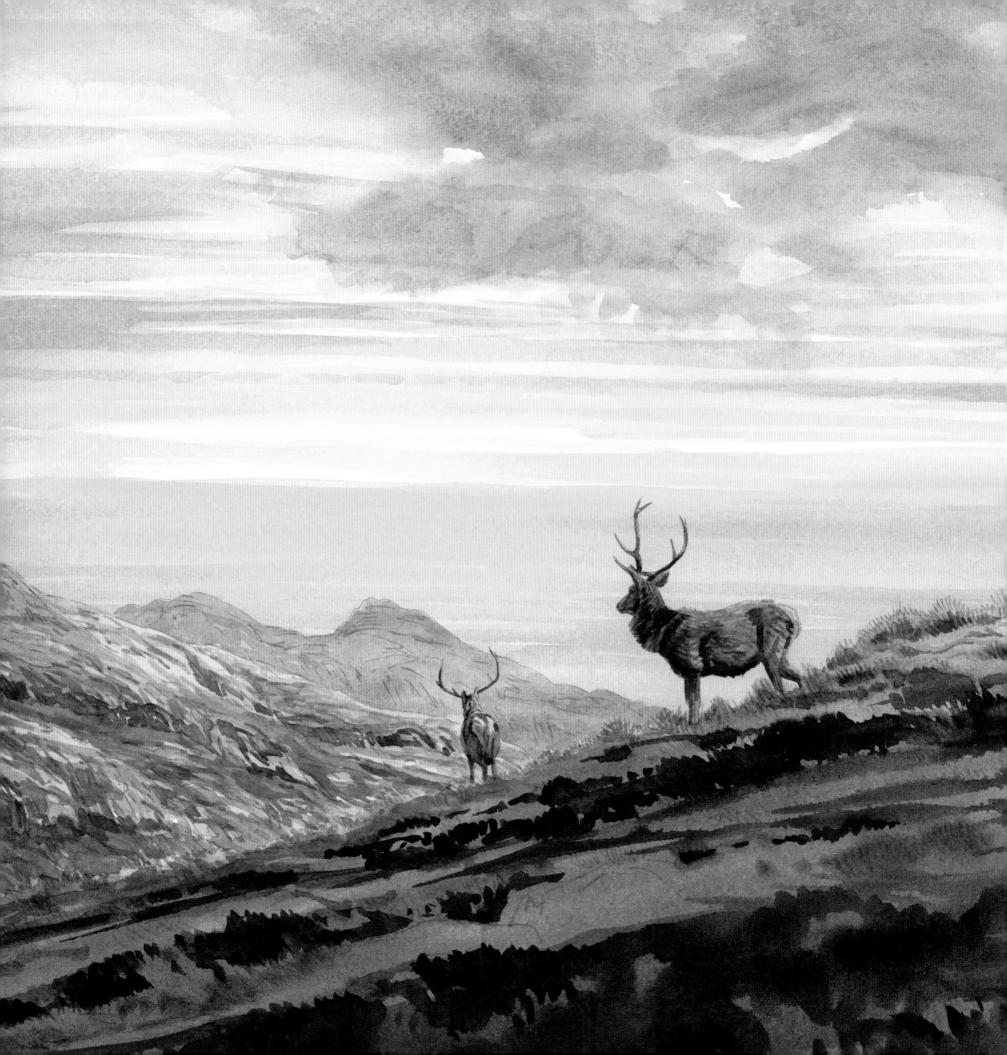

Martin Ridley

It is October, and I am lying on a rain sodden Scottish hillside in the growing gloom. Wiping down my misted binoculars I peep through the tops of the heather to scan for the handful of hinds and a magnificent twelve point stag that for the past couple of hours have steadily been grazing towards me. I quickly focus my binoculars and there he is, my quarry, high stepping behind one of his harem. Suddenly before I can take in what is happening he chases her in my direction. The hind, startled by my prone figure in the heather, shies and leaps high over me, successfully evading her unwanted suitor. The stag, far more pragmatic, stops to eye ball the intruder before turning and with more exaggerated stepping moves off to a more suitable vantage point. Despite the adrenaline rush and racing heart an amused smile spreads across my face and I almost laugh at the sight of the departing stag.

He is wearing what appears to be the latest in Highland accessory: a blue fishing net that dangles in frayed tassels from his antlers. This west coast stag must have been working his head gear on tide-line flotsam and picked up the netting. By the look of the tangle he will have to wait until the antlers are shed to get a clean makeover. I'm not sure what the other stags will make of him, but the ladies seem suitably impressed.

I am a hunter-gatherer who has gone off at a tangent. My day on the hill does not directly put any food on the table but it nevertheless is my livelihood. If I take a shot it will be with a camera not a rifle. I mimic those primitive hunting skills using fieldcraft, crawling about on the hill to get as close as I can to the deer without them (hopefully) ever knowing I'm there.

My objectives are very different from your typical hunter. I am interested in observation, seeing how deer congregate in different seasons, understanding their physique, muscle toning and fur texture and the influences of nutrition

Above
RED DEER SKETCH
Pencil

Opposite
GOLDEN EVENING NEAR POOLEWE – RED DEER (detail)
Watercolour

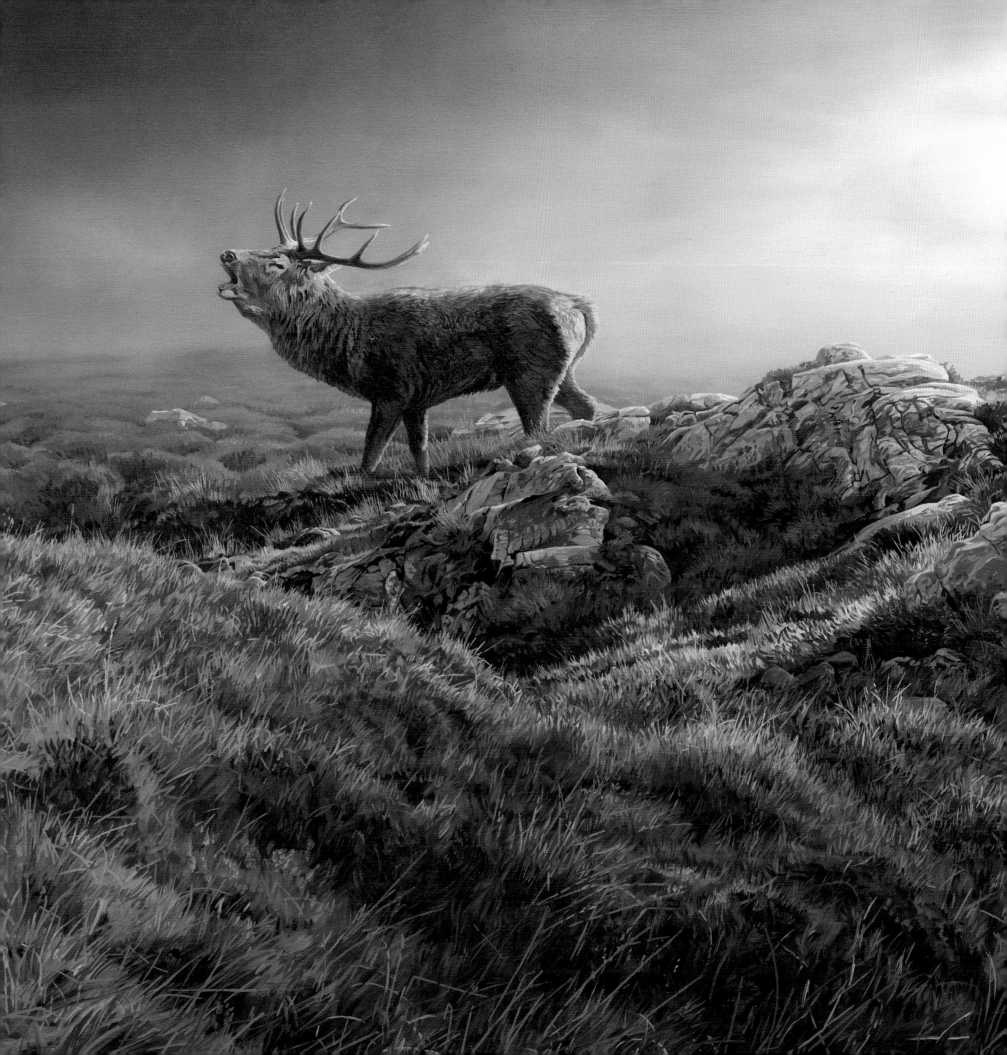

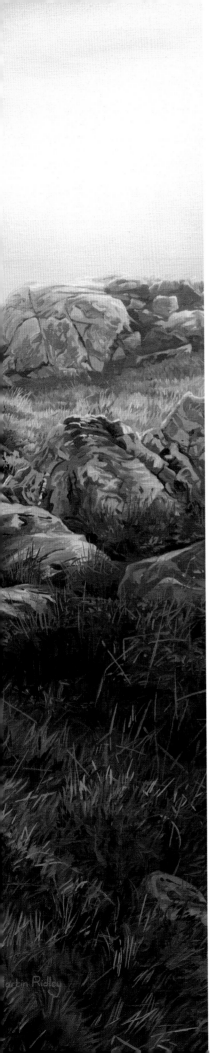

and environment. A big consideration is how the animals appear in different light and weather conditions. All of these experiences enable me to develop an intuitive feeling for natural groupings which I can then transpose into the designs of my paintings.

I prefer to paint subjects that I have an in-depth knowledge of and although I have, over the years, encountered many of the deer species found in the United Kingdom it is only in the last twelve, since moving to Scotland, that they have attained significance in my portfolio. Previous encounters with deer were few and far between, perhaps during a summer holiday or on an occasional day out; but the opportunity now provided by living in the Highlands has been a real education. One thing soon becomes apparent and that is that the Highland landscape, although it looks vast and empty, seldom is. Once you 'get your eye in' there seem to be deer everywhere, be it a couple of roe picking their way alongside a tumbled wall or a herd of fifty plus red deer lying down in the heather chewing the cud.

There is so much to enthuse about deer and their environment that the only way I feel I can begin to elucidate it is through the medium of my paintings. Only in this way can I communicate my passion for the subject with better clarity. I am repeatedly awe struck by nature. It is a human construct to describe something as simply beautiful, but I do not have a better summary. As an artist I am all too aware of the inadequacies of focusing solely on the beauty of nature; reality in the wild is a constant struggle for survival. Pictorially this 'life in the balance' drama can be engaging, though I have encountered extremes. Once I witnessed an unfortunate hind cartwheel through the air after losing her footing at the top of a high crag, whilst on another occasion I was in time to save a yearling calf that I found dangling from the upper wires of a fence. Through my paintings I try to develop a story for the viewer offering up elements of the more typical natural dramas I have witnessed.

Through my work the opportunity has arisen to accompany stalking parties. I have found it a fascinating insight into the deer management process and also the wider traditions of the Highland estates. Invited to reconnoiter for painting commissions I have been introduced to some stunning locations. The day often rewards in a multitude of encounters: a gang of wild billy goats on the crag, a distant view of a pair of golden eagles, or a flock of fieldfares diving down to feast on a rowan. Last time I was out I remember watching snipe being flushed from their hiding places amongst the juncus rush right under the hooves of the red deer.

My paintings depict the deer within their habitat. I do not generally lift them out of context, aiming instead to give the viewer a sense of 'being there' faced with the encounter themselves. The degree to which the deer or landscape dominate is decided on a picture-by-picture basis and I am frequently just as inspired by a wilderness landscape with a dramatic sky where the deer are little more than incidental silhouettes. Deer add scale so as to enhance the grandeur of the landscape, but equally, through compositional experimentation, I can turn

things around so that the view point is that of a deer amongst the herd with the landscape as the background foil. Either way, for me it is important to give equal attention to the landscape and the deer, or the weaker of the two will undermine the whole effect.

Within any landscape there are many potential view points. In preparation for exploring new ground I study maps, working out where will be the most interesting topographically. I consider where the deer might be sheltering, given the weather conditions and what time of day the area might catch the sunlight. Once I am on location a bit of clambering around can provide an enhanced perspective. Even a few yards up or down the slope will change the overlaps between bumps of ground, and a little searching might reveal a striking foreground of boulders or a little burn leading the viewer's eye into a potential painting composition. My inspiration is gleaned from so many things; from the wildness of the landscape, the weather, the fresh air on my face or just the range of vegetation. At close quarters I experience the damp cushions of sphagnum moss and scratchy clumps of heather, the sounds of trickling water and squelch of my boots on the ground. The musky smell where deer have been and even the smell of them on my jacket after I have been crawling through the grass. My thoughts meld together and from this platform of memories I design the painting composition.

When it comes to exhibiting it would seem logical that the more the viewer of the painting has experienced what I have, the more they will relate to the painting. Although this is often the case, what's derived from a painting is so personal that all I can do is paint my inspiration in the style of 'deer according to Martin Ridley' and display it. Paintings can have an aesthetic that communicates beyond what we have

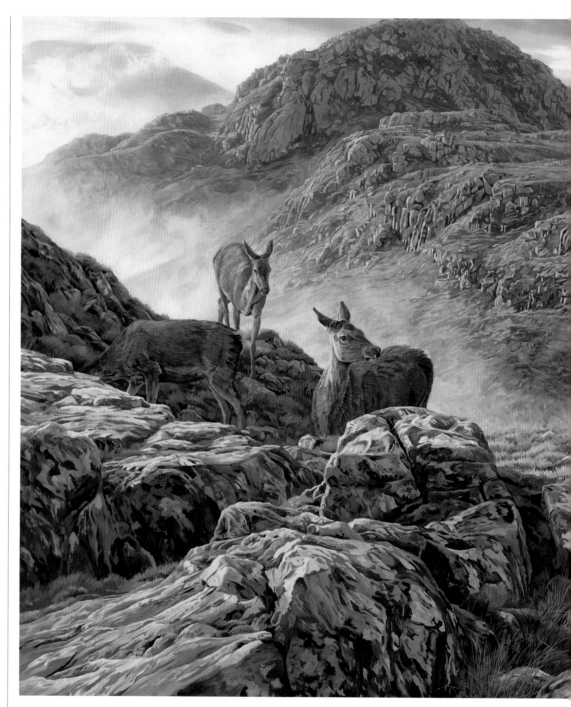

ourselves encountered and it is rewarding to see a painting appealing to a wider audience in ways you would not expect.

The two species of deer that we see locally are red and roe. I roam the hills to watch the red deer, whereas studying the roe is a more intimate affair. Last August a very fine old buck passed

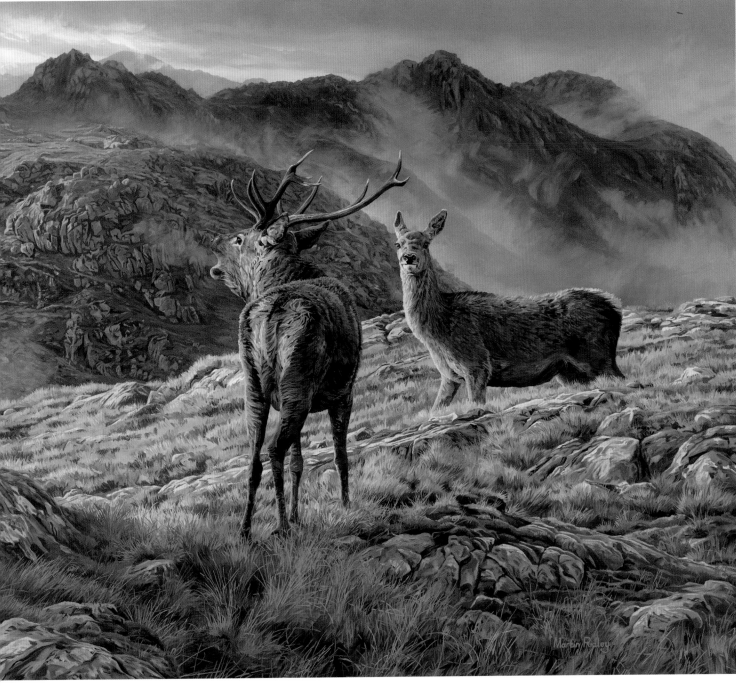

Left
DRUIM FADA RIDGE
Oil 24 x 48 inches

Below
RED DEER SKETCH
Pencil

away. It was a sad moment as I had known him for the eight years that I had lived in Comrie. For the next six months I saw no mature bucks on the vacant patch then almost in unison three new contenders arrived. To date, the three have carved up slices of the previous buck's territory, which just goes to show how dominant he was.

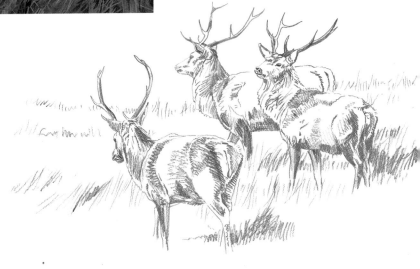

To observe the roe closely I have a dense patch of cover enhanced by screens of piled up branches that I've added to over previous seasons. When the wind is from the prevailing direction I can approach and observe undetected. In the all too brief daylight of winter, bringing all the elements together can be challenging. I periodically scatter food to hold the deer in the area. Frequently there is nothing to see, the carrots lying untouched for several days. If a herd of red deer find them I back off with the food supply as a few hungry reds can eat a heavy bag of carrots pretty quickly and I will struggle to keep up. However, if the roe deer latch onto the resource, supplying top-up food is more manageable and I try to visit as often as possible.

Sometimes it gets quite frustrating. Even if a group of roe is visiting regularly there is plenty that can go wrong. I might turn up too soon and spook a doe approaching the area. After a few warning barks, all the deer in the vicinity are bounding for cover. Turn up two hours later and all the carrots might be gone. A great deal of patience is required when working with wild animals and the Scottish weather. Often there will be plenty of deer, but dark and rainy conditions day after day. Then, when at last I wake up to a crisp bright morning, it might be too crisp, making the sound of my approach very hard to stifle over crunchy frozen snow. I have to brush a clear path for a silent approach and can end up waiting a couple more days for an opportunity. At last I peer through the hole in my screen to watch a buck and doe with accompanying young. I watch their interactions from a few yards away gaining new insights.

Much of my red deer fieldwork is carried out during the rut, when the glens resound to the evocative roar of the stags as they compete to father the next generation. It is a marking of the

seasons that I always look forward to and when it comes to wildlife drama I think many would agree that few surpass this spectacle.

When stalking the most important thing is giving consideration to the wind direction. I have studied many different mammals in the course of my work and few are as sensitive to scent as red deer. A corrie will be emptied of deer if they pick up human scent, even from over a mile away. Using the bumps and hollows of the slopes to conceal me I climb to a suitable vantage point. Deer generally look down the slopes for approaching danger so climbing high to spy on them from above I am less likely to be detected. Viewing from above also gives me a better chance of revealing out-lying deer tucked away in hollows. There is a real importance to locating every deer before moving closer, as spooking any single animal will usually lead to the whole herd becoming alert and moving off. Even if they do not move off an alert herd on look-out is more difficult to approach than one that is settled. I study the lie of the ground, looking at how I

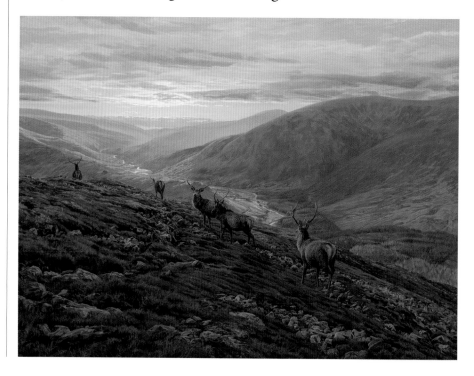

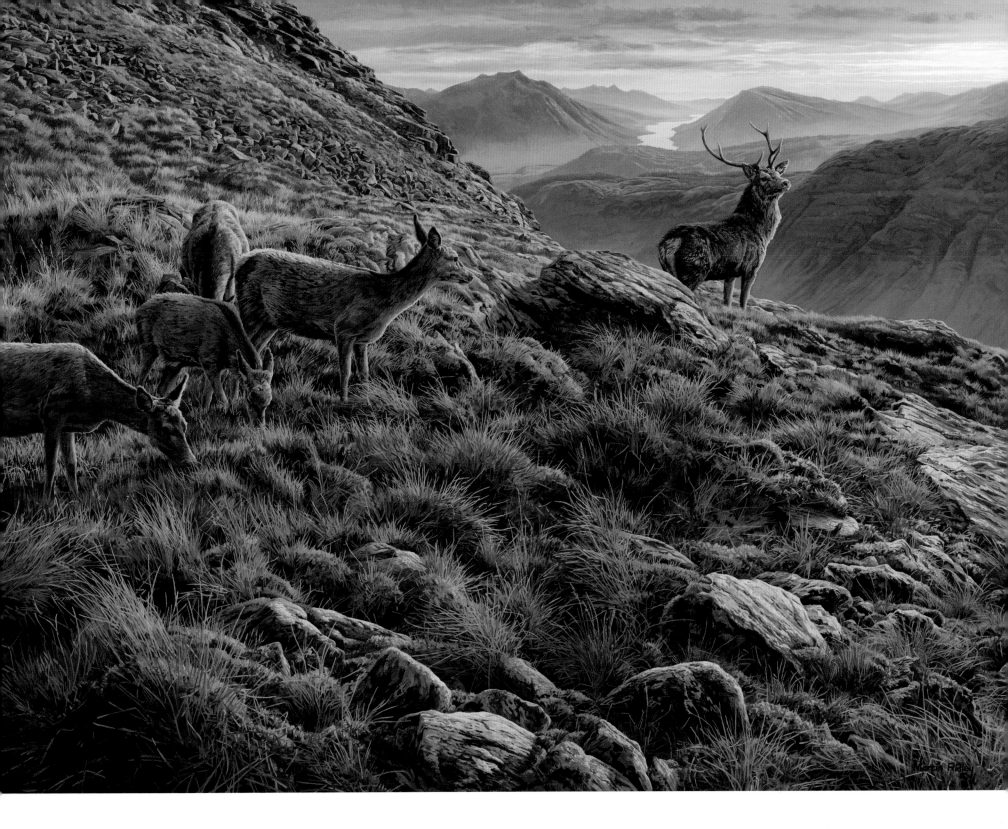

Above
RED DEER ABOVE LOCH ETIVE
Oil 29 x 39 inches

Left
CREAG NAN GABHAR,
Red deer stags near Braemar
Oil 30 x 40 inches

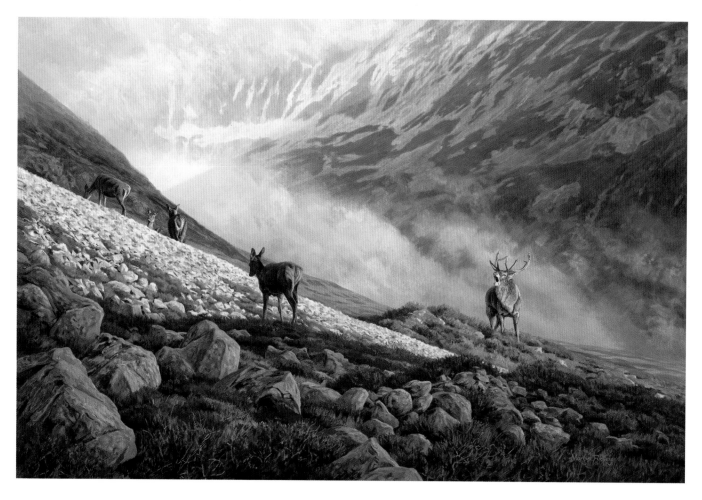

might approach hidden in a gully or whatever hollows are available. If the deer are looking into low sunlight it might also be possible to stalk slowly across the face of shadowed slopes with my whole body in view. I am in no rush. A carefully considered stalk is more likely to be successful.

Observing the deer's behaviour might reveal an opportunity. A particular stag might patrol the edge of his herd in a predictable pattern, or the hinds may look as if they are keen to move down to lower ground. I try and position myself accordingly, wriggling forward to a concealed location that will provide good views, allowing the deer to approach me in their own time. If my plan comes together, as once in a while it does, the slopes will stay illuminated long enough to view the warm colours of the lowering sun on the herd.

Spending so much time outdoors has given me many memorable experiences. Recently I was trying to get close to a stag holding hinds. The sun was right in my eyes and each time I cautiously looked up to spy ahead one of the hinds would be staring straight back in my direction. She had the advantage of looking with the light and was clearly drawn to the slow raising and lowering of my veil-covered head. The deer gradually moved back along the ridge. After an hour the ground between us provided some better cover and I moved forward to about 80 yards (74m). At this point a raven turned up. It flew around a few times before landing behind me and cawing noisily. Taking

flight it headed straight for the deer, landing on a rock amongst them. It then cawed again and raced back to me. It showed great interest, boldly diving down at my location before flying directly back to the deer and repeating the process. It exhibited quite different behaviour to all the ravens I had encountered over the preceding days, which had all kept a respectful distance. As a member of the Corvidae family the raven is from a most intelligent group of bird species. I do not think I am reading too much into the encounter by suggesting that the raven associated camouflaged stalkers with the likelihood of a good feed of deer gralloch and it really seemed to be trying to show me where the deer were. I would be interested to hear whether anyone else has noticed similar raven behaviour?

Studying the daily routines of particular animals is often useful. On some cleared forestry I tucked into a hollow in a pile of brash, laying a few fronds of bracken across my knees as extra camouflage. Beyond me the seed heads on

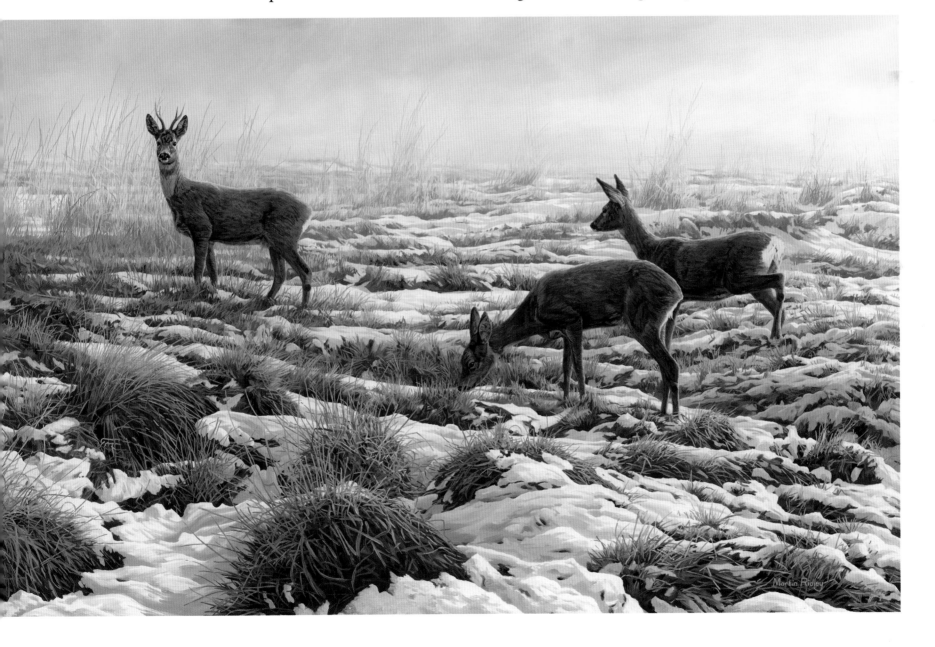

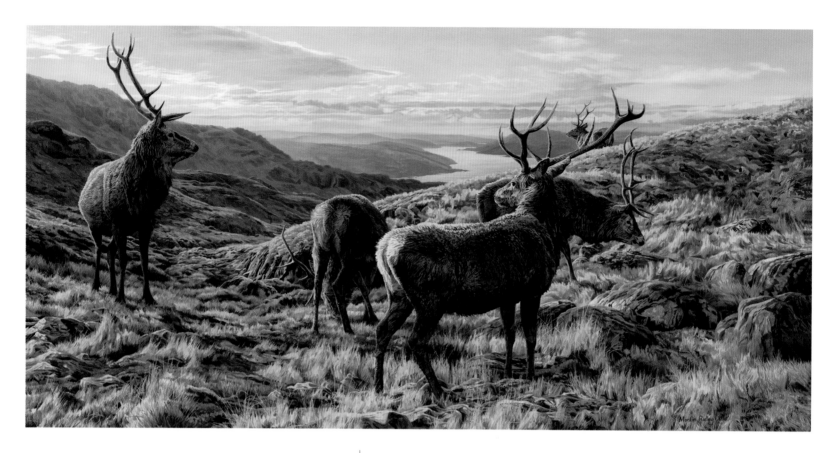

golden tussocks of grass quivered occasionally as cooler air sank into the glen. A few red kites drifted overhead as they passed by on their way to roost and a brown hare loped along heading down to the fields. As the light faded two roe does emerged from the forest and made their way onto the open ground before at last I heard the stag, his progress through the trees punctuated by roaring. Hinds broke from cover first, startling the roe. The hinds stared ahead looking for danger before skipping down into the rushes to feed. Over the next half hour they advanced through the marsh and up the small rise towards me. The posturing and roaring stag advanced with them. They could have walked anywhere within the 100 yard (92m) gap between the fences but I'd chosen my location carefully beside a well worn path. As the whole herd drew closer they formed a ragged line and stepped right past my concealed form. Twenty-

six deer within five yards, if any one of them had gone the other side of the pile of brash the wind would have blown my cover. I found myself holding my breath, looking up under the chin of a roaring stag. Out of all the deer one young calf stared at me briefly before trotting to catch its mother up. What made the experience all the more fulfilling was that they all passed and carried on down to the fields without detecting my presence (except for the calf). I feel a certain satisfaction with the deer not being disturbed; my aim essentially is to observe wildlife without impacting on or influencing their behaviour.

Having sneaked away in the dark I cycled back to the cottage, where I contemplated the encounter while warming myself by the wood burner. As a creative stimulus such a day gives me a rush in a way no visit to a deer park or farm ever could. I plan my year around the best times to be out on the hills with the red deer or

Left
STAGS ABOVE LOCH SUNART
Oil 24 x 48 inches

Below
LOWERING SUN
Red deer stags
Oil 20 x 30 inches

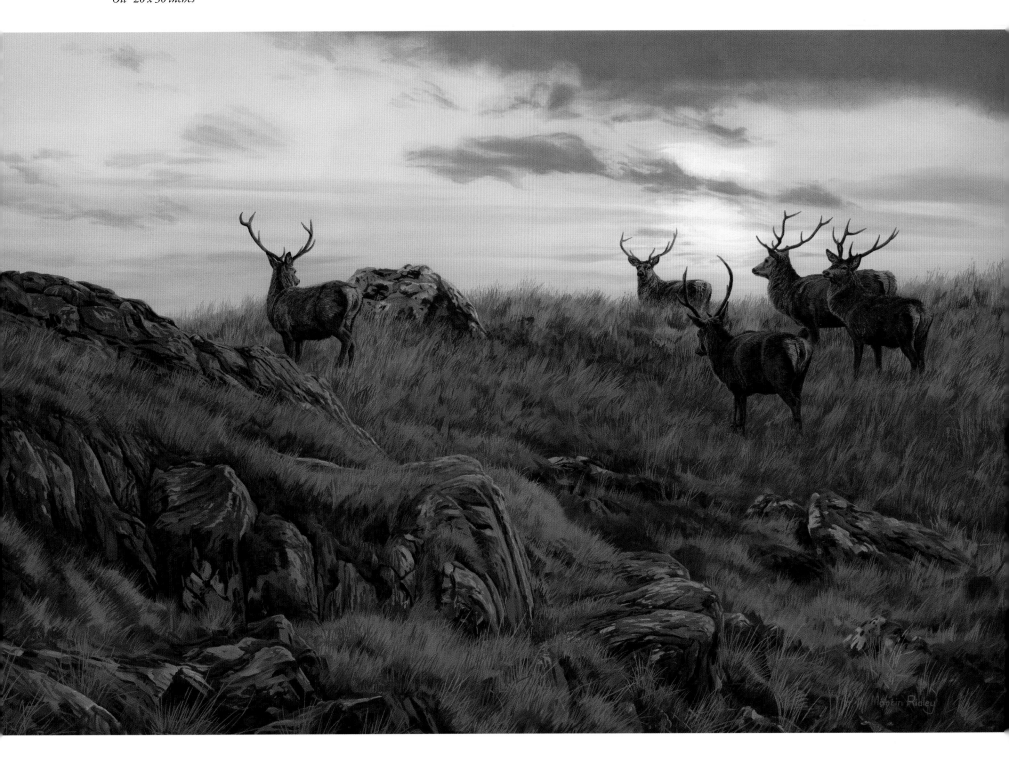

sneaking through my local woods checking up on my favourite roe bucks. I do not spend my week thinking about what hobby activities I will do in my spare time because my hobby is my life. Discovering a passion for both painting and field study at an early age, I feel very fortunate that I have subsequently succeeded in transforming this into a sustainable vocation. I struggle to separate myself from this obsessive fascination with nature and its depiction. The two are intertwined. For me the challenges of each are exciting and rewarding with so many variables that I cannot imagine tiring of either. I enjoy the challenge of striving for wildlife encounters and if they could be guaranteed on every outing my job would be less satisfying. In Scotland weather often changes rapidly and the cloudscape faster still, on the days when the wildlife proves elusive there is still an invigorating visual feast.

Right
HERE COMES TROUBLE
Chasing roe bucks
Acrylic 18 x 24 inches

Below
ROE DEER SKETCH
Pencil

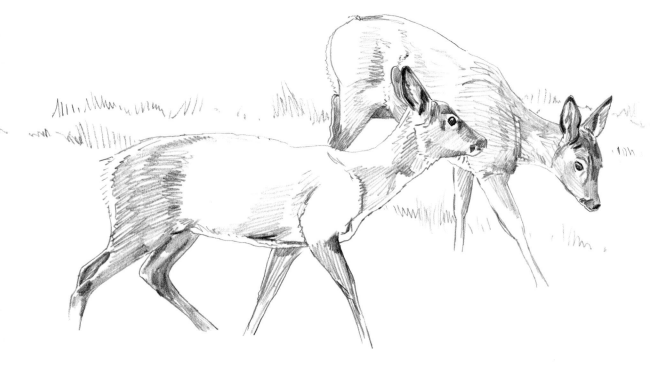

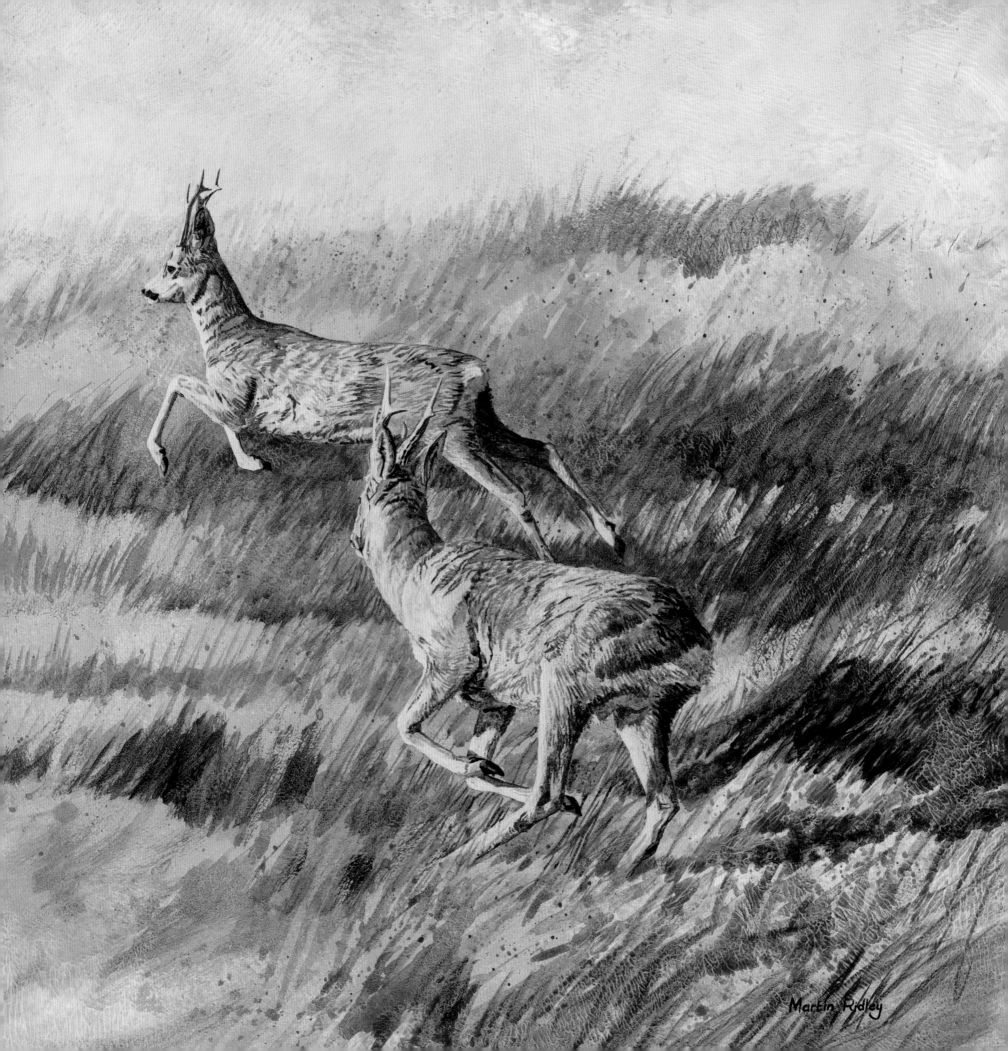

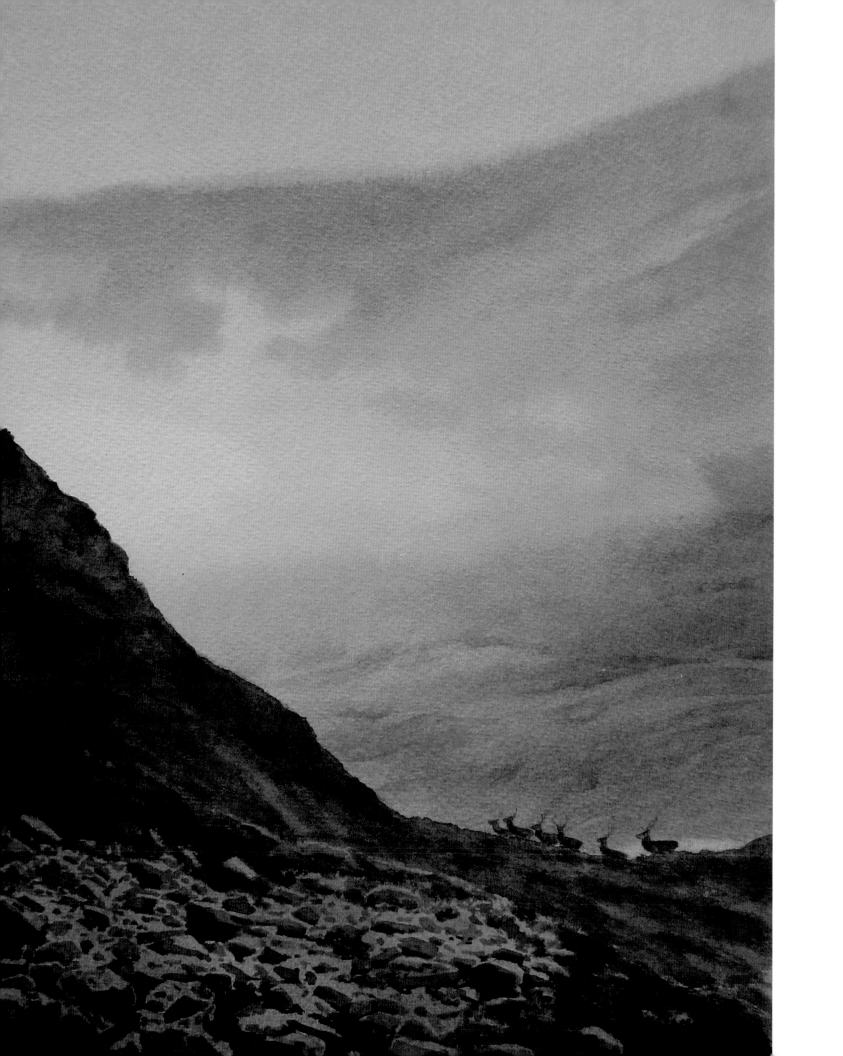

Owen Williams

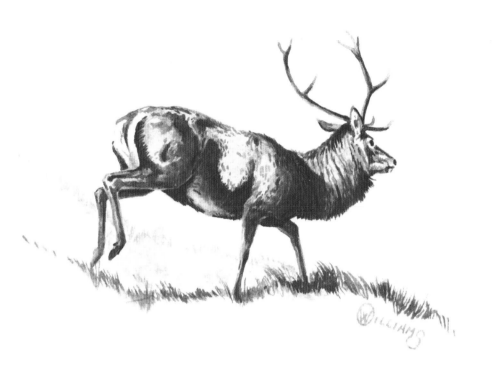

Some of my fondest memories of my early teens are of sneaking up on flocks of starling with an old air pistol in the fields around my home in Wales. Invariably these hunts ended in a whirring of wings as the pellet from my gun thudded harmlessly into the nearby grass. On reflection this was good training in the management of my expectation, because even at my glowing best I can only be described as nothing more than an average shot. But this entertaining activity, along with the crawling in on hares with no other objective than to see how close I could get, gave me the understanding that it's as much about the hunt as the kill.

I envy those who grew up in areas where woodland shadows held secretive roe or fallow, and Highland hillsides cupped herds of grazing hinds. How much more exciting these would have been as subject of my wet-kneed hunting fantasies when compared to a quarrelsome flock of starlings.

My first experience of deer came a number of years after I had embarked on my career as a sporting artist. Until then my early days making a living painting watercolours in the spare bedroom were dedicated to depicting the species that I was familiar with such as wildfowl, snipe, and woodcock. Looking at the work of Lionel Edwards and Balfour Browne I learnt that the greatest deer pictures were those that conveyed a powerful narrative, which could only be taken from experience. So it was with great excitement that I received a generous invitation in 1989 to shoot my first stag on an estate in Inverness called Garrygualach.

This followed a trip made a month earlier to the same estate to work on a commission for a customer who was passionate about ptarmigan shooting. After three days walking with the Guns on high ground overlooking Loch Arkaig I was completely captivated by the landscape and wildlife of this beautiful part of Scotland. The owners of the estate kindly suggested that

Above
RUNNING
Watercolour

Opposite
GLOWING DAWN
Watercolour

I might like to return in 'the rut' to have a day's stalking in exchange for a painting. This kind of offer takes little time to decide on, and so it was that I shot my first hill stag.

Garrygualach was far from being the classic sporting lodge, devoid of any Victorian grandeur the modest house could best be described as an extended bothy. Neither windows nor walls were gale proof, I recall one particularly rough night when the thick blanket hung in the dining room doorway to keep the room cosy flapped its failure as we sat and ate our dinner. The occasional drip coming from the leaky roof gave every impression that this modest building was

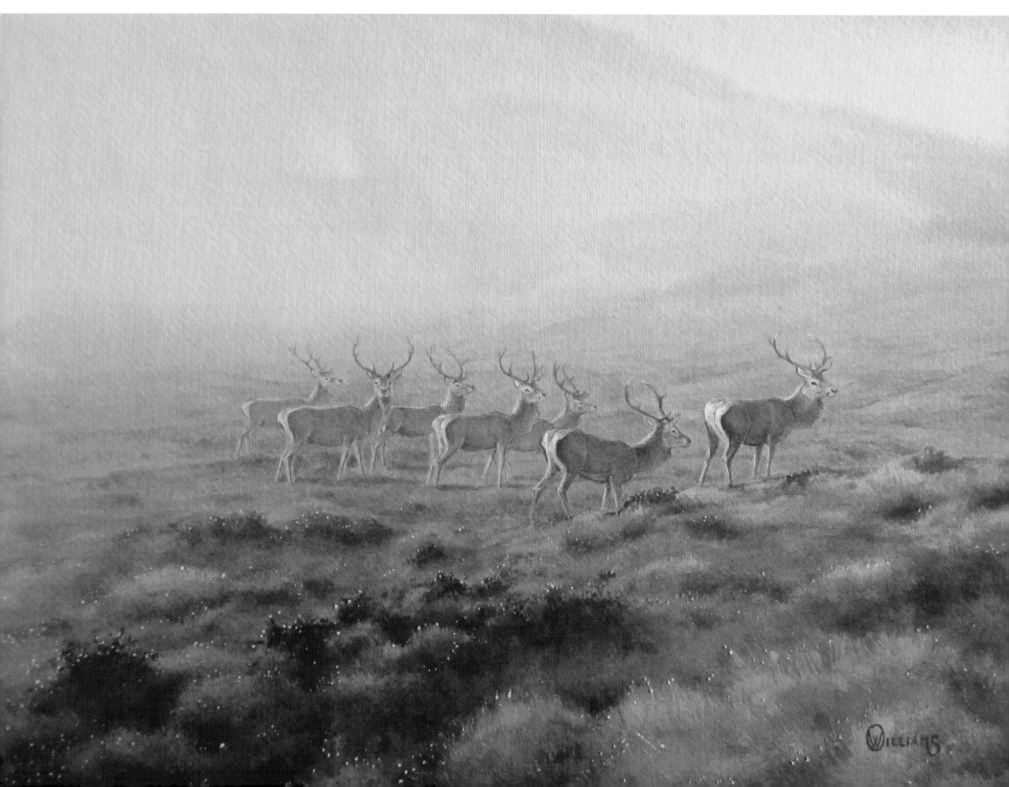

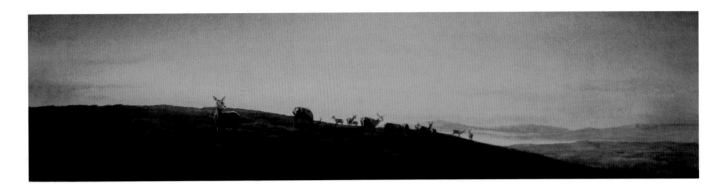

on a very short-term loan from the surrounding wilderness.

Stalking at Garyguilach required a long walk from the loch-side pastures that surrounded the house, up through rank heather to the scree speckled upper slopes of hill with exotic gaelic names such as Sgurr Choinich and Gael Charn.

My stalker on this first day on the hill was Ken Morrison a tall athletic fellow with a hint of the military about him. Each year he made the journey from Northamptonshire up to Garryguilach to work as a stalker for a few weeks during the rut. It was clear from the first step through the pony gate onto the hill that this was a man with the build and stamina to walk all day, like a Highland pony his pace was purposeful and steady. As I followed in his footsteps, with my friend and fellow artist Terence Lambert who had come along for the trip, I pondered the enormity of what I was about to do. Until this time I had shot nothing bigger than a goose, but a stag was very different, being a few more notches up the sentient scale. On the weeks prior to the trip I had played devil's advocate with myself, 'did I really need to do this'?

There were two factors that made my decision for me; this was part of a yearly cull meaning that the stag that was chosen for me to

shoot would be an elderly specimen who, having passed on his genetics over preceding seasons, was in the autumn of his life. His future, if left to live with failing teeth and ageing body, would be determined by how harsh the following winter was. Argyll winters show no mercy to the weak and infirm, the odds were that he would die after a prolonged period of starvation. The second factor was that as a sporting artist who had a growing appreciation for the Highlands I had wanted to paint red deer, however to do this with no experience on the hill would be a mistake. I also believe a sporting artist can't make up the feeling in a painting because this is not just an exercise in recreating an image – it is about conveying a narrative and to do that you have to have a story to tell. Small elements in a painting such as the wind direction on grass or the wetness of the peat in a hag trigger memories in the viewer, which enable them to add their own narrative to that of the picture.

Early on in my career as an artist I gave talks to local art and WI groups about my work. One of the more thought provoking questions I was asked was how I could be so fascinated by the beauty of birds and animals and but also be able to kill the objects

of such beauty. This is a very good question, which forced me to think a bit deeper about what I was doing. I have both painted and shot for most of my life and I had never felt they were mutually exclusive. To reduce the debate to 'I would not kill anything of beauty' is a mistake, mainly because beauty is subjective, but also because most creatures are intrinsically beautiful and were humanity to adopt that criterion we would all quickly starve.

Whether my next meal is a chicken reared for food, or a duck shot on the estuary should not matter a jot as long as it has been killed

in a humane way. If my shooting is part of a sustainable harvest then there is nothing else to worry about. Those who are squeamish about death and yet eat meat have no right to lecture those of us who are prepared to take full responsibility for killing our own meat.

Modern day values condition us from an early age that we should be squeamish about carcasses and blood. This is only because in the past 100 years of human history the killing of our meat is done conveniently beyond our gaze. This is not a move towards a more civilized society it is the symptom of a society's disconnection from the

Above
SKYLINED
Watercolour

Right
NO CONTEST
Watercolour

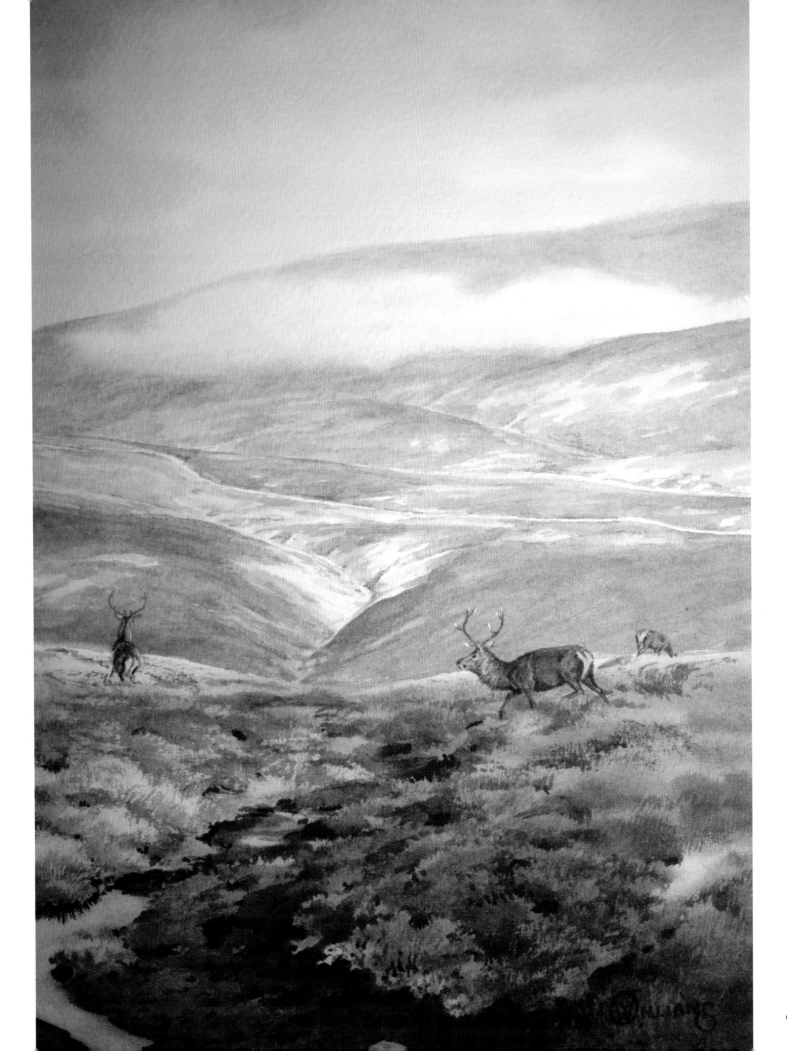

reality of how our food reaches our table.

So we have now arrived at a point where those who are wilfully blind, or in a position of ignorance are trying to stop us doing something that is a valid part of our human heritage. We are being told that we are cruel and should get on and eat our shrink-wrapped steak in the same state of disconnect as the rest of modern society.

For many of us shooting and fishing enables us to re-connect with our natural role as hunter-gatherer. On that first day's stalking at Garrygualach I felt a sense of being reconnected. I was in an environment where I did not have total control, weather and the supremely sharp survival instinct of the deer would dictate the outcome of the day. This is an environment that forces humility upon us. Maybe some of society's problems stem from our lack of humility with adolescents believing that they are outranked by no one, because now they make and live by their own rules.

Some way up the hill on that day stalking at Garrygualach we spied a group of hinds, but were unable to see whether they were being held by a stag. On walking in closer using the cover of the broken ground on the flank of Scurr Choinnich we were still unable to see a stag. Now within 300 yards we decided to lay up and wait to see if a stag would reveal itself from the dead ground between us and the hinds which

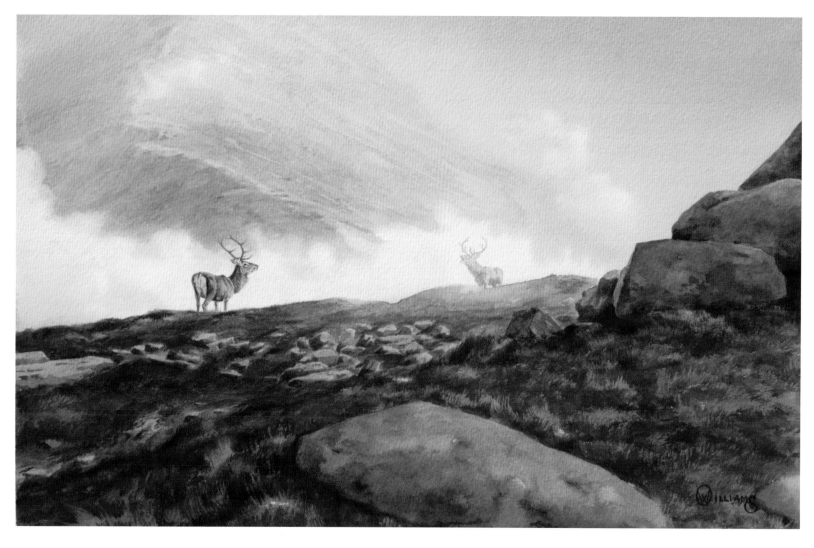

were slowly grazing their way up wind unaware of our presence. With very little cover all three of us lay flat on our bellies and Ken suggested we take the opportunity to eat our 'piece' (sandwich). Now had this been a British Rail sandwich, the proverbial two anemic slices and a few shreds of cheese, eating would have not been a problem. But two heavy slices of whole grain home-baked bread restraining heavy slices of mature cheddar posed quite a problem in the swallowing. Maybe for the practiced stalker, who for all I knew probably preferred eating this way, this was all in a day's work, but for two softies from 'doon Sooth' the best we could do was to mimic an owl trying to swallow a large mouse. Half way through mine Ken nudged me, and being sure this was not to admonish me for my poor table manners realised that this must mean that there was a stag to go for.

In quite a hurry we crawled forwards onto a grassy lump a few yards ahead. The stag was a 'traveller' a scrappy specimen who, on seeing the unattended hinds, decided this was his moment. He was walking in rapidly down slope from the left and so I had little time to judge my shot. Ken stopped him in his stride with a passable impression of a roar and as the stag stood side on, but looking straight at us, I fired and was relieved to see his front legs give way as he fell dead to the ground.

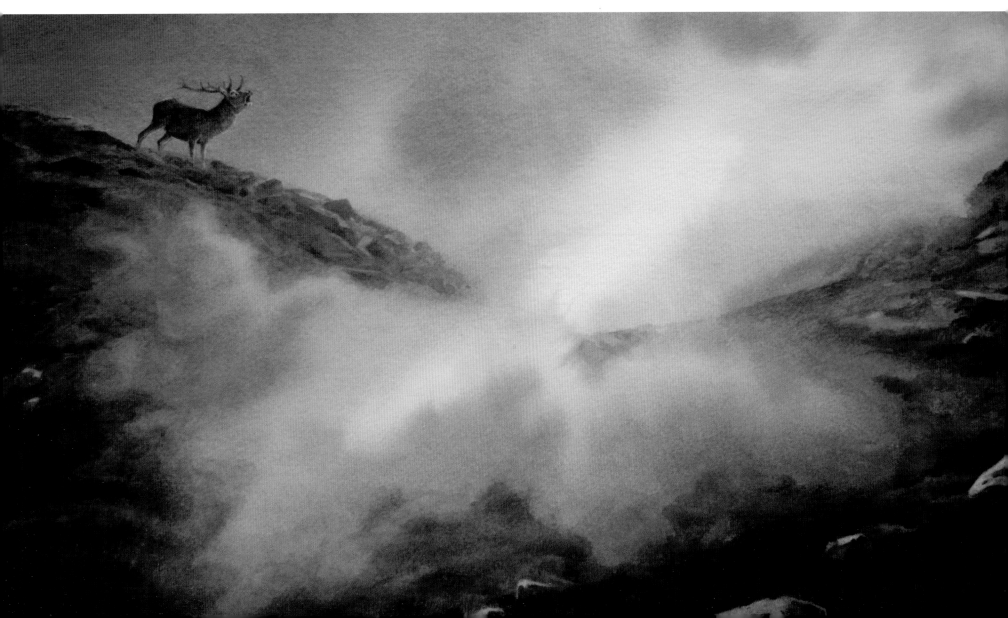

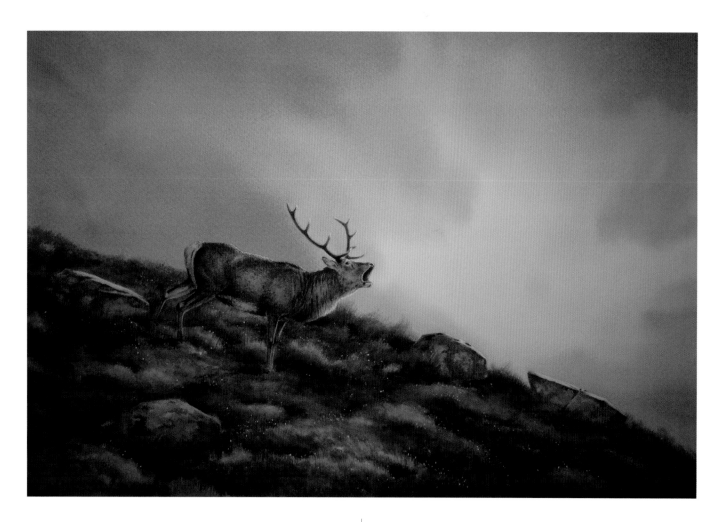

In this modern age of argocats and quadbikes getting beasts off the hill is an easy business. With the difficulties of getting regular supplies of fuel across the loch there was little choice at Garrygualach but to use garrons (ponies). The Grey family who ran the estate were keen on Icelandic ponies, these were every bit as hardy as the traditional Highland breed and so there were always two or three grazing on the greener ground around the bothy.

Such was the unreliability of the domestic hydroelectric supply that radios, which needed daily charging, were of little use at Garrygualach. Communication on the hill was difficult and largely relied upon using one's eyes to spot where people were on the hill. So it was that in the early afternoon the ghillie leading his pony came up the winding path with the vista of Loch Garry behind him and then took the wrong turn and headed on a path away from our hill. Despite lighting a small fire out of wet grass, which sent a contour-hugging plume of white smoke along the flank of our hill, we were unable to attract his attention. With mounting frustration Ken asked me for the rifle I was carrying and fired a round into the air. With a fantastic illustration of just how slow sound travels, seconds later the ghillie came to a gradual halt along his wrong path, turned around and headed towards us. Terence looking through his binoculars, and ever happy to impart some wit into a situation called to Ken 'I don't think it was a heart shot, maybe you should take another'.

To see my first stag come off the hill on the

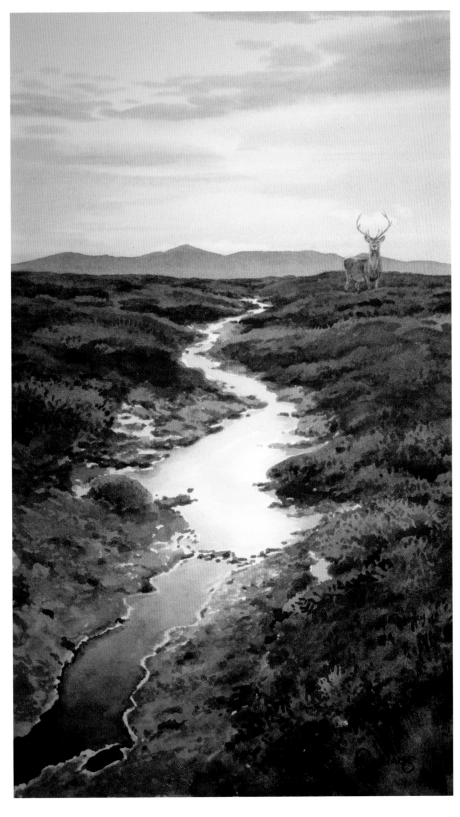

back of a garron was the icing on the cake on that first stalking trip. Over the past 50 years many estates have moved with the times and invested in modern all-terrain vehicles. It's lovely to see that some are now returning to the use of ponies, which can get to all but the peatiest ground and cause far less damage to the fragile habitat. As I know from experience any stag shot in the pat hags just has to be dragged out, hard work, but to my mind every bit a part of the stalking experience as the stalk itself.

Every October I enjoy a week stalking on Dalnamein beat on the Atholl Estate, a piece of ground that pulls in good numbers of stags in the rut. This is where I top up on inspiration for stalking paintings with ample opportunity to watch deer behaviour and the ever-changing light on that glorious Perthshire landscape.

The Atholl estate have a herd of Highland ponies which earn their keep on the ground through the stag and hind seasons and also carrying panniers in the grouse season. Their ponies are under the experienced charge of Debbie Mclauchlan who has spent most of her life around these magnificent and dependable animals. She worked for a few years at the Balmoral stud helping train their ponies for trekking and carrying deer. Foals are trained to foot following the mares at work from a very early age to get them used to the sight and smell of a dead deer. As Debbie says 'the Highland pony is made of stern stuff, there are not many breeds that would carry a dead animal on their back'. The garron is perfectly suited to the task, with a wide beam, large 'plate' feet and an innate understanding of where to tread, they are highly dependable and only encounter difficulty on very peaty ground where they can get bogged with the additional weight of a stag on their backs. My week on Dalnamein would not be half as

Left
Roaring stag
Watercolour

Above
Reflections
Watercolour

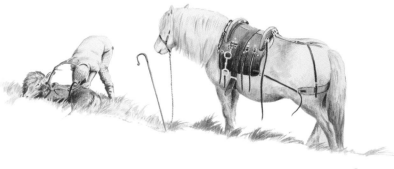

enjoyable without the experience of seeing my stag carried off the hill on the back of a pony. The deer saddles they use on the Atholl beats are all very old dating back to Victorian times. Their leather carries a wonderful dark patina made up of over a century of peat and gralloch blood stain, the copper stud heads and bright buckles glowing against jet black leather.

I don't have a wide experience of stalking, but I have enjoyed the company of several excellent stalkers such as Ronnie Ross and his son Kenny at Kinlochewe, Kevin Grant and latterly Ben Rhodes at Blair Atholl. It's clear that apart from having an intimate knowledge of their ground and deer behaviour, stalkers also have to be good with people for each day they deal with guests of differing experience and levels of fitness and need to adapt their approach accordingly.

One of my best days on the hill was tagging along as an observer when Ronnie Ross took my son Sam to shoot his first stag at the Nest of Fannich at Kinlochewe. This was a piece of ground that I had been lucky enough to stalk on a few times before and as the day dawned clear and bright with a light westerly breeze I knew we were in for a classic day on the hill.

We had quite a tricky stalk as on several occasions when getting close to a beast the light breeze backed us and we had to beat a hasty retreat before the deer winded us. Finally Sam took his shot well and dropped the stag where it stood. As I congratulated Sam and watched the

rest of the herd run off into the bowl, the stag's body, having relaxed a little, started a dramatic roll down the steep face only stopping when it arrived at a boggy shelf below. On our hurried way down Ronnie paused and picked up an old rag, which he instantly recognised as a gillet that had been left by the owner of the estate on a stalk many years before.

Personal possessions are frequently lost on the hill, and after a particularly long belly slide down hill to get into a stag on Dalnamein I noticed the buttons on my camera pocket had come undone and the camera had fallen out. Despite a lengthy search it couldn't be found. Ben the stalker reckons that large quantities of expensive phones, cameras and binoculars are scattered around the Scottish Highlands in this way.

Much of my stalking has been on the hill, however good friends have offered me the experience of lowland and woodland stalking. My first roe doe was shot in Fife with my good friend Steve Keay. We had driven from his home near Perth to a piece of ground near Auchtermuchty before daybreak on a very frosty morning so that I could get a chance at shooting roe doe. As we walked out through fields white with haw frost the cold light of dawn began to reveal the fence line down which Steve knew the deer would walk. Trying to lie quietly on the frosted grass was very difficult and as there was little wind we had to be especially careful about every movement. After about 45 minutes through the slight fog came three roe doe right down the fence line as Steve had predicted. Although very cold the

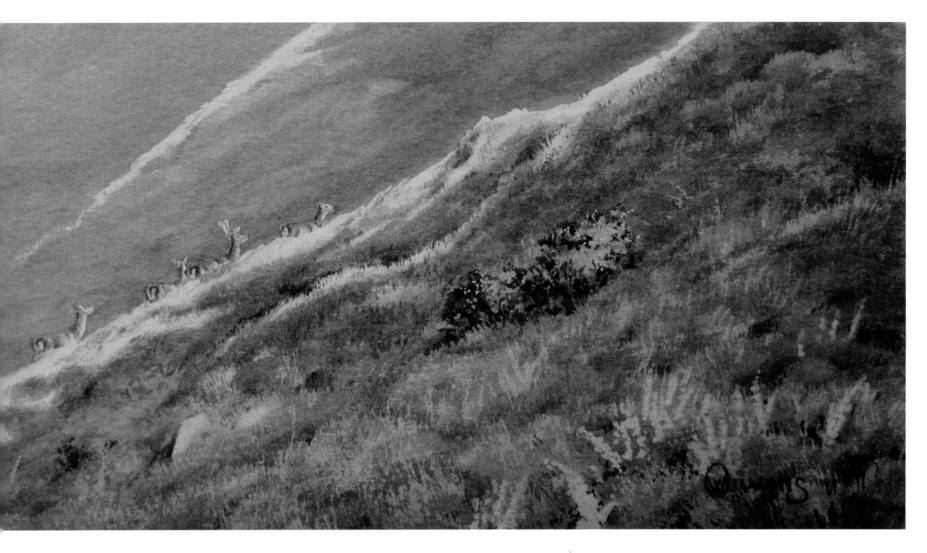

rush of adrenaline steadied my shivering and I was able to hold a steady aim and fired the doe dropped after a short run. Sometime later I had a chance of another, but by this time the cold caused me to shiver so much that I decided that it was wiser not to shoot for fear of losing a wounded animal.

I have also been woodland stalking when taken by sculptor Simon Gudgeon who took me for my first roe buck and fallow buck in the New Forest. I will never forget the thrill of being entrusted to stalk a piece of woodland alone. After a while I was aware of movement to my left and realised that there was a roe doe quietly a browsing along a parallel course about 30 yards away on the outside of the wood. I was stalking fallow, so I slowly crept away pleased to leave her in peace.

In January of 2012, my wife Sally and I were invited to a wedding in New Zealand, and on hearing that I was keen on stalking the groom's father Mike kindly invited me to go stalking with him near to his home near Marlborough in the north of South Island. The history of deer in New Zealand is a fascinating story. When Europeans arrived in New Zealand they found an ecosystem, which lacked the broad diversity of species they were familiar with at home, this was due to the evolutionary isolation of New Zealand. At a time when we were ignorant about

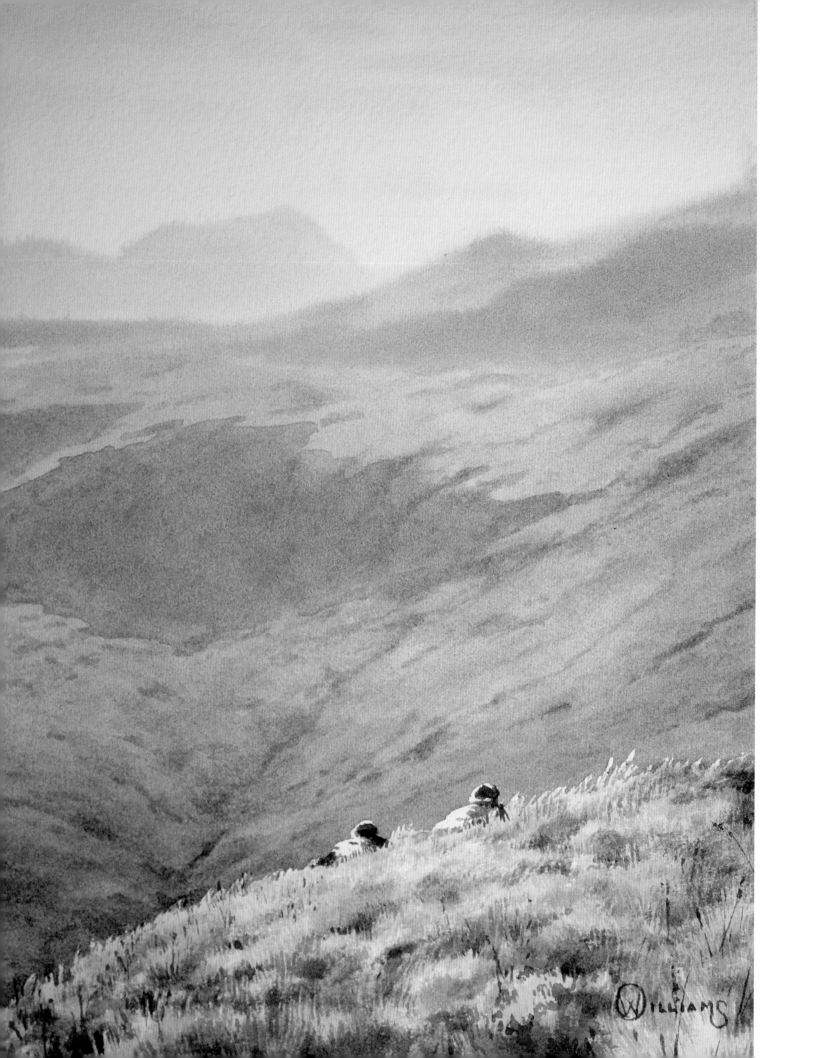

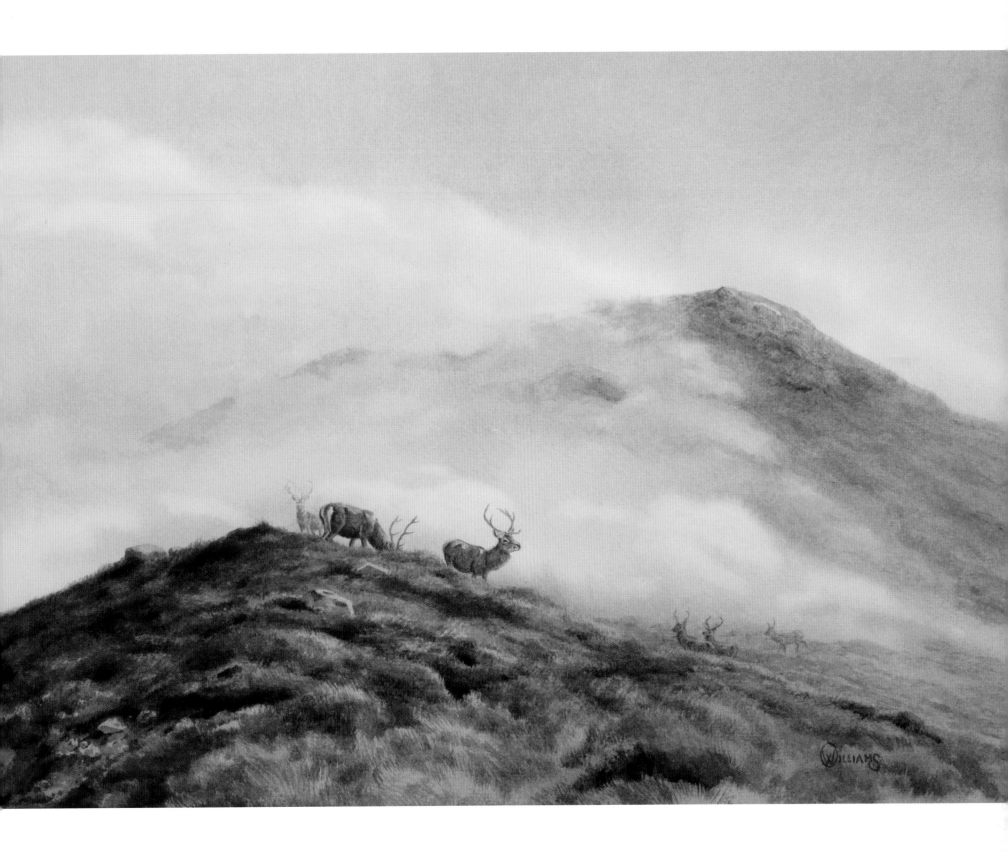

Left
SAM AND RONNIE CRAWLING IN
Watercolour

Above
HILL FOG
Watercolour

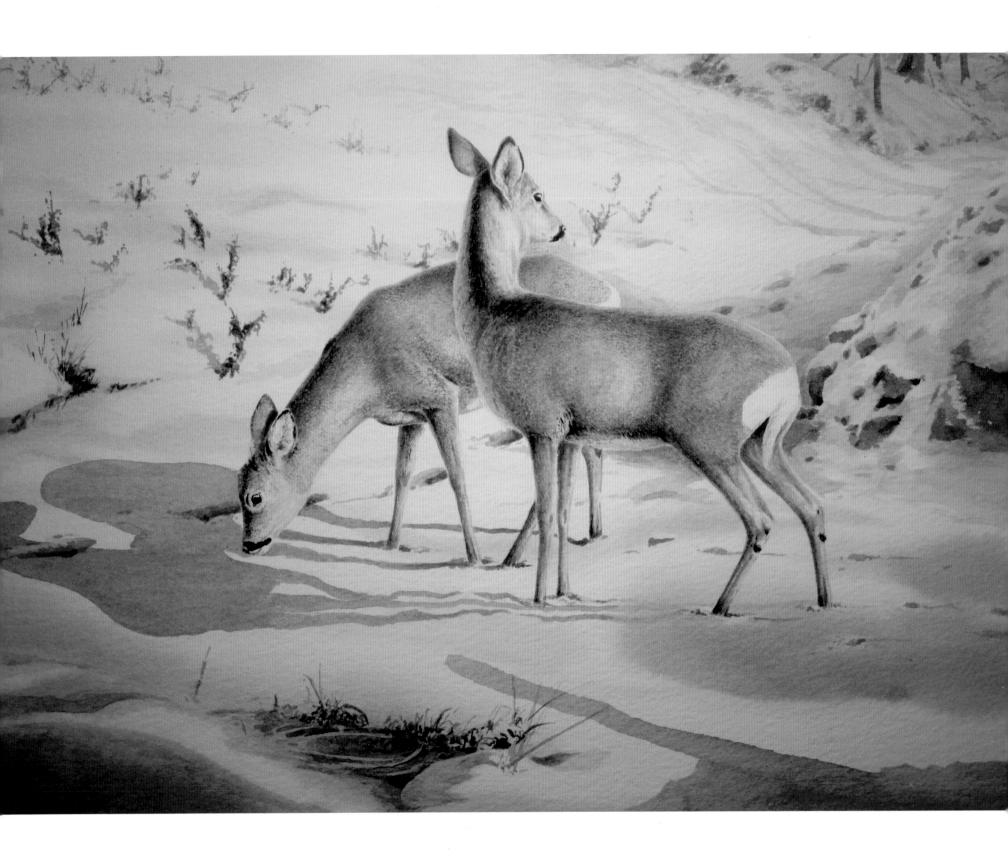

the delicate balance that exists between the flora and fauna within ecosystems and the potential impact of adding others at a whim, the settlers in New Zealand formed 'Acclimatisation Societies' whose purpose was to import species to fill these gaps.

In 1871 The Earl of Dalhousie donated seven deer to the Otago Acclimatisation Society, which were released at Lindis Pass, near to Omarama on South Island. These along with many species of birds and plants soon took hold in the rich environment of Southern New Zealand. Within a few decades the many descendants of these seven deer were soon causing major ecological damage to the fragile wilderness.

In the 1920s it was realised that recreational hunting was not sufficient to keep this growing deer population in check and so the government set about organising a major cull. At the same time the country established a viable export market in Germany for its wild venison. Despite this lucrative business the culling of deer in New Zealand never managed to reduce the population in the massive wilderness of Fiordland on South Island. Unlike in the UK, ground up to 6000 feet (1900m) is well vegetated and perfect habitat for deer, despite the use of helicopters to access this remote terrain and wholesale shooting from the air, culling never managed to reduce the population. The incentives were great with considerable money being made by pilots and cullers in what was referred to as the 'Venison Rush'. Carcasses were flown down to towns like Te Annau from where they were shipped to Christchurch for processing and eventual export.

Locals soon saw the potential for deer farming as the demand for venison from Germany was outstripping supply and so many pilots ventured into the highly dangerous business of live capture of stock on the high tops to supply deer farms. In the early years this involved men jumping off helicopter skids and wrestling deer to the ground, the risks of injury or even death were considerable, but then so were the financial benefits with up to £2500 being paid for a good stag.

Because of the remaining problems of deer damage there is no season for shooting deer in New Zealand, it seemed strange to be told on my visit that I could shoot both hind and stag in what was their summer.

Our journey from Blenheim to the ground on which Mike had stalking took us up the Wairau valley and then off into the hills surrounding the Waihopai Valley. The plan was to let the heat go out of the day and wait for deer to emerge from the cool shadows of the trees to graze in the evening. To save ourselves a climb the best past of a 4000 feet (1250m) climb in summer sun we took a quad up the very rough and precipitous track to the top of a spine ridge from where we set out on foot. The most remarkable feature of this ground was how rich the vegetation was even at 5000 feet (1500m). No wonder deer like this place, walking on this ground was difficult because not only was it steep, but hidden beneath the tall summer grass were loose rocks and boulders which with one lapse of concentration could have easily resulted in a severely twisted ankle or worse. Mike always carries an EPIRB gps distress beacon whilst hunting and as the temperature dropped suddenly later that evening I could understand his caution.

As we made our way across the face of a long ridge we saw wild goat, another species along with pigs that are out of control in this habitat. Eventually we reached a good vantage point overlooking some woodland and soon we saw deer moving below. Mike sent me off on a crawl along a ridge to see if I could get a good firing point on a stag that was wandering along a gully below us. Despite us both looking hard and comparing notes via the radio, the stag vanished in the scrub and long grass below. However Mike had seen another stag with a few hinds browsing up another gully and radioed directions. As I approached a decent look out point I realised that to get near would require a shuffle down a steep slope on my bottom trying not to dislodge any loose boulders. Gaining cover behind a Manuka bush, which helped to stop me sliding further, I was

able to get the scope onto a young hind, which gave me some comfort in the knowledge that she wasn't suckling a calf.

Apart from one occasion shooting from a high seat another off sticks, all the rifle shooting I have done has been done lying prone. On this occasion I was shooting on such a steep slope that I had to rest the fore-end of the rifle on my knee and take the shot seated. It was with some relief that I saw my hind drop to the ground with a clean shot, although it took some time to find her in the long grass at the bottom of the hill. The impracticality of carrying the carcass up a steep and dangerous slope necessitated that we bush butchered what meat we wanted and left the rest of the carcass for the wild pigs

to devour. This felt odd because all the deer I've shot in the UK, and plains game in Africa have been recovered and eaten, but with terrain like this there was no option.

A day later, after a fabulous whale watching trip in Kaikoura, Sally and I met up with Mike's daughter and son-in-law at their house where we ate those delicious venison fillets grilled to perfection on a barbecue. Served with green salad and boiled potatoes and helped along with a nice bottle of New Zealand red, this was a meal to remember.

I always take a camera with me when I'm on the hill and although this is not the sort of equipment which enables great close up deer reference, it is ideal for getting quick reference shots of the ever changing light on the landscape whilst stalking. I rarely copy these photographs directly unless I am painting a commission for an estate owner. More often than not these photographs give me a theme to work from which consists of colour and tonality.

Most of my pictures start with a watercolour wash, which is done rapidly using a 'wet on wet' technique where I will wash in areas of colour in order to capture the mood of the scene. This is a very difficult stage as the pigments suspended in water move and creep on the paper, this is why it's difficult to be precise about specific shapes in the landscape, very often I will throw away a number of attempts if the wash doesn't work the way I want it to. After this I can relax and start working in the more detailed elements including the deer.

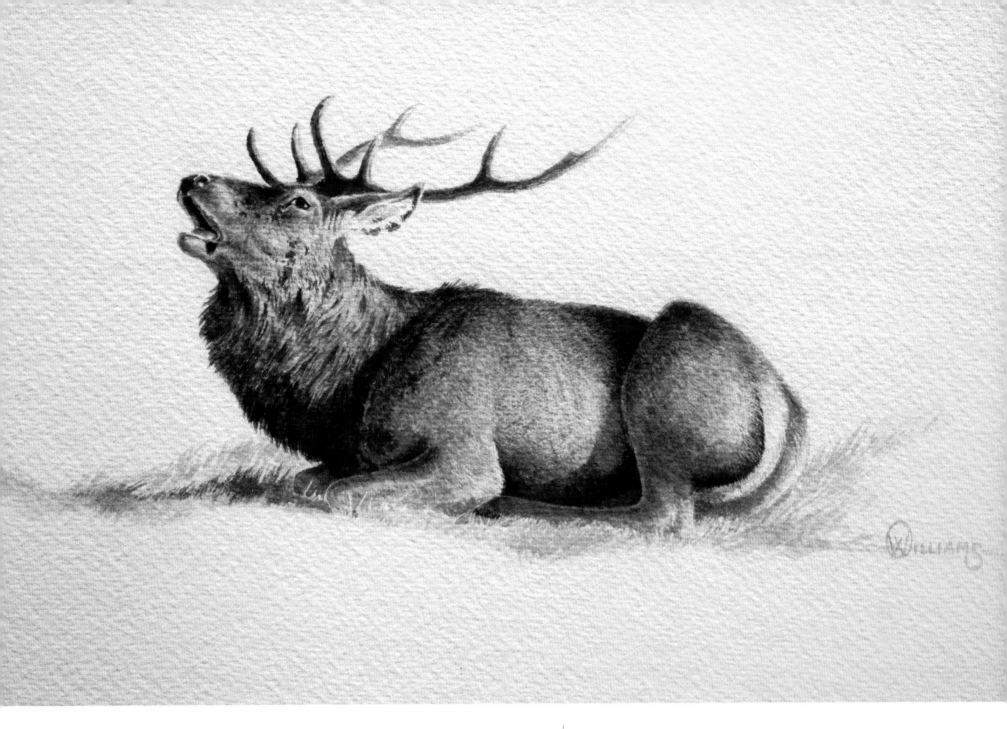

Above
ROAR STUDY
Watercolour

Left
FORDING
Watercolour

I have a number of reference photographs of deer, but I rarely directly copy these as often the stance or the direction of light is not what I want, so I tend to start drawing each deer from scratch. I have always found deer very challenging to draw accurately, particularly when they are small elements in the landscape, in contrast to the 'Monarch' of the Glen style of painting.

I recall at an exhibition, sufficiently long ago now as not to cause me too much embarrassment, where a local vet pronounced that a particularly badly drawn stag in one of the paintings 'needed some veterinary attention'. I would like to think that as the years have gone by both my deer and my landscapes have improved, but this is very much work in progress. What is for sure is that a trip to the Highlands stalking gives me a wealth of new ideas for paintings, but it also satisfied the same urge I felt as a young boy with my air pistol, to be back in that familiar role of being a hunter.

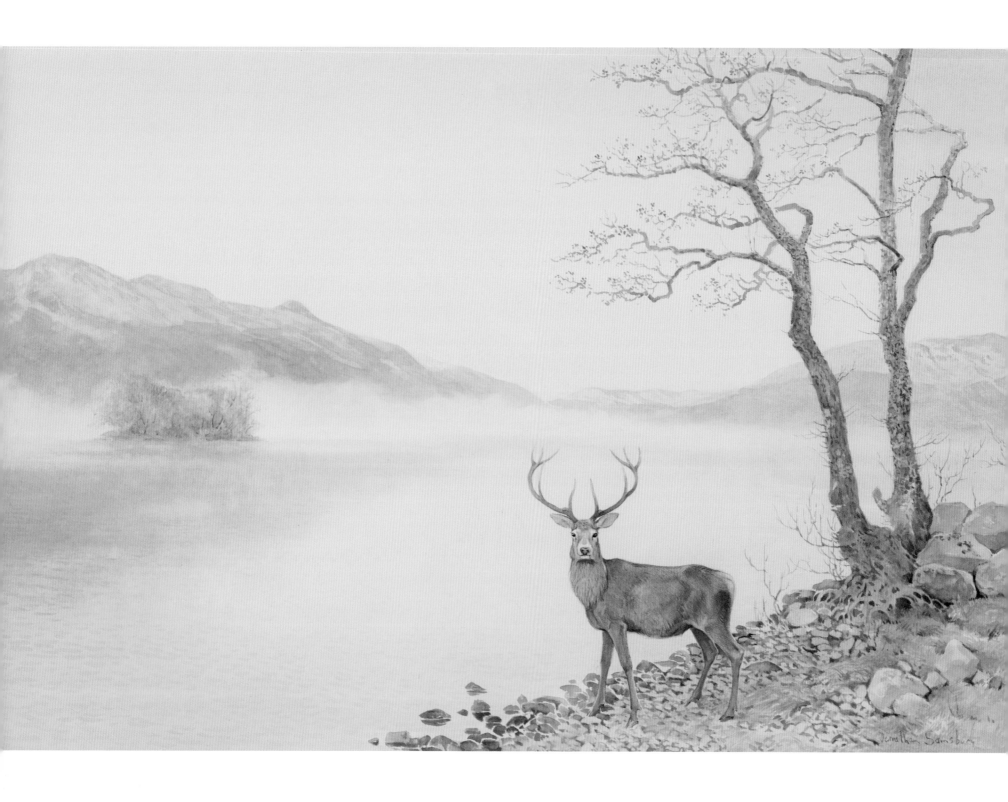

Jonathan Sainsbury

As I write this it is autumn in Perthshire and the stags can be heard roaring continually. The stag-stalking season has finished and the snow-capped hills are a portent of the winter to come.

Winter is a good time for wildlife artists as the creatures are pushed down from the tops to lower ground, the trees are free of leaves and good sightings are made easier. Fewer sightings are clearer than those we used to get when we lived in a house overlooking Loch Earn in Perthshire. Red deer used to jump into the garden and often as I opened the back door at night to let the dog out, there would be a stag just feet away, both of us equally shocked by the other's presence. One such encounter gave me the model for the stag in the painting by Loch Earn.

I learned a little about the legend of St Hubert from my wife at that time which was connected with stag hunting. St Hubert began life as a wealthy medieval nobleman, born a hundred years before Charlemagne, whose favourite pastime was hunting. One day in Holy Week when others were at their devotions, he went off on the chase. He had run a deer to a standstill, when it turned to him and he saw a crucifix on its antlers. A voice then admonished him, calling him to give up his misspent life. As a result of the experience, Hubert took holy orders and was subsequently made bishop, in the Ardennes and Brabant where he is still remembered fondly. This story draws together in the figure of the saint, both the desire to hunt and the reverence for life, which I and probably most sportsmen have experienced.

Deer are common everyday creatures to me now but as a child growing up in Warwickshire countryside, near Stratford-upon-Avon, that was not always so. My only glimpses then were of fallow deer, hidden behind the famous, and now protected, Charlecote fence which Shakespeare had climbed to poach deer and in turn was caught and fined. In my muddled

Above
ROE DEER AND ALDER (detail)
Watercolour

Opposite
STAG OVER LOCH EARN
Watercolour

childish thinking this story of lawlessness and punishment and the stories of Royal hunting forests and people in the past being punished by hanging for stealing the royal beasts, meant that I kept away from them. Yet, I knew of two people in the village who used the silent but deadly crossbows for poaching. And I tucked in with relish to venison served at the table.

As a young man starting out as a wildlife artist after college, I bought myself a dog – 'Rags', a liver and white Springer spaniel, similar to the one we had had as children. The two of us walked morning and evening around Warwickshire farmland. 'Springers' have that

name for a reason: they do spring, tirelessly, flushing every living creature that walks on this earth and I have to thank Rags for initiating many pictures that featured spaniels flushing game. But a picture that was never painted was what happened when she spied deer: she chased. The deer would run to the wood, clearing a high fence that would make most dogs stop. But not Rags.

If she didn't clear it in one jump she would run up and over the wire and the crashing and banging of the chase would continue – how embarrassing! I'm told 'to err is human (or in this case, Springer), to forgive divine' – but I found it

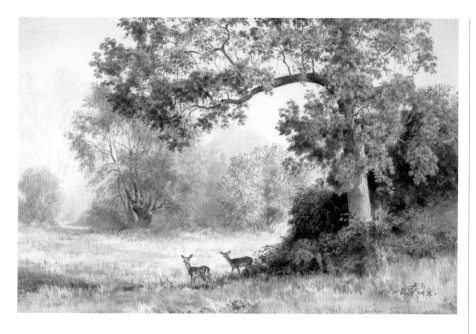

hard to feel forgiving – having prostrated myself time after time on the same fence in an attempt to stop her.

I painted a few deer during my time in Warwickshire but as subject matter they did not loom very large in my portfolio, partly because I was attached to the William Marler Gallery who handled Balfour Browne, Munnings and Lionel Edwards who had deer and stag-hunting pretty well covered. I travelled to Scotland to paint other subjects, spying red deer when I was there. Then I moved my home to North Devon.

Henry Williamson wrote great wildlife accounts about the wildlife of north Devon, stories about otters, herons, salmon and red deer. Beside the wonderful stories of natural history, he captured something about the place that attracts people, an idealised countryside for which people yearn. I heard these stories on the radio and they spoke to me too. I also tried to create pictures of landscapes that drew people out of their ordinary lives.

Exmoor has lovely rich heather with distant coombes, (the name given locally to steep-sided valleys), and views to the sea. It is small-scale moorland compared with Scotland but beautiful in its own right. Lynton, Lynmouth, the Quantocks: these were names I had heard in my land-locked childhood. There were other names associated with that area that I did not know: Captain Ronnie Wallace, and the famous stag hunts of those parts. What I knew were the images associated with them that had been wonderfully painted by the likes of Lionel Edwards and Munnings. In the style in which I painted, I could not improve or add to their knowledge of the hunt.

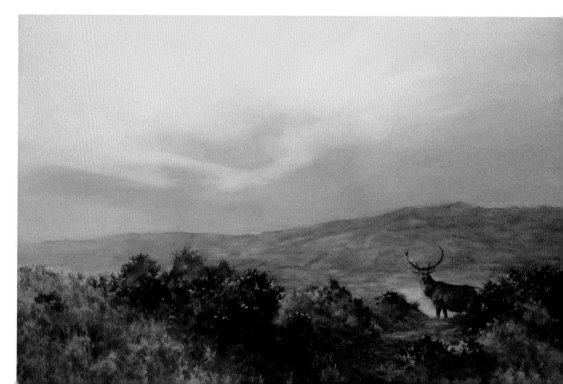

In those days, I learned a hard lesson about selling paintings that concerned the danger of naming location. I was exhibiting a watercolour at a Scottish game-fair whose subject was an Exmoor stag. A collector had admired the work and said he wanted it. He was writing a cheque while I was wrapping the picture, when I said conversationally to him that this was a view of the north Somerset coast. Bang! The cheque book was shut, it went back in the jacket pocket and the gentleman told me he would only buy pictures of Scottish deer. No sale. Nowadays I am more reluctant to divulge the settings for my work!

For myself, seeking to achieve atmosphere through watercolour, the dappled light of the richly-wooded north Devon coombes gave me endless pleasure. Roe deer were often the subjects in these pictures. This quote from Andrew Marvell's poem *The Garden* expresses my feeling for these places:

> *'Here at the fountain's sliding foot,*
> *Or at some fruit-tree's mossy root,*
> *Casting the body's vest aside,*
> *My soul into the boughs does glide:*
> *There, like a bird, it sits and sings,*
> *Then whets and combs its silver wings,*
> *And, till prepared for longer flights,*
> *Waves in its plumes the various light.'*

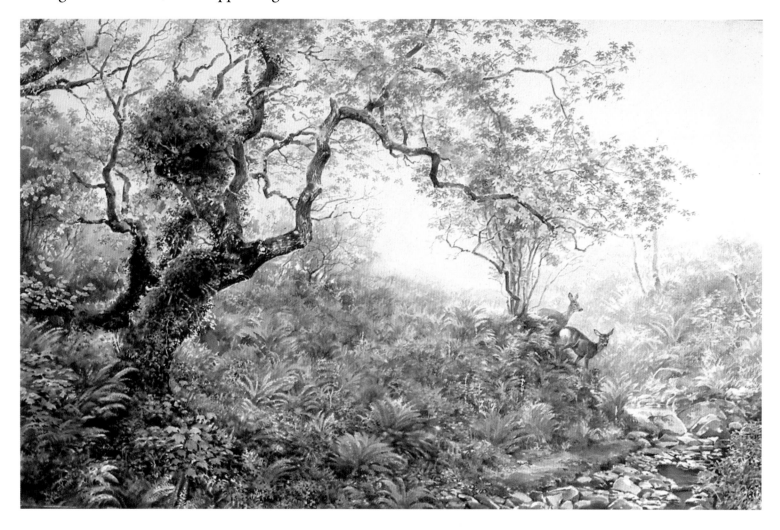

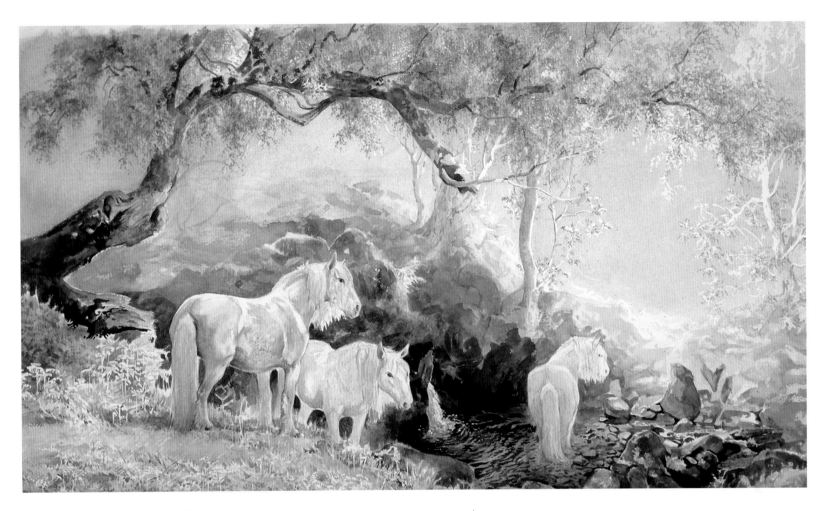

Above
PONIES IN THE MORNING LIGHT, FINDOGLEN
Watercolour

From north Devon we moved to Scotland – and in time to Findoglen, a traditional Highland house with a split front-door flanked by decorative pine columns. There we lived next door to the game keeper on an estate that kept Highland ponies to bring down the stags strapped to deer saddles. This brought me for the first time into close contact with deer-stalking and Highland ponies. How beautiful those ponies are – gentle giants – in fact not giants at all: broad and strong but not too tall, as the effort required to lift a large stag is formidable so the taller ones are not favoured by the pony boys – 13.2 hands is ideal.

At this time I struck up quite a relationship with one pony called Scorn. He would run down the hill to greet me – anything for a piece of carrot – often applying the brakes too late, skidding past me with his front legs straight out in front. I had to throw myself behind a tree, while he would drop a shoulder and roll over and over a few times, stopping just a few feet short of the stone wall at the bottom of the field. At that time Scorn was often my model in pictures of stalking ponies.

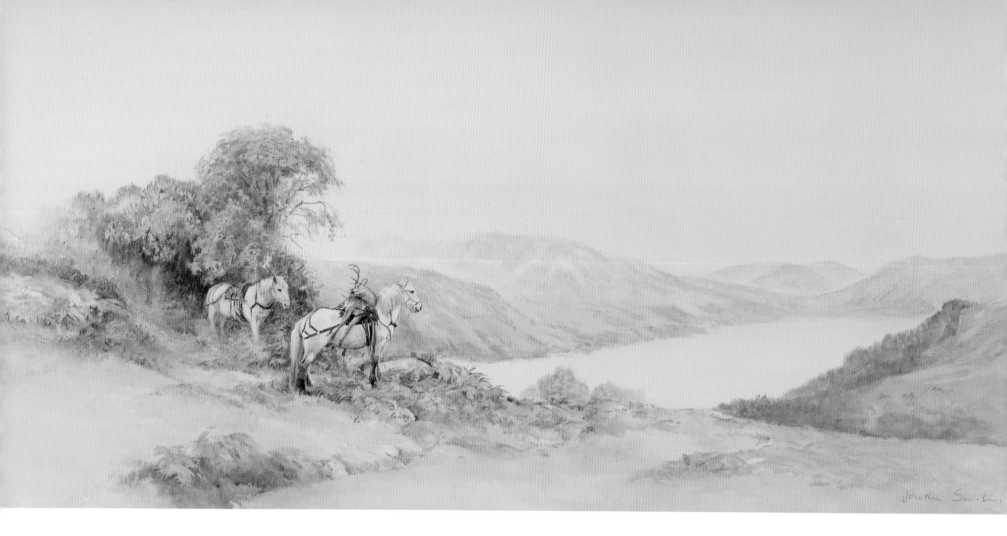

I would see the end result of a stalk – the still-warm body of the beast strapped to the deer-saddle, the still-fresh eyes, the strong scent that fills the air, the blood-stained pony. I can only imagine the skill and expertise required to hunt the prey and to get close enough to take a shot. From my perspective as a man who doesn't stalk, the moment of encounter between stalker and quarry seems a profound one, accentuated by the size of the beast. When you look through the sights at a creature, you are connecting with life itself. That conundrum of life and death expressed in the relationship between the two sizeable creatures, the dead stag and the live pony, is what I painted in the picture of the stalking pony with the rainbow representing the tumult of the elements as background.

Summer brought people out from the cities to enjoy camping and fishing by the loch and this sent most of the deer away up the hill. The red

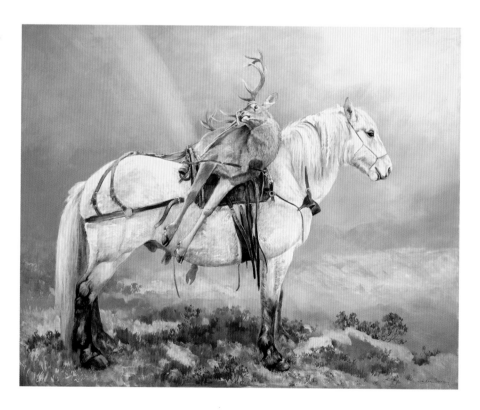

Anticlockwise from left
STALKING PONIES OVERLOOKING THE LOCH
Charcoal and watercolour

STALKING PONY
Oil and egg tempera

ROE DOE RESTING
Sepia

ROE BUCK
Sepia

deer stayed up there anyway for breeding. The roe deer kept quiet during the day.

But when the season was over very few cars came down our road and wildlife was plentiful again. I enjoyed painting the seasonal atmosphere of cold winter light and the otherness of snow. I could draw deer from my studio window as they ate shrubs in the garden.

There was so much wildlife during the winter months that whilst driving the girls to school in the half-light of dawn, we would play the game where we had to look out for each of the big five: red deer, roe deer, brown or snow hare, red squirrel and woodcock. I think we always scored at least three and fives were not impossible.

We now live in Comrie, a small village in Perthshire. Our house is on the confluence of the river Earn and the Lednock and all around are woods and mountains. In the woods are my favourite deer, the roe; he is handsome and she is pretty: delicately built and nimble. Yet the aggressive bark of a roe buck, very close by, is one of the few sounds that makes me jump out of my skin and feel wary for my well-being.

The roe is plentiful but many do succumb to road accidents. If the specimen is not too damaged, they offer an opportunity to study closely the various features, from their eyelashes to their coats. I have noticed them changing from summer to winter, the hair retaining its grey shank and gaining cream tips in winter.

Until recently I walked three dogs, a Cavalier King Charles, a Whippet and a Border terrier. The Border was a small boy with more

Left
WINTER STAG AT
THE LOCH SIDE
*Charcoal and
watercolour*

Right
ROE BUCK AND
BIRCHES
Watercolour

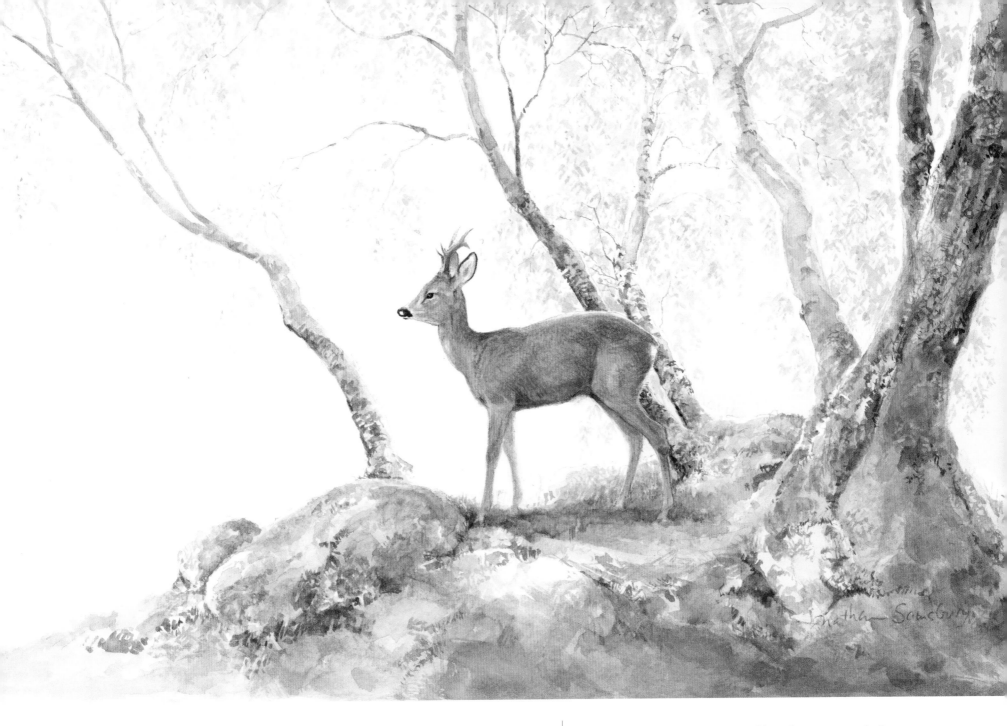

testosterone than an angry elephant. He loved people but thought every other fur-covered creature should be attacked on sight. This meant I walked him in lonely places early in the morning when I could be confident of not meeting another dog. The plus side was seeing many deer. On one part of the road going up Glen Lednock I would come face to face with roe buck and hares. I had a wonderful frozen moment many times when they were both looking at me and I at them. It lasted only a moment before they ran off but long enough for the picture to form in my mind.

Over the last few years, the New Forest has played an important part in our lives. Frequent visits to this very special place have proved a rich ground for paintings. The New Forest was originally William the Conqueror's hunting ground – a varied terrain of woodland and heath – home to five types of deer: red, fallow and roe, the most common, but sika and muntjack are present also.

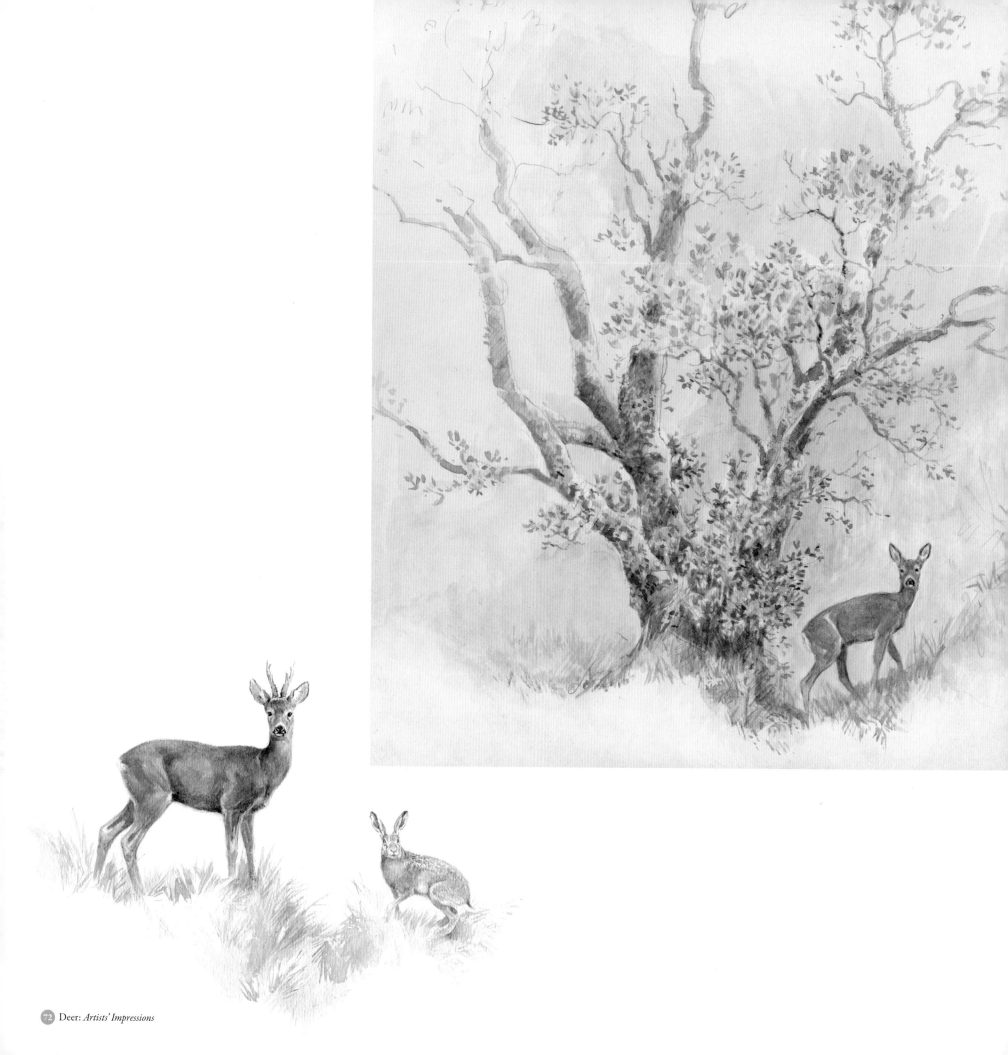

Left to right
ROE BUCK AND HARE
Sepia

ROE DEER AND ALDER
Sepia

RED STAG AND HINDS IN THE FOREST
Watercolour

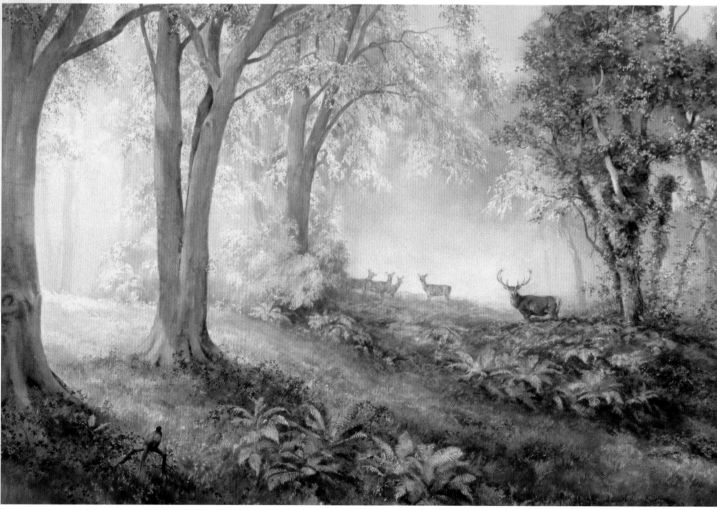

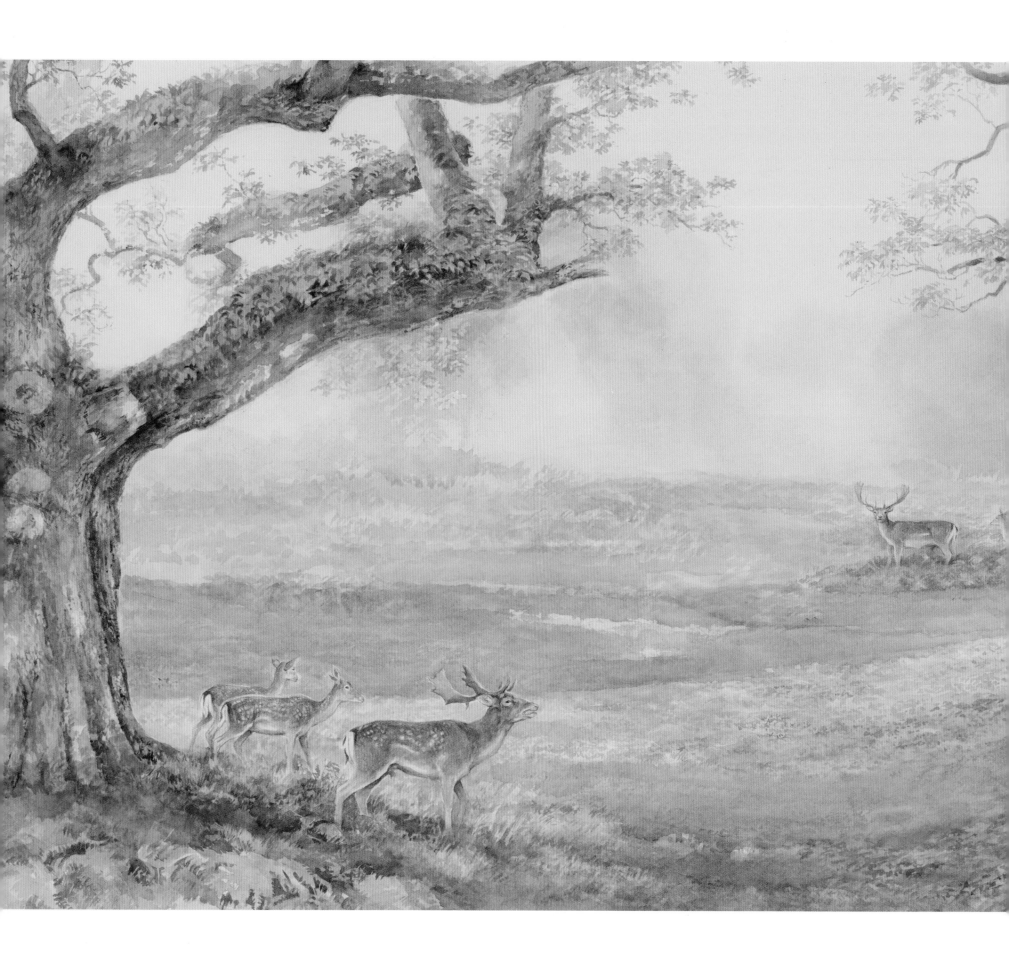

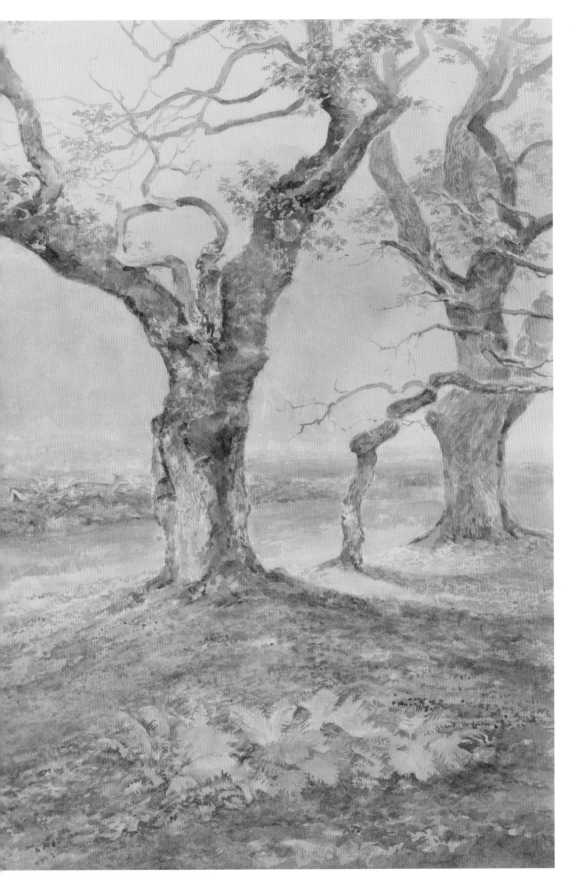

On one of my first visits, in winter, the snow lay on the ground and a herd of fallow deer were running through the woods in the failing light, making the scene evocative of that painting by Uccello, *Hunt in the Forest*. This is a painting I have not yet painted but intend to do.

What is the painting that would epitomise deer in today's world? Is it a traditional stalking scene, a sentimental Bambi? In the past Edwin Landseer painted the *Monarch of the Glen*, that portrays the beast as Royal superior, above the rest, looking down from his mountain top to those below, like the aristocracy who hunted him. It is a comment on the status quo of the time. In France, Courbet brought realism to the kill and a respect for his prey as much as his delight in the hunt. One thing that seems to me to be constant is that people who are participants in game sports often take life but have the greatest affection and regard for their prey and a greater appreciation of the natural world than many others who would condemn the sport.

Over this year I am painting and sketching all the events that happen in a small piece of church glebe land across from our home. It is a wildflower meadow, bordered by the river Lednock, with a few trees and a labyrinth cut into the grass in its centre. I visit it most days at dawn. The roe deer look up and gently move away, sometimes jumping the fence, other times following the banks of the river. What a joy to see this so consistently! I am a lucky man.

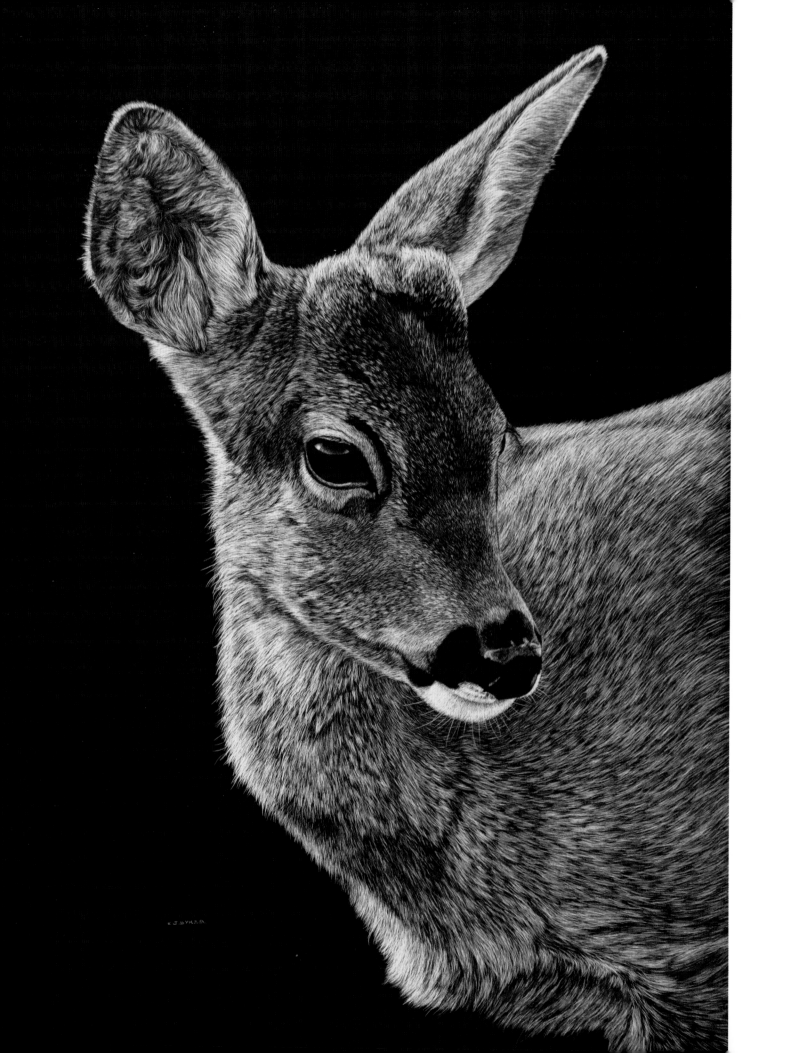

Keith Sykes

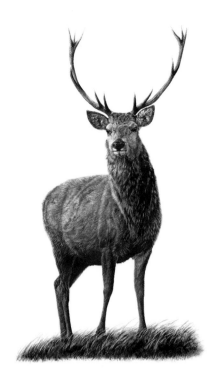

Despite having spent countless hours observing, photographing, stalking and portraying deer in art, I do not consider myself a 'stalker' nor would I claim to be an expert on any of the six species found in the UK.

As a youngster my first 'artists' impression' of deer was Sir Edwin Landseer's *Monarch of the Glen* which was painted in 1851. The grace, elegance and impressive posture of the Lanseer red stag remains an iconic artist's interpretation of Britain's largest wild animal. The image has been popularised as the branding associated with a number of well-known household products.

Through my black and white work with ink on scraperboard I try to reflect the character of the species, from the shy and sensitive roe to the confident rutting stag. The pictures must capture the texture of the coat, be it the clean smooth fallow or the rugged peat-sodden winter coat of a Highland stag. I use fine hatching in an attempt to depict the form and highlights of the antlers of bucks and stags. The animal must always be true to its environment, for example the trophy heads and heavy bodies of the well-nourished lowland red deer must not be confused with their less fortunate slim cousins fighting for survival on the hills and mountains of the bleak Scottish Highlands.

All deer have individual facial features and without doubt and within each species some bucks and stags are more handsome than others, the same can be said for aesthetic features of does and hinds. I tend to favour those handsome and pretty individuals as basic

Clockwise from top
RED STAG
Scraperboard

YOUNG ROE OVAL
Scraperboard

YOUNG ROE ON BLACK
Scraperboard

reference ensuring that they fall within the breed standard. I do not necessarily create the best trophy heads but generally something well balanced that can be enhanced if required with a little artistic licence, when portraying fawns and calves I strive to represent the tender, fragile innocence of youth.

In recent years I have been commissioned to produce portraits of a number of blood-scenting dogs specifically bred for use by deer stalkers, although dogs are not always associated with

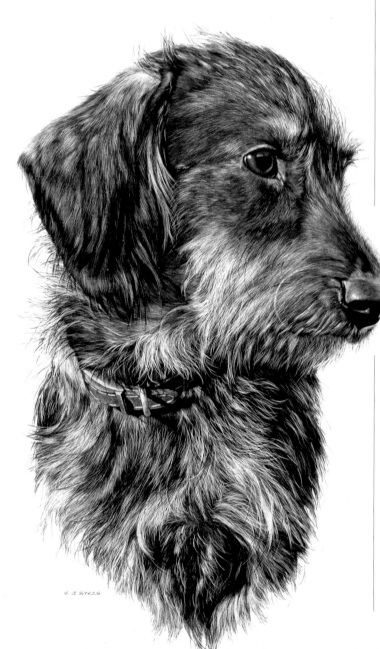

deer stalking in the UK they are often used to great effect when stalking in densely wooded areas. Most of these specialist dog breeds such as the Alpine Dachsbracke and the Teckel originated from the continent and differ in appearance from traditional gun dogs, they have been specifically developed and trained to track deer and other wounded animals even when the trail has gone cold.

I feel fortunate to have stalked and shot both roe and red and I found the experiences to be wonderfully exciting, challenging, rewarding and educational. I was also satisfied that the result was justifiable and well deserved, something often difficult to convey to those without an appreciation of the sport and in many cases the quarry.

From 2005 until his retirement in February 2011 I was fortunate to spend many happy hours in the company of stalker Dougie Langlands on the beautiful Ardverikie estate in Inverness-shire. A location so picturesque that the estate and house have been used as the setting for a number of films and TV programmes including the BBC television series 'Monarch of The Glen'. I have taken hundreds of reference photographs of the red deer through the changing seasons and many of stalking parties with the iconic garrons extracting the stags from the hill. My trips to Ardverikie inspired my desire to portray red deer and I remain captivated by their beauty and the breath taking scenery in which they exist.

Within a thirty minute drive from my home is a resident population of outstanding wild red deer that I have occasionally studied and

photographed, they are nationally renowned for the exceptional proportions of their antlers and large physique. These deer reside near Carnforth on the Leighton Hall Estate which is adjacent to the RSPB Leighton Moss Nature Reserve, a wetland area into which the deer often venture particularly during the rut. Despite the impressive size of these outstanding specimens I still prefer their Highland cousins.

The experience of stalking either in woodland or on the hill, with a rifle or camera provides a uniquely intimate understanding of the species, observations of habitat, body posture and movement combined with an appreciation of the highly tuned senses for survival that that all wild deer possess. It is often during these expeditions whilst sneaking around quietly disguised in camouflage that the unexpected is observed.

On a warm summer evening in August 2007 I accompanied a stalker friend in pursuit of roe buck in North Lancashire, the long grass provided good cover and whilst the light was still good we were able to approach a suitable buck grazing in open pasture, it soon became apparent that the buck was in the company of a roe doe. We approached the pair totally undetected and whilst preparing for a shot a young fallow buck appeared in the same field. We watched in amazement as the roe buck defended the honour of his companion and soon the two bucks of different species and of differing weight divisions were engaged in an aggressive clash with the clattering of antlers echoing against a nearby wood. After a few minutes a mutual stand-off ensued, the roe buck stood his ground close to his mate as the fallow slowly left the scene. Sadly for one of the stars of the event

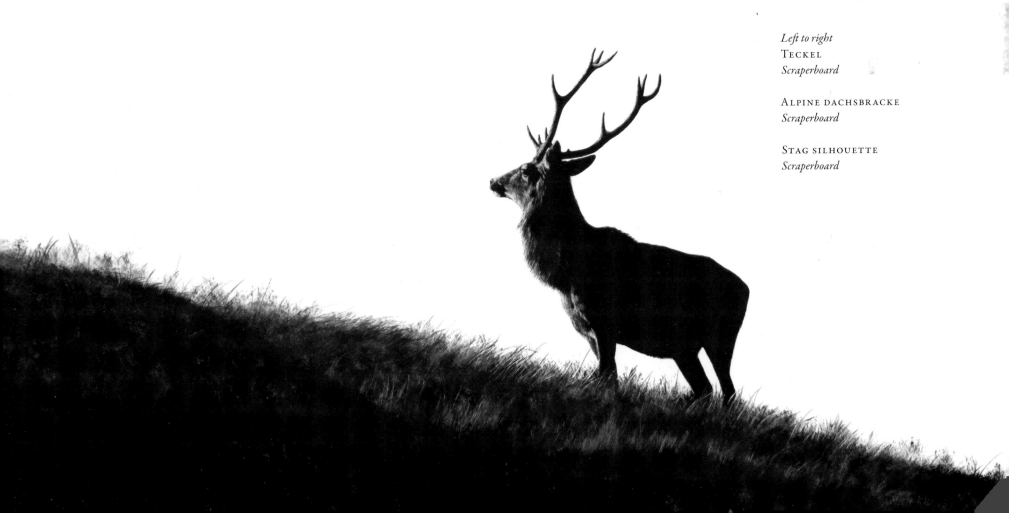

Left to right
TECKEL
Scraperboard

ALPINE DACHSBRACKE
Scraperboard

STAG SILHOUETTE
Scraperboard

the stalk was resumed with a swift conclusion, a close inspection of the dead roebuck revealed a cut to his nose as a consequence of his brief encounter.

Roe deer are certainly not in short supply in the area surrounding Morecambe Bay and in recent years they have even been sighted on the beach at Morecambe. Despite the high density resident population being so close to home they still hold something magical in my heart and I will never become tired of observing, drawing

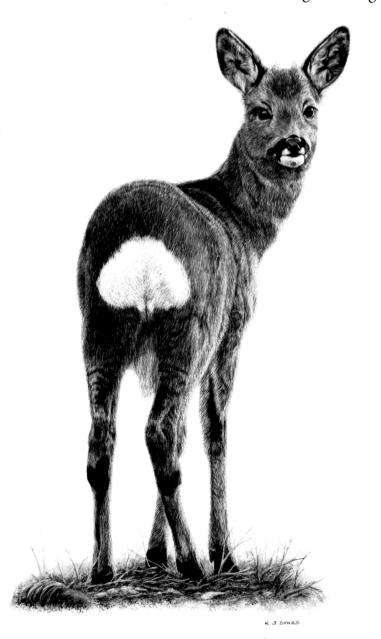

K. J. SYKES.

and photographing them. The speed, flexibility and agility of this fragile and shy creature never fails to impress me, they have an amazing ability to jump clear of hazards and to change direction by avoiding obstacles when running at full speed through dense woodland.

I presume that most contemporary UK sporting and wildlife artists would agree that their passion to paint deer derives mainly from observations of red and roe, the only truly native deer species to our land. Despite the fact that the fallow have been running free on the British mainland for hundreds of years, they seem to feature more extensively in historic British paintings rather than in more contemporary work.

I have studied, photographed and sketched parkland fallow on many occasions, the closest herd being on the Dallam Tower Estate near Milnthorpe in the South Lakeland District of Cumbria. There are also a well-established number of wild escapees in the area that have evolved to be slightly more athletic in build and certainly more aware of potential danger. Despite the seasonal influences the colour variations of fallow deer appear extreme compared with the other deer species in the UK, diversities from black melanistic in every shade through to white, red and all shades of brown. The unique long flicking tale with a characteristic black stripe is often helpful in clear identification.

Acquiring accurate reference material through observation and photography is imperative for my detailed work. Fortunately due east from my coastal home is the Trough of Bowland which holds a resident population of non-indigenous Sika deer in beautiful wooded surroundings, this provides me with a great source of inspiration and reference. The raised frowning brow and generally dark and drab,

Left to right
YOUNG BUCK
Scraperboard

CHINESE WATER DEER
Scraperboard

MUNTJAC
Scraperboard

RED CALF
Scraperboard

often spotted coat identifies Sika stag at a glance. By contrast the hinds I have observed are more generous of colour and with lighter dappled coats.

My knowledge relating to the non-native Chinese water deer is very limited compounded by the fact that the majority of the wild UK population are currently residing many miles south east of my Lancashire home, consequently I have only been able to observe them in captivity. Their more rounded proportions and raised rump posture differs totally from the more

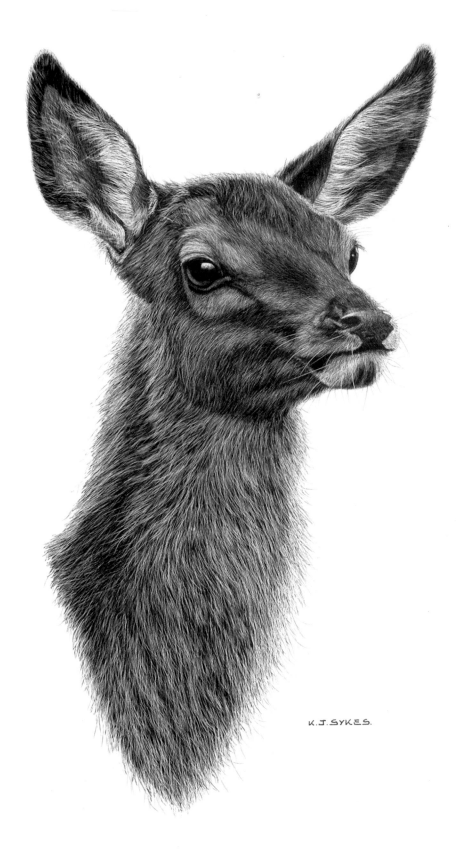

K.J. SYKES.

elegantly built red, roe, fallow and Sika. As a portrait artist I see the buck's protruding tusks in lieu of antlers and the lack of visible facial bone structure keeping them low in the beauty stakes and maybe that is one of the reasons their appearance in sporting paintings is relatively rare. Facially Muntjac are certainly more interesting due to their unique markings and detailed features including small antlers and tusks, but paintings of them are still few and far between. Although it is widely acknowledged that the Muntjac population is increasing rapidly and spreading north from the southern counties of the UK I have yet to observe one in the wilds of northern England, this is despite a handful of unsubstantiated claims of sightings in north Lancashire and south Cumbria.

I hope that in the future I will have the time and opportunity to work on many more pictures of deer, I have an abundance of ideas, images and compositions in mind including experimenting with much larger works.

The American architect Frank Lloyd Wright is well known for his quotations and two come to mind because they reflect my feelings with regard to my artwork relating to deer. He was once asked how he could conceive and oversee so many projects, he answered 'I can't get them out fast enough.' He was not talking about buildings; he was talking about ideas. Wright also said 'Study nature, love nature, stay close to nature. It will never fail you.'

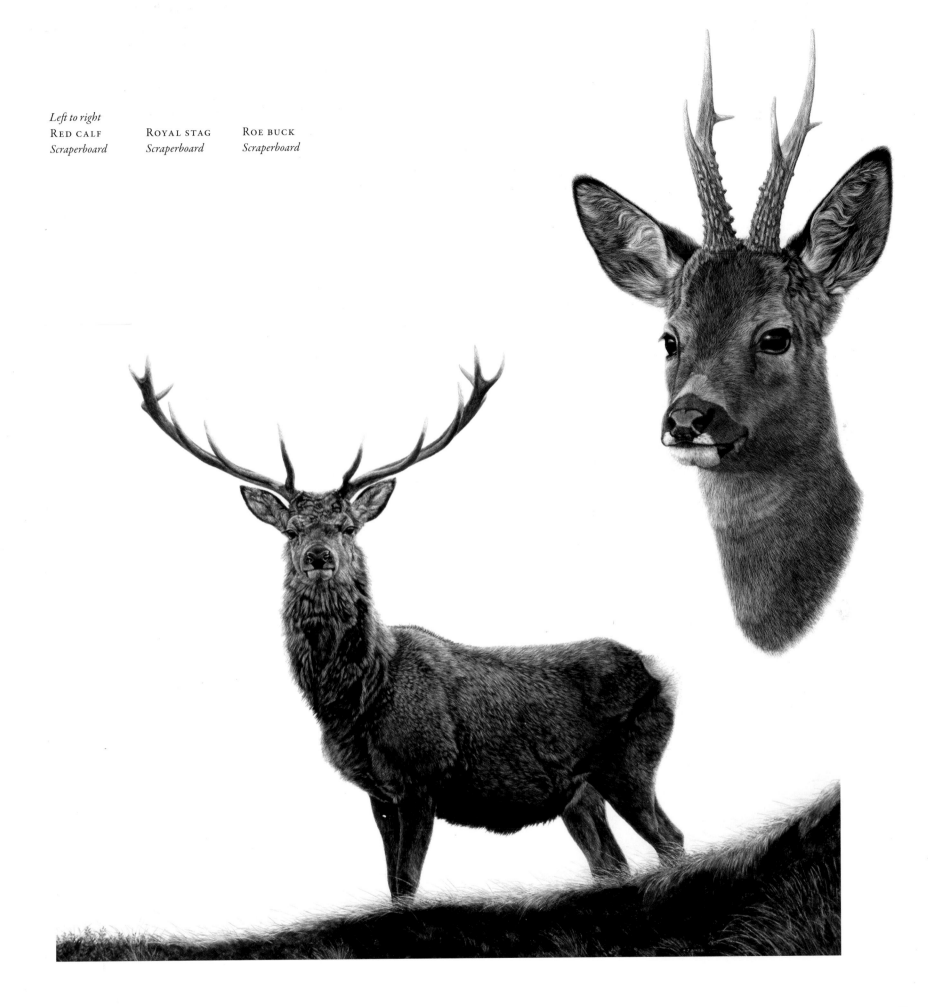

Left to right
RED CALF ROYAL STAG ROE BUCK
Scraperboard *Scraperboard* *Scraperboard*

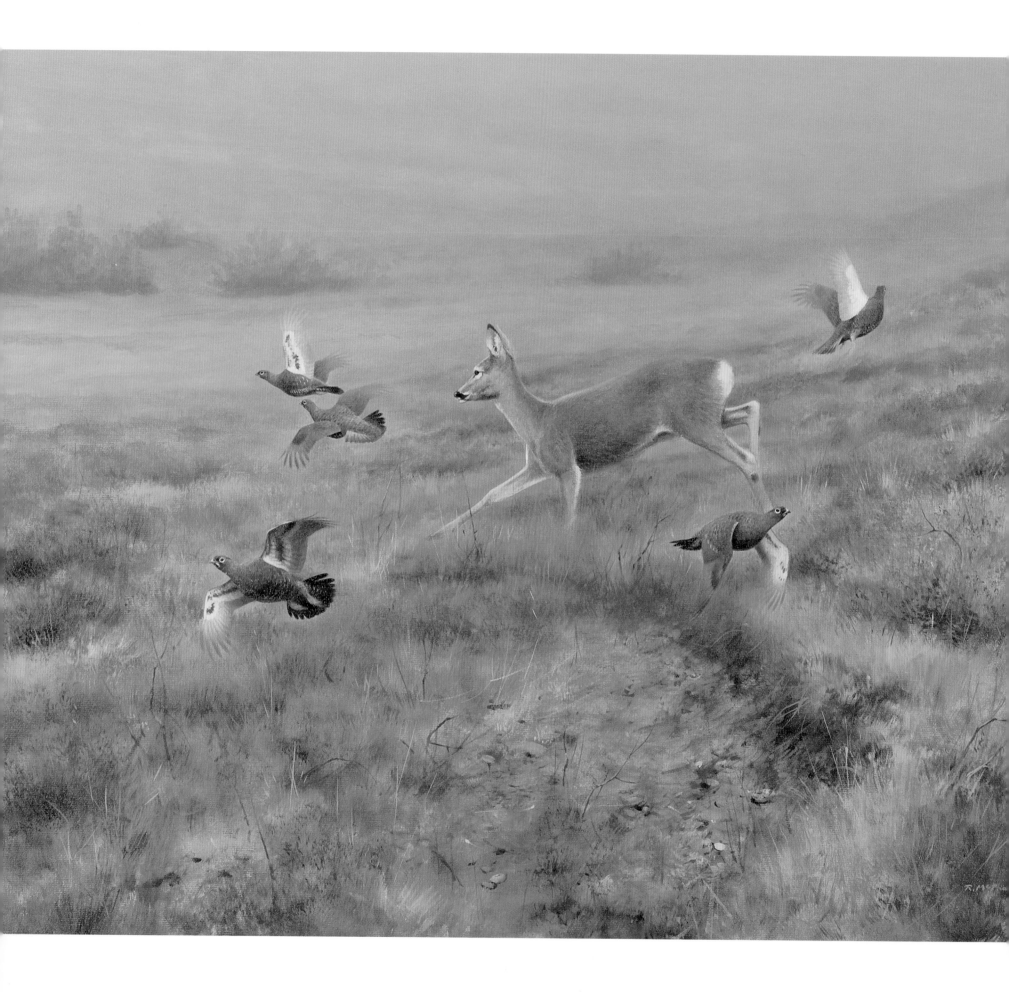

Rodger McPhail

The very first pictures produced by mankind were painted on the walls of caves about 40,000 years ago. Most of these early works depicted hunting scenes and wild animals, including deer; so sporting and wildlife art has a long history.

Hunting and painting deer has continued ever since without a break. The pursuit of wild animals is part of our human psyche. We have been doing it ever since we arrived on the planet and it is unlikely to stop because it has been deemed politically incorrect in the past few decades.

It is not surprising that deer have always been so popular. They are usually large, attractive and edible. Another delightful characteristic is that the males obligingly grow and shed antlers every year. These amazing ornamental weapons – the fastest growing tissue in the animal world – have always appealed to us. Since the earliest times we have carved them into artefacts, used them as tools, included them in our ceremonies and displayed them as trophies. In the east, antlers in velvet have long been used in medicine. Antlers make deer instantly recognisable and they are one of the first animals that a young child learns to identify.

The popularity of deer for sportsmen and artists has remained unchanged throughout the centuries. In early medieval times there were nearly 2,000 parks in Britain purely for the hunting of deer. Throughout the ages artists have portrayed them in tapestries, frescoes, paintings and sculptures and used their image to adorn coats of arms and pub signs.

Today in our crowded islands deer are thriving and they are probably more numerous than ever before. Consequently, they are increasingly coming into contact with the public. The nocturnal ravaging of roses and other prize blooms does not endear them to gardeners. Their sudden appearance in the headlights can have alarming and expensive results, as tens

Above
SKULL OF A CHINESE WATER DEER
Oil

Opposite
ROE DEER AND GROUSE
Oil

of thousands of motorists find out every year. However, for most people, the sight of a wild deer is an exciting and pleasing experience. They are beautiful, impressive animals that have always commanded our admiration and affection. For an artist they are irresistible.

Though I am often moved to paint various species of deer I have to admit to feeling slightly out of my depth when doing so. To paint a subject well you have to know it intimately and although there are roe deer in the woods near my house, really good opportunities to watch them are rare. I have stalked red deer in Scotland for nearly forty years, but those few precious days spent on the high tops in autumn are not enough to become as familiar with the animals as I would like.

Red and fallow deer can, of course, be observed in semi-captivity but the colossal stags in English parks bear little resemblance

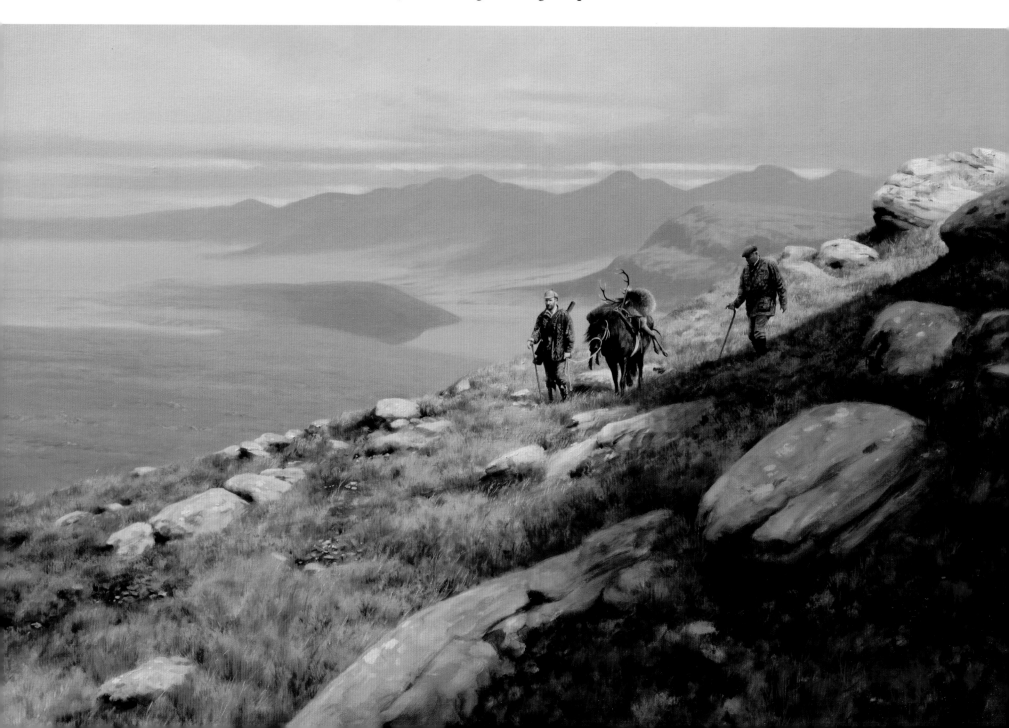

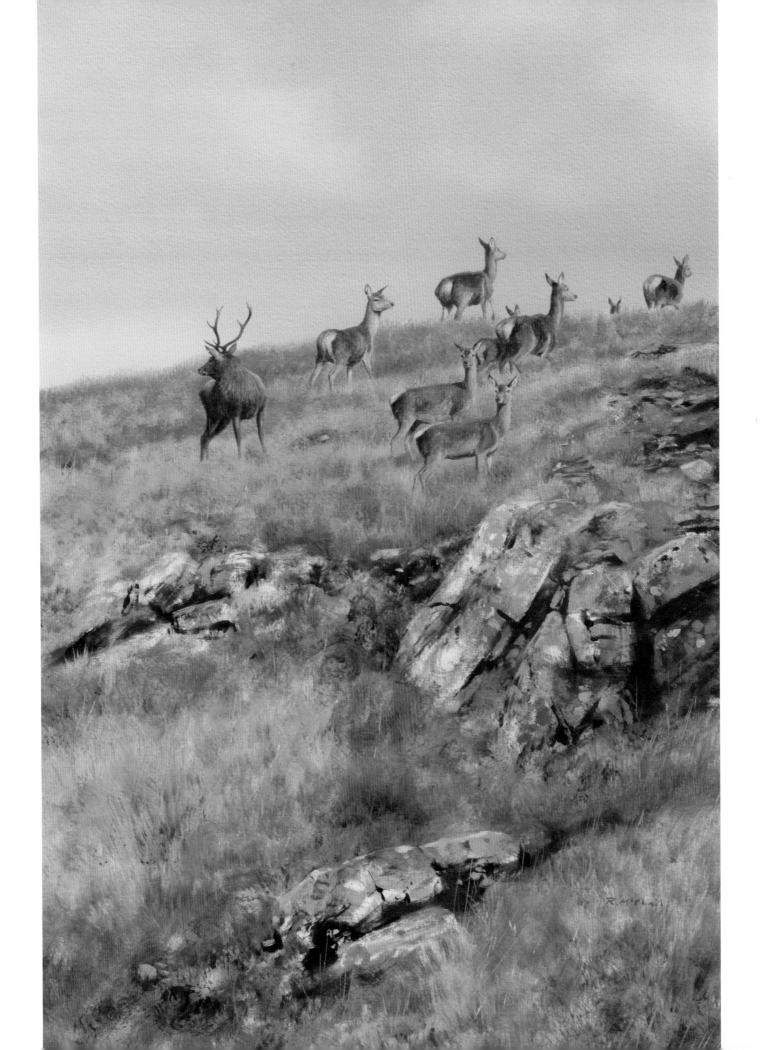

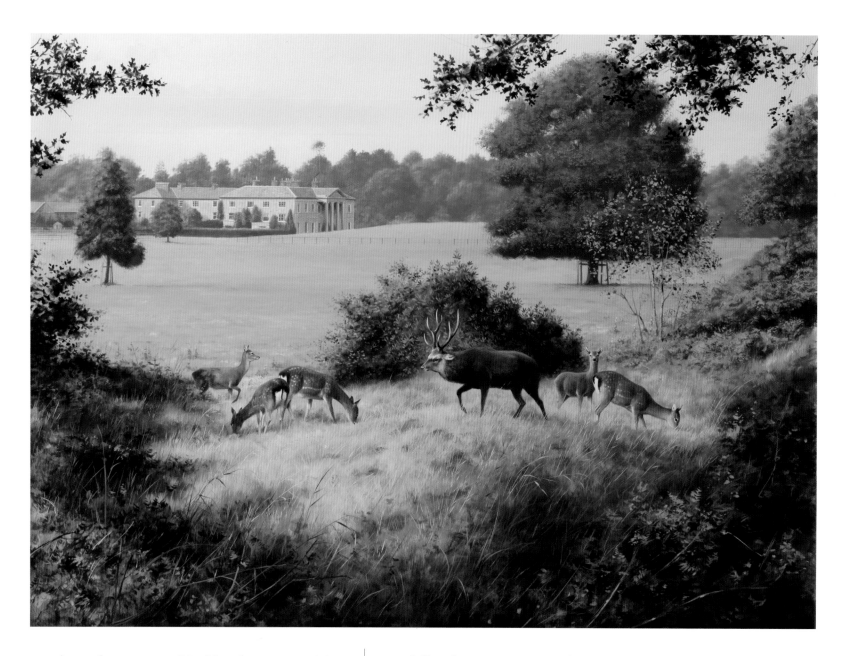

to their diminutive Highland cousins. There is the bewildering variety of antler growth and seasonal pelage, as well as the subtle process of aging. A young roebuck has a comparatively innocent expression compared to the surly suspicious look of a mature animal.

Getting it right is not easy and few artists have the opportunity and single-mindedness to put in the necessary hours studying deer. On a few occasions I have stalked hinds and it is then that the depth of my ignorance has been painfully obvious. To me a bunch of hinds all look pretty much the same but to the stalker they are individuals and he knows exactly the age and condition of each animal.

I am reminded here of a drawing by the late Rien Poortvliet, a Dutch artist of great imagination and terrifying skill. The top half of the page shows a group of hinds silhouetted against a skyline. The bottom half of the page depicts a dozen or so human females, ranging from little girls to arthritic grandmothers, with

Above
SIKA DEER AT
COLEBROOK
Oil

Right
THE RUT
Oil

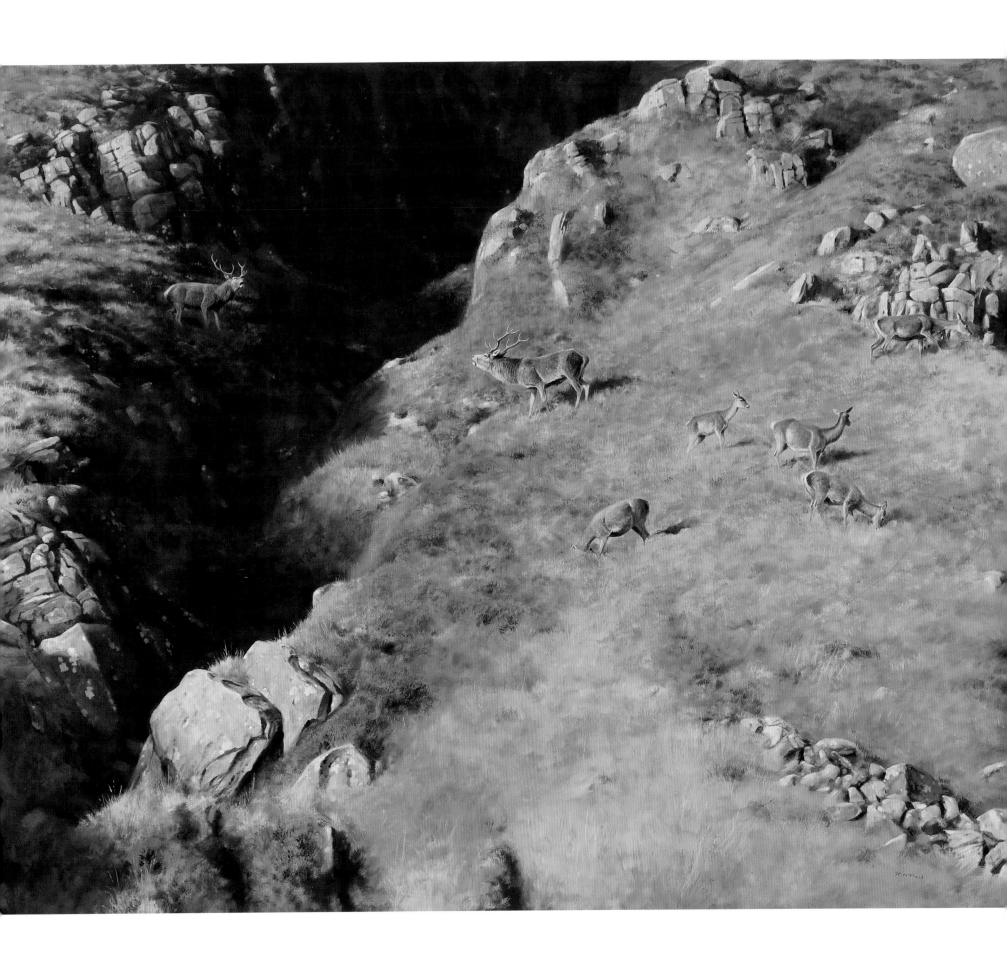

every shape and size and age in between. There was no caption!

Yes, deer are not easy and at any country fair you will see pictures which, though they may be skilfully rendered, are just not convincing. At the other end of the scale the works of Ian MacGillivray demonstrate just what can be done with a deep understanding of the subject.

In spite of the difficulties and pitfalls, wildlife artists and sculptors constantly rise to the challenge. The reason is not hard to see; deer are undeniably beautiful.

The roe is, quite simply, the loveliest animal to be found in the British Isles. What painter or sculptor would not be moved to portray such an alluring creature? Red deer, and their wonderful Highland habitat, are paintable at any time of the year, but it is in the autumn that they are most compelling. The red deer rut is like Venice – once experienced an artist has no choice but to paint it! The stags are then at their most arrogant and majestic. There is constant activity as they round up their hinds, wallow in the mud, chase off rivals and set the glens echoing with their baleful roars.

I have never eaten a disappointing piece of venison. It is a good, tasty, healthy meat and, of course, genuinely free-range and organic. The

Left
Muntjac
Oil

Right
The fallow rut
Oil

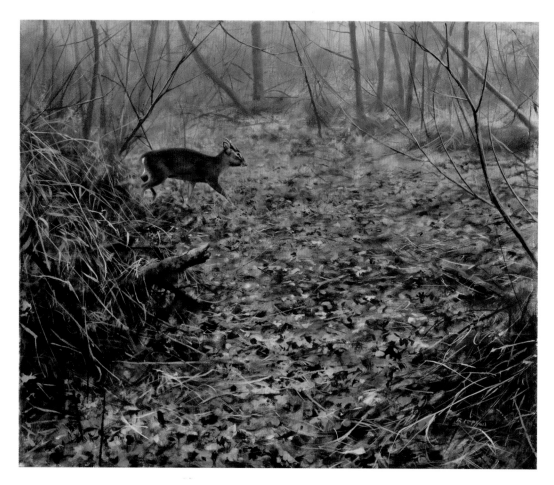

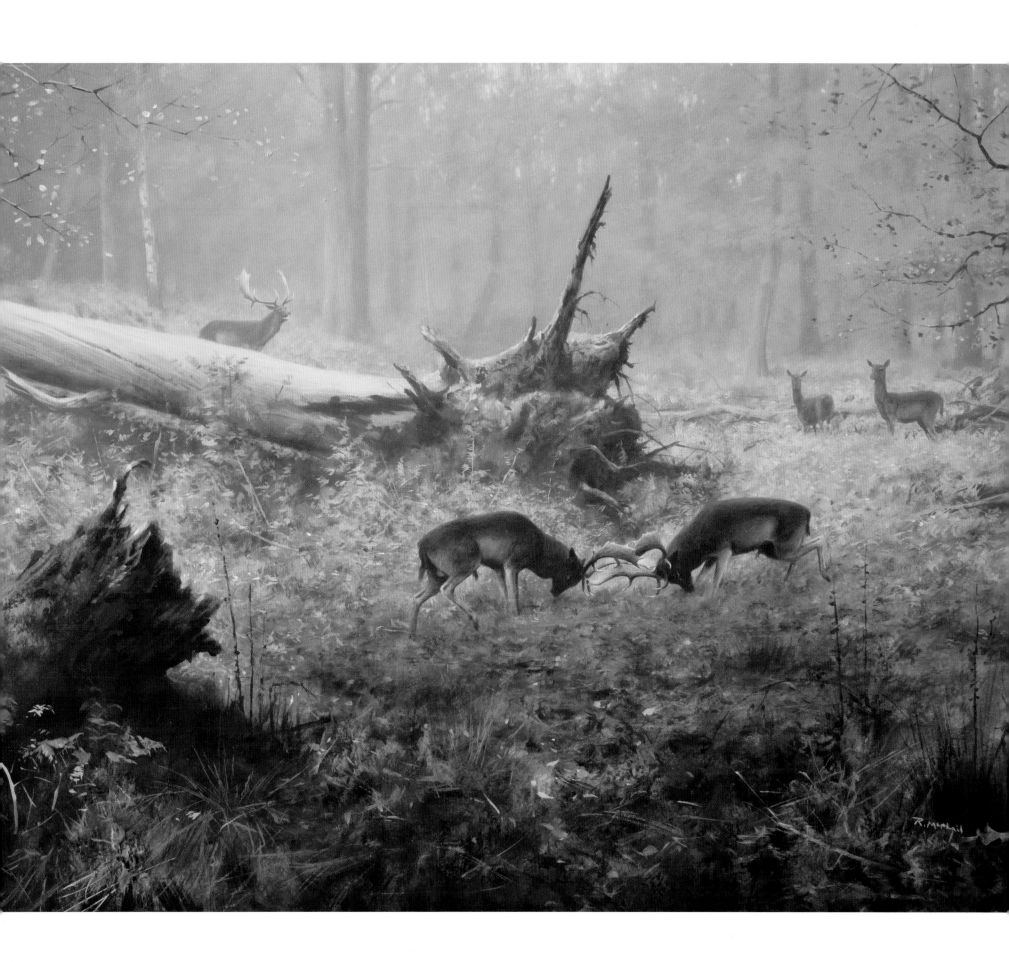

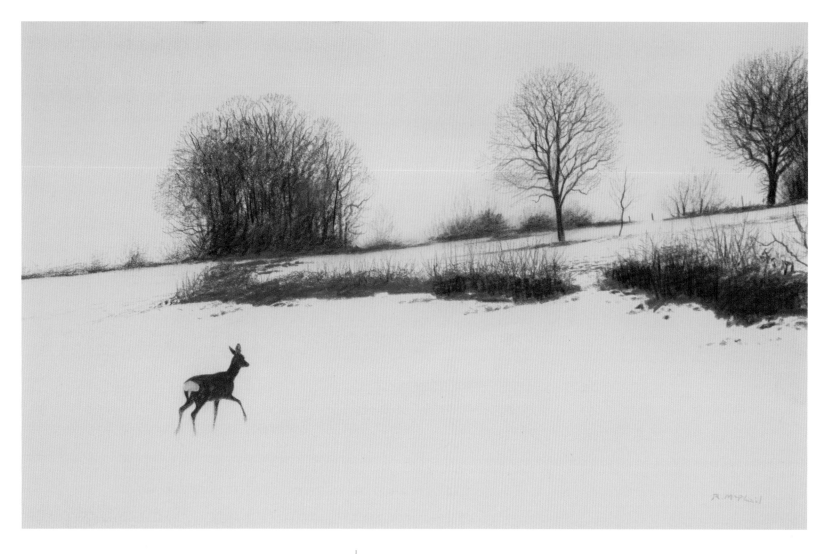

ancient gaunt and testosterone-filled stags shot during the rut are all, thankfully, exported to Germany to be made into sausages. Red hinds and young stags are very good eating. Roe at any age or time of year is delicious. Sika is also superb venison and the little muntjac probably the best of the lot. For flavour and texture it takes some beating; well worth the tricky business of removing its skin. Skinning and jointing deer can be very educational for an artist, as can further butchery, such as boning out shoulders etc.

Although it's not something I set out to do, over the decades I have been lucky enough to stalk all the British species of deer. As an artist this has been invaluable. The pursuit of deer has taken me to places that I would otherwise never have experienced and provided images and memories that have resulted in many paintings.

Invariably on these expeditions, I have been led by people whose knowledge and understanding of deer far exceeds my own. Their guidance, advice and company have played a major part in the enjoyment of the sport.

It has been a privilege to have spent so many happy days 'chasing the wild deer and following the roe'. I feel honoured to have hunted and painted these magnificent animals and, by doing so, continued a tradition started by our ancestors forty thousand years ago. ✐

Above
Roe deer
in the snow
Pencil and watercolour

Right
Roe in winter
Oil

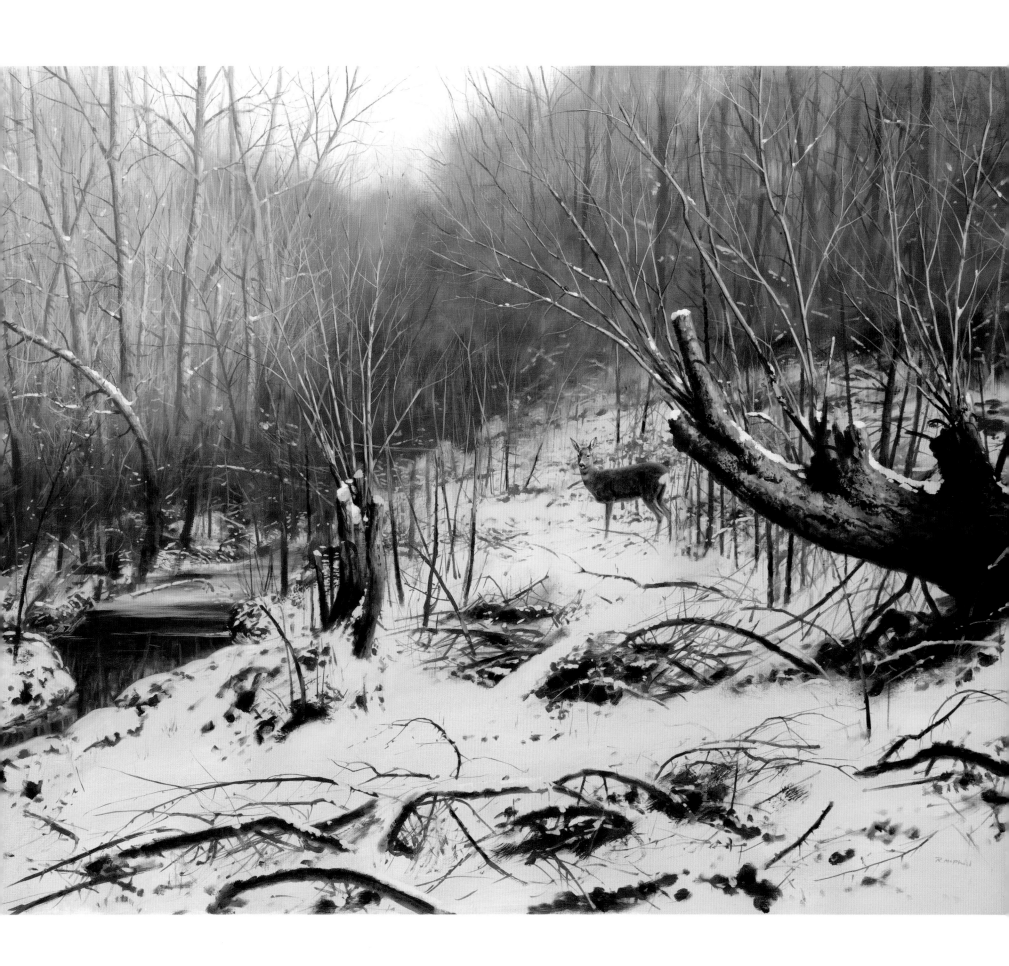

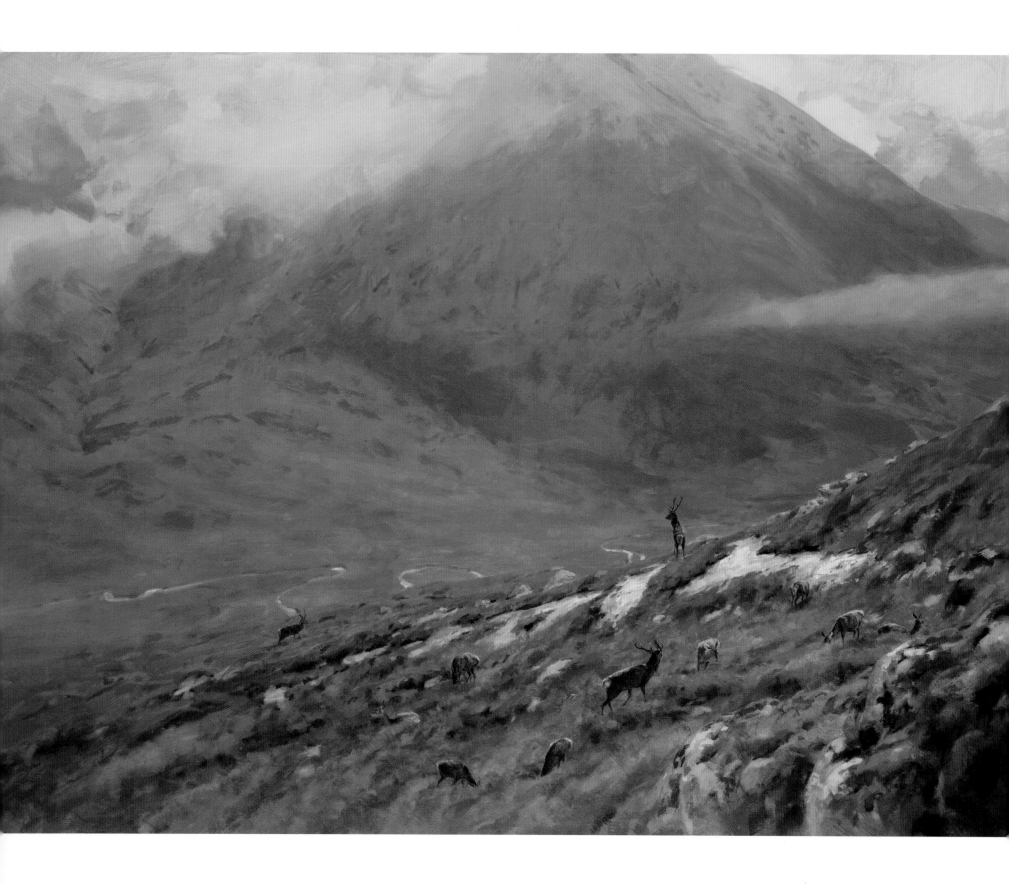

Ian MacGillivray

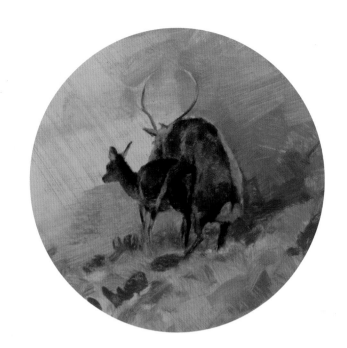

Why paint deer?

If you enter London's National Gallery by the main entrance on Trafalgar Square, go up the steps and turn into the galleries on your right, you are among the paintings. Buzz through the Impressionist galleries and turn sharp left into Room 34. Hanging on the left hand wall you will find John Constable's painting *Cenotaph to the Memory of Sir Joshua Reynolds*, painted in 1833-36. Depicted is a monument almost engulfed by dense woodland. Before it stands a dark coated fallow buck looking wary and about to make off.

This is one of several representations of deer in the National Gallery and various aspects of our understanding of this animal are communicated through these paintings. Constable's painting suggests an embodiment of spirit, and it certainly conveys something of the deer as the spirit of the woods.

Onwards through the central hall and you will arrive in room 9. Home to *The Death of Actaeon*, Titian's late masterpiece of 1559-75. Diana has transformed Actaeon into a stag and is pursuing him along with his own dogs. Here is the hunt and deer as prey.

Next door into room 15 and on the stairs is *A Deerhound with Dead Game and Implements of the Chase* painted in 1708 by Jan Weenix. A deer hunt is taking place in the background but in the foreground the chase is over. A stag lies dead and a deerhound presides over him. The prey has now become a trophy and comestible.

Go to the Sainsbury Wing and into room 53 to find the *Wilton Diptych* made about 1395-9. The alter piece is either English or French, but the artist remains unknown.

The inner panels show Richard II being presented to the Virgin and Child accompanied by angels. On the outside of the piece are the king's heraldic shield and a chained white hart

Above
THE WRONG STAG IN THE RIGHT PLACE (detail)
Oil 7 x 9 inches 2011

Opposite
SHOWERS FROM THE WEST
Oil 44 x 60 inches 2011

95

with a crown around its neck. The deer is the king's personal emblem.

Not far away in room 63 and another altar piece and unknown artist. The Master of Saint Giles painted *Saint Giles and the Hind* in about 1500. It illustrates a hunt that has gone wrong. An arrow intended for the hind has injured the Saint and participants of the hunt kneel before Saint Giles as he protectively embraces the hind. The hind accepts the guardianship of Saint Giles and here a further facet of our relations with deer is rendered.

All these aspects of our link with deer can be simplified to a list that reads, the embodiment of spirit, prey, trophy, food, a personal emblem and a subject worthy of our guardianship. At least one further aspect of our bond with deer can be added to this, the dimension of time. Carbon dating of Paleolithic depictions in the caves of Chauvet in Southern France have established these ochre paintings were made about 30,000 years ago. There is a significant history to our understanding of this animal and of our desire to portray it.

For me all of these various aspects of our connection to deer hold an interest. Over periods different viewpoints have been amplified and the course of personal development is steered accordingly. I sense the simple answer to the question, 'Why paint deer?' is, 'Because they are beautiful.' Beyond this, the interest that I've invested in deer has formed a bond that is utterly engaging.

Initially I set out into the hills with paints to try to capture a sense of the wild beauty in the landscape and making oil studies on the spot is a practice that I return to increasingly. However to be able to make paintings of wild deer you really have to learn to stalk. A degree of fitness is necessary as well as a propensity to be alive to the here and now of the environment. I don't claim to be particularly good at it but I do know that when I am stalking deer, my mind is on nothing else. Having established a certain amount of experience it becomes clear that whilst walking the hills may be interesting enough, to stalk deer in the hills is something entirely different. There is always a story to be told at the end of a stalking day, regardless of outcome. It is the intent that conjures it and this narrative naturally finds its way into paintings of stalking scenes.

A sporting interest in the red deer stag brings hunters to the hill in September through to mid October. The stag season is in full swing and the drama of the rut can be experienced. There are a few days in early October when the hill glows green gold as summer grasses give way to autumns burnt ochres and the stags begin to roar. This is an immensely exiting and captivating time to be in the proximity of deer and witness the haunting theatre of the hills being played out.

Deer change throughout the year as dramatically as the seasons and I have been keen to convey in my paintings the story of deer beyond the autumn rut. In harmony with the seasons and as the winter hill seems to be drained of life the deer's thickening coat takes on a grey brown hue. At this time it is good fortune to have a few days hind stalking coincide with hard frost and clear skies. Beautiful ice cold blues dazzling in crisp winter light. All this beauty can be tempered with a crawl over grass tussocks frozen concrete hard. Harsh on knees and ungloved hands. Other times at the hinds can contrast sharply as the damp winter hills become the colour of whisky and the rain penetrates.

Right
CHALLENGE
Oil
36 x 52 inches
2008

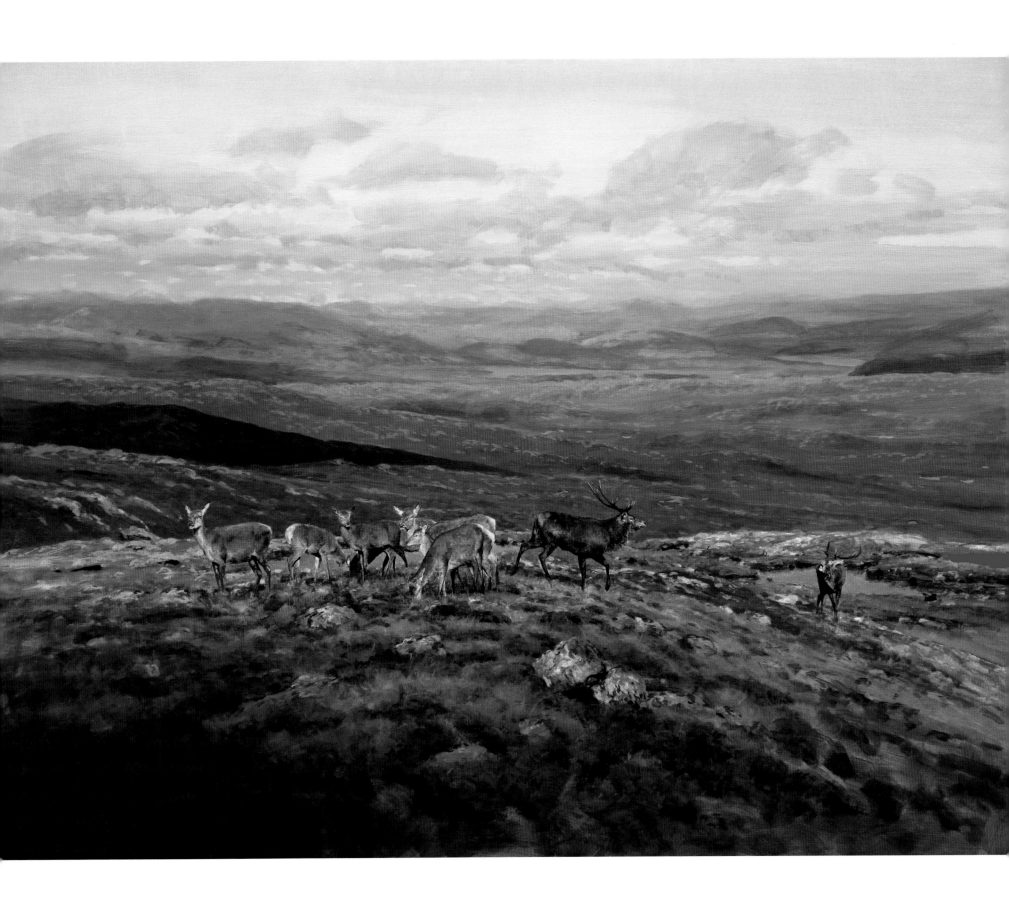

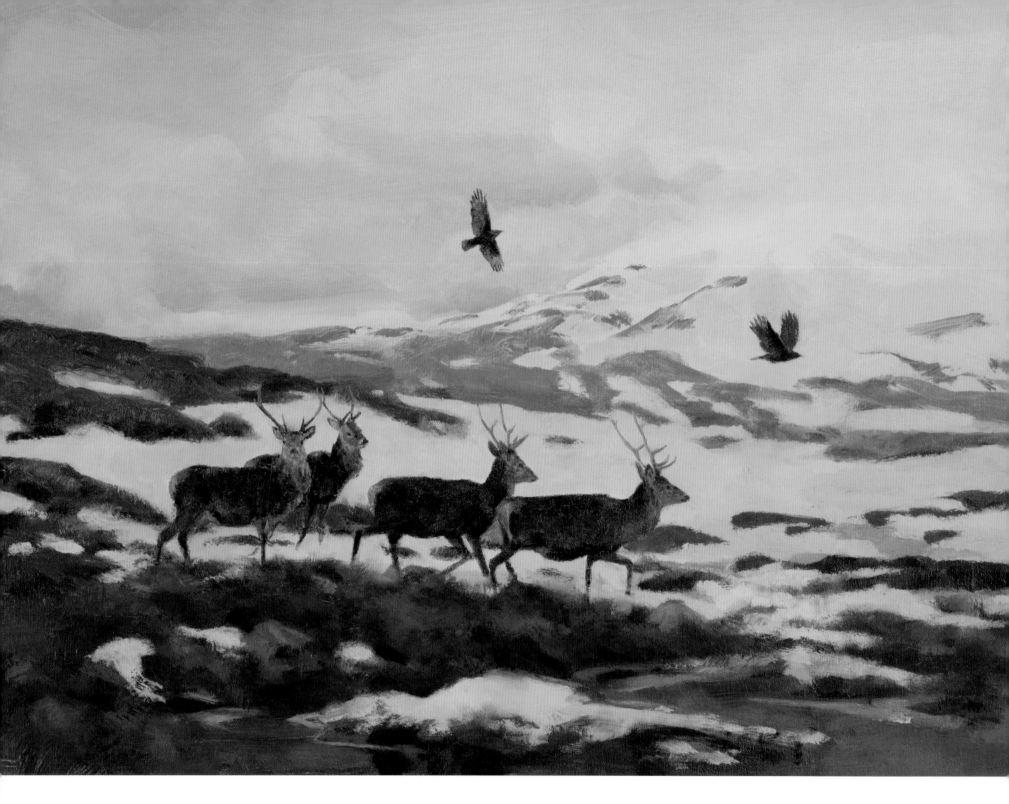

A YEAR ON THE HILL

Clockwise from above
JANUARY
Oil 10 x 16 inches 2011

FEBRUARY
Oil 10 x 16 inches 2011

MARCH
Oil 10 x 16 inches 2011

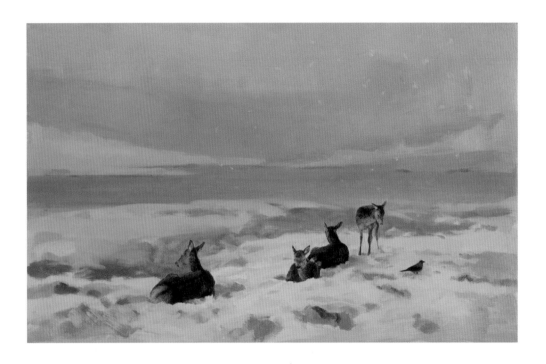

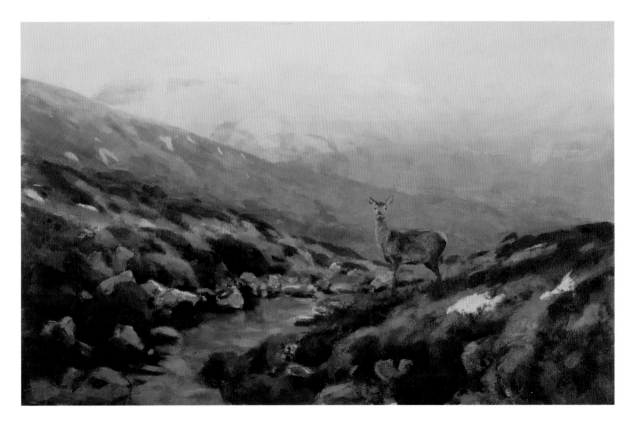

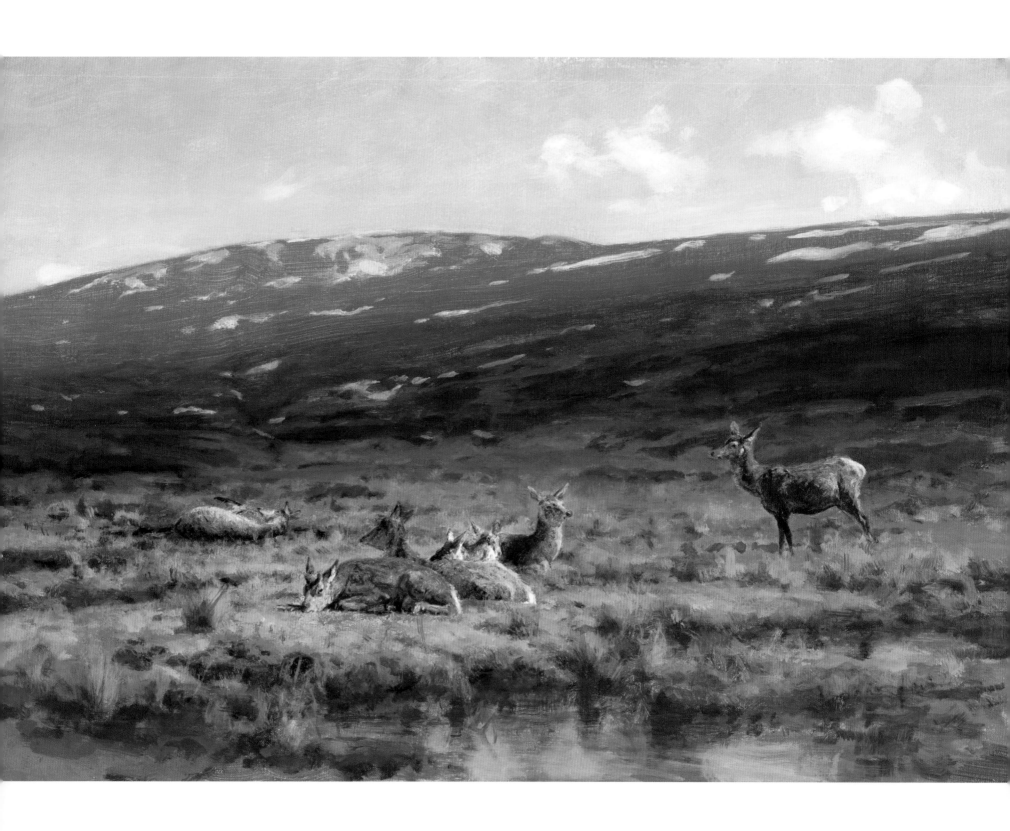

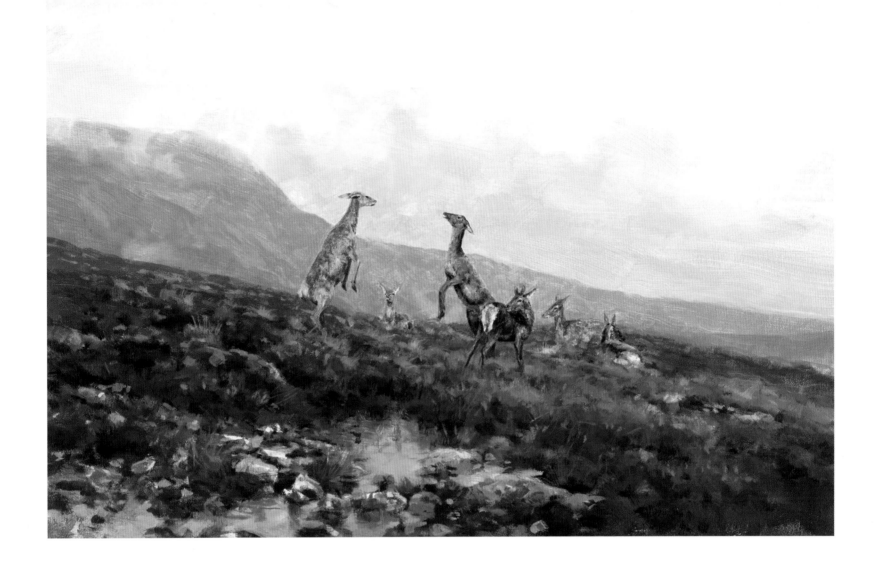

A YEAR ON THE HILL

Clockwise from left
APRIL
Oil 12 x 18 inches 2009

MAY
Oil 12 x 18 inches 2009

JUNE
Oil 10 x 16 inches 2011

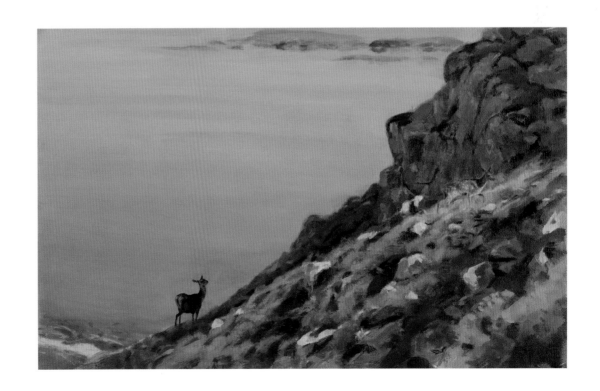

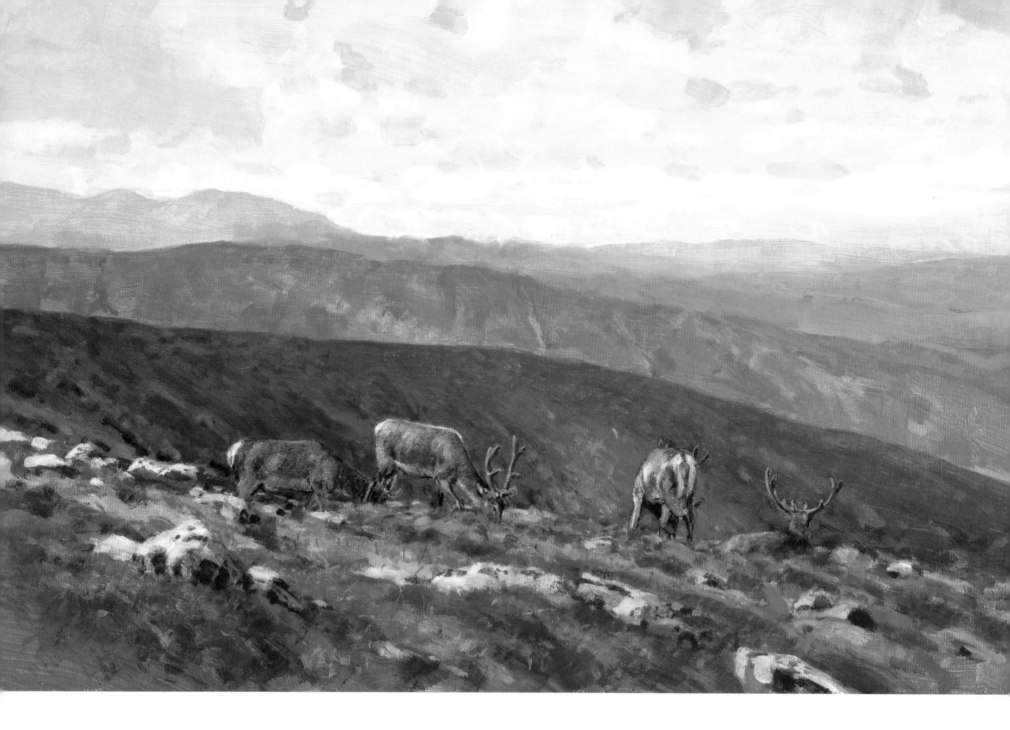

A YEAR ON THE HILL

Clockwise from above
JULY
Oil 12 x 18 inches 2009

AUGUST
Oil 12 x 18 inches 2009

SEPTEMBER
Oil 10 x 16 inches 2011

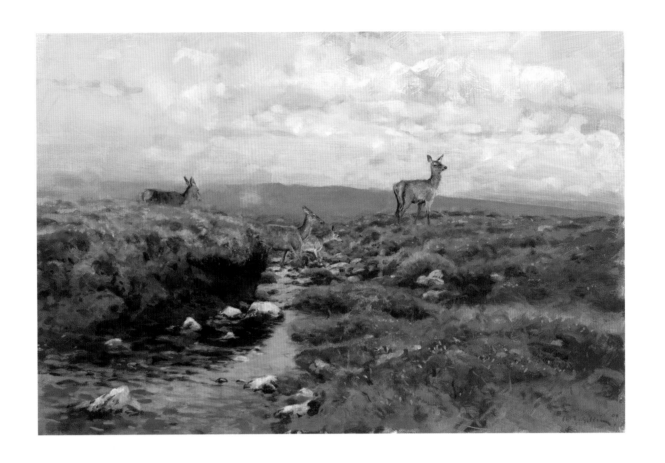

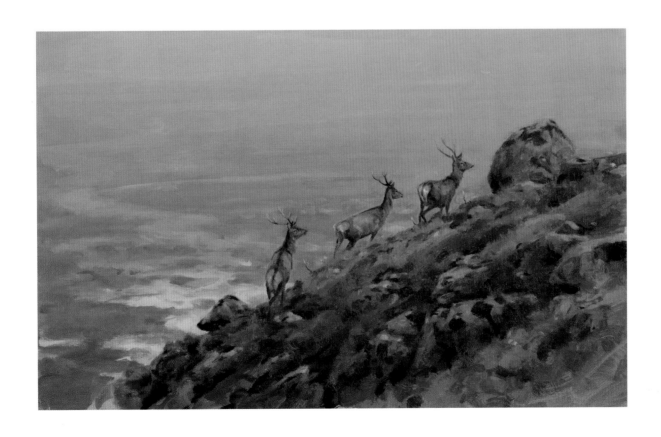

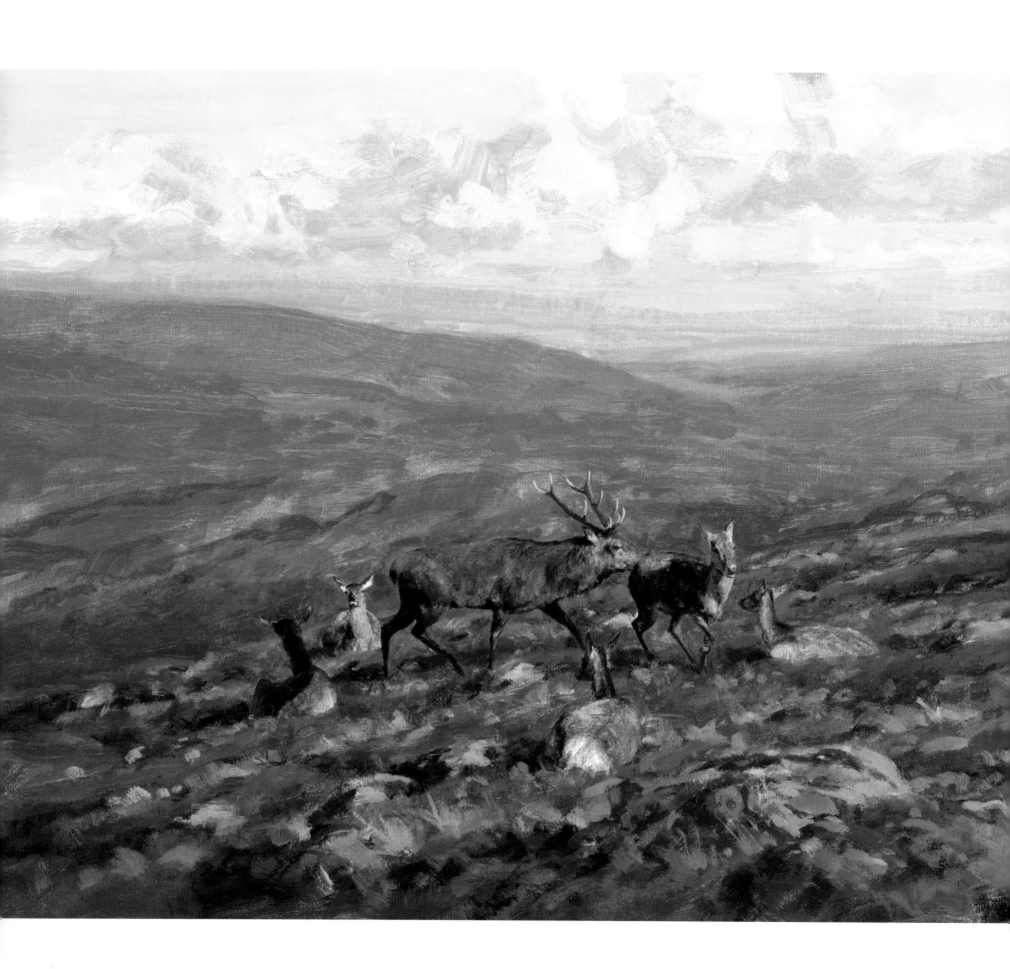

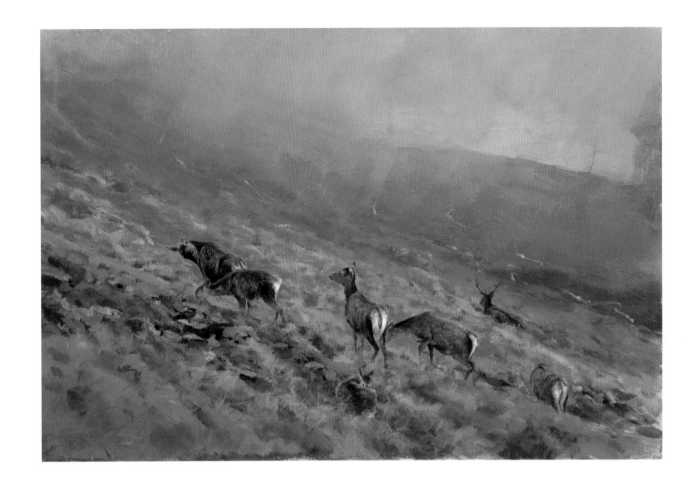

A YEAR ON THE HILL

Clockwise from left
OCTOBER
Oil 12 x 18 inches 2009

NOVEMBER
Oil 12 x 18 inches 2009

DECEMBER
Oil 10 x 16 inches 2011

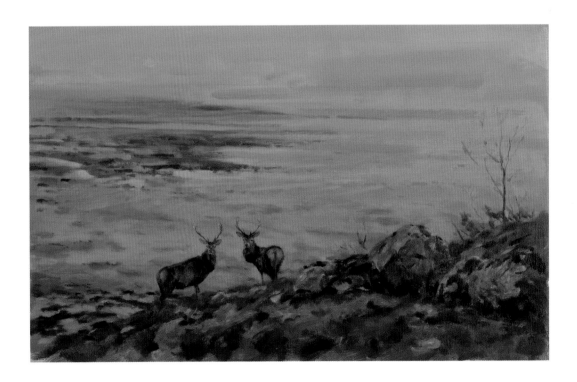

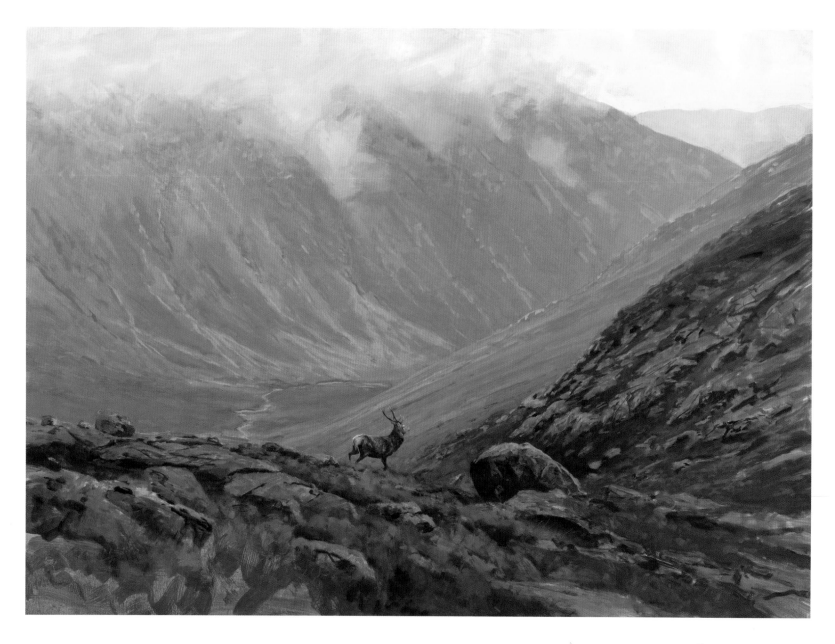

Above
TRAVELLING STAG
Oil 32 x 44 inches 2009

Right
SEPTEMBER STAGS
Oil 42 x 88 inches 2009

Stags cast their antlers at the turn of the seasons of winter to spring. The hill takes on a pale lime green colour and the final hurdle for survival comes as the fresh bite of April emerges through the dry dead grasses of the previous year. The stags' new antlers are growing immediately the old ones are cast and in very late spring and early summer hinds bear new calfs.

I stalked into the rich green hill of June and observed a hind resplendent in her restored red coat, a new calf by her side. In this without doubt I had found a beautiful, uncomplicated and wild nature. There was something in the view before me that was magical. The scene was so completely captivating that I was incredulous to find how many hours passed unnoticed.

Through the summer the stags' antlers grow at an extraordinary rate and by late August they begin to shed their velvet. Into autumn and the rut approaches. The antlers harden, the neck thickens and the reproductive cycle is ready to begin again.

Seeing deer in the wild and on the open hill is for me captivating and being witness to a truly beautiful sight. When you are at your last gasp and struggling to make progress on steep ground, how beautiful to see with such graceful agility and strength deer picking their way in fleeting seconds over ground you have stumbled and laboured over. The scene uplifts and inspires.

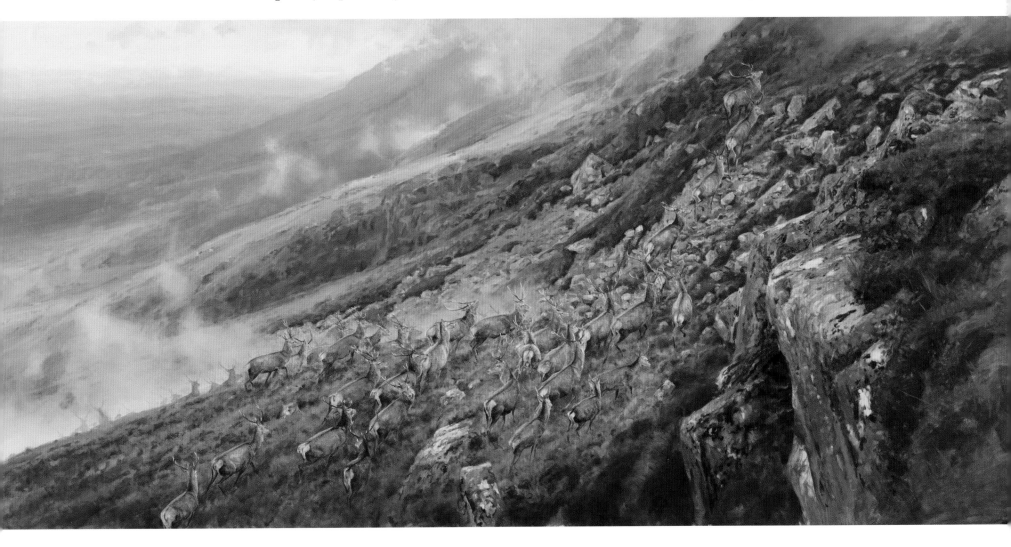

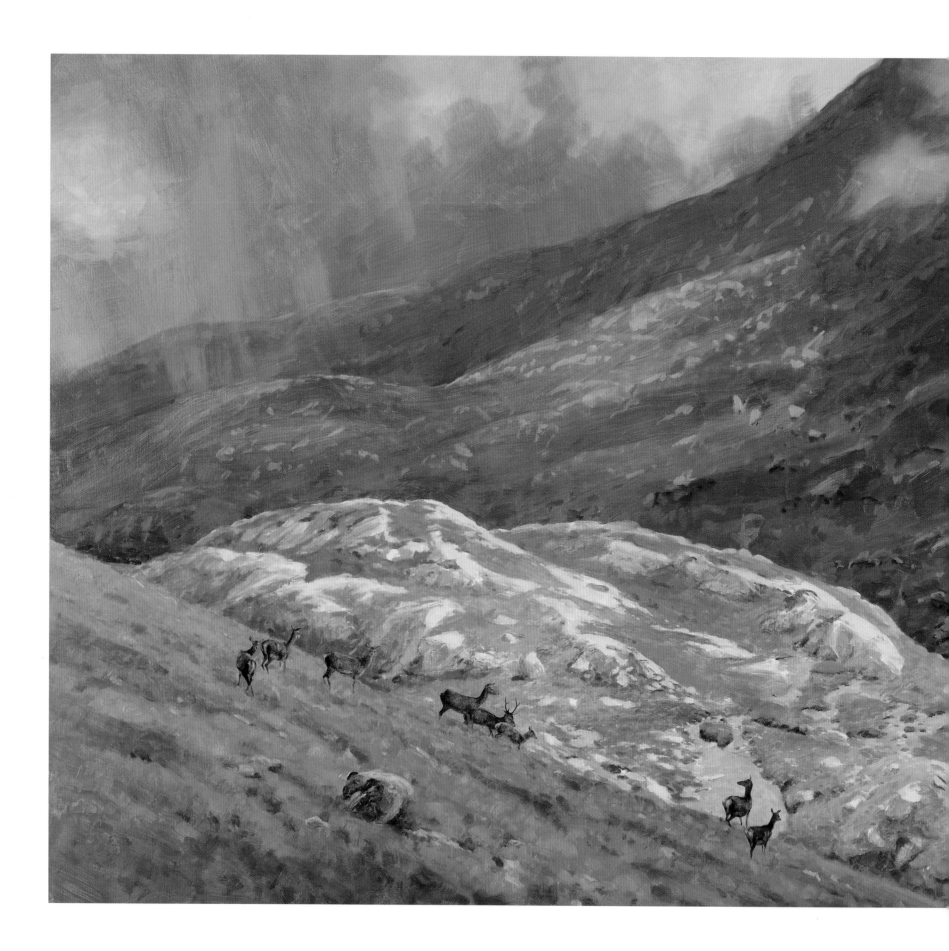

Clockwise from left
IN THE HILLS
Oil 36 x 56 inches 2010

THE BLACK STAG, OCTOBER
Oil 10 x 16 inches 2011

WINTER FEED
Oil 10 x 16 inches 2012

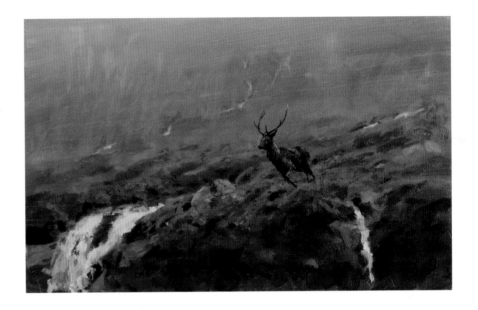

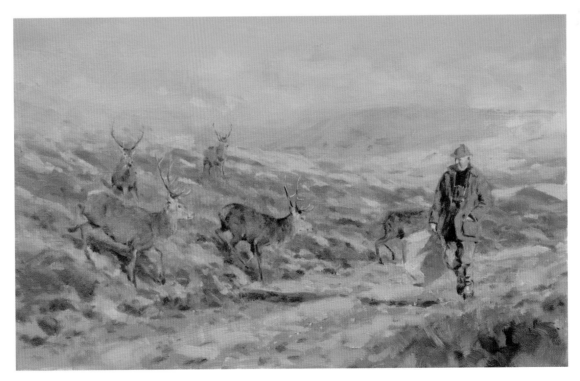

A YEAR ON THE HILL IN FOUR SEASONS
Oil 24 x 30 inches 2009

SPRING

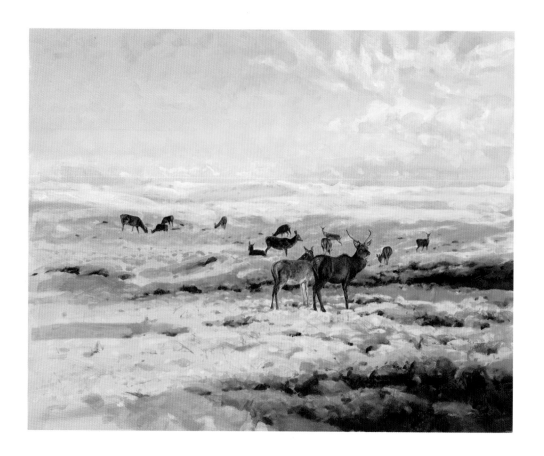

SUMMER

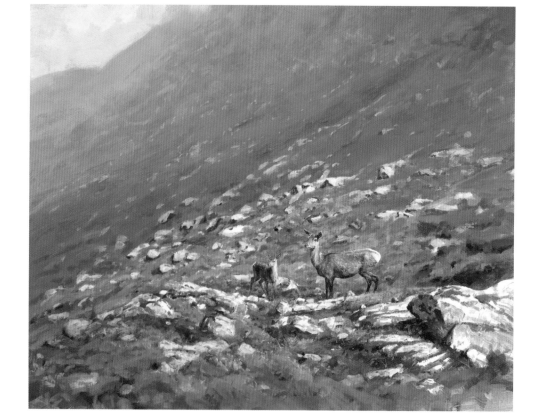

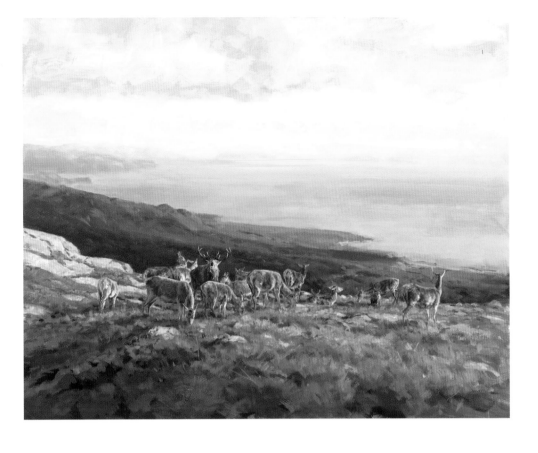

AUTUMN

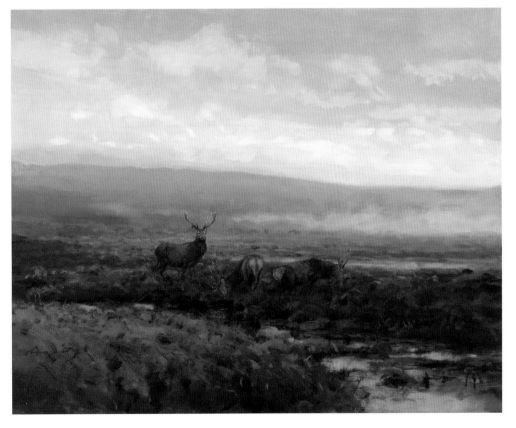

WINTER

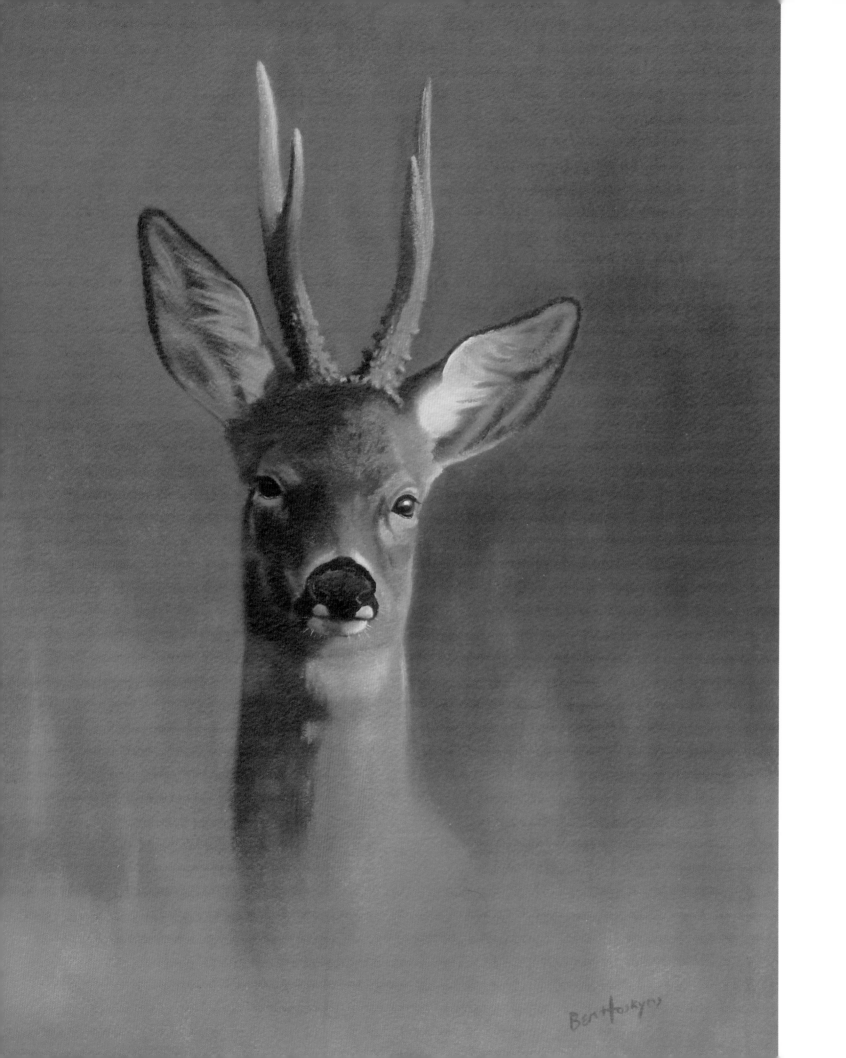

Ben Hoskyns

Ben Hoskyns

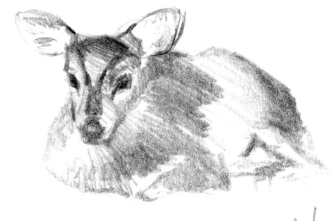

Deer had very little to do with my becoming a wildlife artist. My passion for wildlife was all down to shooting and, although I had stalked by the time I started to paint professionally, I did not know a great deal about deer at that point. And the more I have learned about them since, the less I seem to understand them.

We never had many deer around us in Suffolk until I reached my mid-twenties. It was always a joy to see the occasional roe but I never had the chance to really get to know them or their habits. I'd had some close contact with red calves and roe and muntjac fawns but felt they were far too cutesy to paint.

I did some stalking during the '80s – a brief few days after hinds in Perthshire which I loved but mostly fallow which I did not particularly enjoy (and probably why I didn't do very much of it). The Scottish deer forests were too far away for me on my meagre artist's income so I generally concentrated on birds when it came to painting at the beginning of my career.

In the early '90s I wrote and illustrated a book (*The Nature of Game*, Quiller, 1994) which required a little research into all of the UK's deer species, as well as some of the more important sporting mammals of continental Europe and North America, and my interest in deer stirred.

We saw the first fallow here in 1989 and, as in many places, the numbers suddenly exploded. By 2000 they had reached ridiculous levels and, as my contact with them increased, so my interest grew further.

At around the same time, we also began to see muntjac. The increase in fallow was understandable as they are tremendous wanderers, but with the muntjac it must have been a steady, rolling extension of their range and yet it went from occasional to common sightings in a matter of a few years. I have always been intrigued by the interaction between different

Above
MUNTJAC FAWN
Pencil

Opposite
ROEBUCK HEAD
Oil

The light on an autumn afternoon turns everything the most wonderful colour.

species of birds and animals and it was fascinating to see how pheasants and rabbits behaved in front of them – wary and alert as though they thought they were foxes (particularly in their summer coats) whilst now they pay them little or no attention.

Interest turned to irritation fairly quickly as these two deer made free use of my feeders. It wasn't so much the cost of the wheat, which had dropped to around £60 to £80 per ton, as the fact that the hoppers were emptied so quickly. The fallow would bang against them all night and empty them in a matter of days.

Eventually I managed to find effective deer guards to minimise this, but the situation became untenable when we started planting up an old gravel pit and the fallow simply pushed the tree shelters over, snapping the stakes and browsing off the exposed trees.

I started badgering two of our neighbours, who had stalkers in place, to do something about it but quickly realised that it was unreasonable of me not to make some effort of my own – I still had a deer rifle and, therefore, no excuse.

The fallow were largely resident over the three plots of land or as much as fallow can be resident. There were quite a few muntjac which were all over the place and we had a few roe as well, but these had been largely pushed out by the fallow and needed little attention.

I've heard people argue that muntjac compete for food and territory with roe but it was unquestionably the fallow herd that had destroyed the ground cover and left the woods bare beneath a browse line.

We needed to work together to get on top of the situation. Stalkers are an odd bunch and are generally very territorial about their own patch – deeply mistrusting those who show even the slightest interest in their set up. But fortunately we all realised that we needed to be completely open and keep each other informed of any deer movements on our boundaries.

At our first meeting, we came to the conclusion that there were, maybe, 100 to 120 fallow does in the immediate area. With a one-third population increase year on year, it was clear that the problem was running away from us. At that point we were seeing groups of up to forty animals and it was fast becoming a daunting task for three part-time amateur stalkers. The fallow were clearly very content and we came across several instances of twins – at least in pregnant does although whether these would have been carried to full term remains unclear.

We knew that we had to achieve a cull of forty does just to 'stand still' and that is what we shot during the first season. So we increased our efforts over the following years and within five seasons had reduced the herd to sensible levels and there is no longer a great urgency to get out at every opportunity.

Above
ROEBUCK AND SWALLOWS
Acrylic

Vivid colours along the banks of the South Tyne.

Left, from top
RED CALF
MUNTJAC BUCK IN VELVET
MUNTJAC BUCK
Pencil

Right
RED STAG
Pencil

Below
WALLOWING STAG SKETCH
Pencil

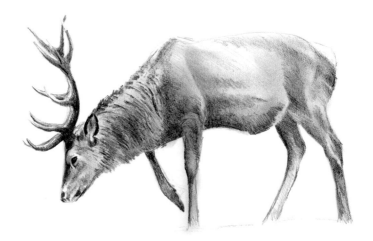

Realistically, we probably don't need to shoot more than about fifteen (mixed - bucks, does and youngsters) between the three plots of land for the numbers to remain stable. In a wider area around us, other stalkers have made good progress so immigration on a major scale is unlikely. We have reduced the muntjac although there are still plenty of these odd little deer. The roe have come back in, but in reasonable and manageable numbers. There have been a few sightings of red deer and one or two have been shot but, overall, we seem to have achieved what we set out to do.

With the damage to all the woodland in the area, I had initially wanted the total eradication of the fallow but I now enjoy seeing them and I have enormous respect for them. I have learned a lot over the past ten years although my knowledge is minimal compared to some of the stalkers I have met.

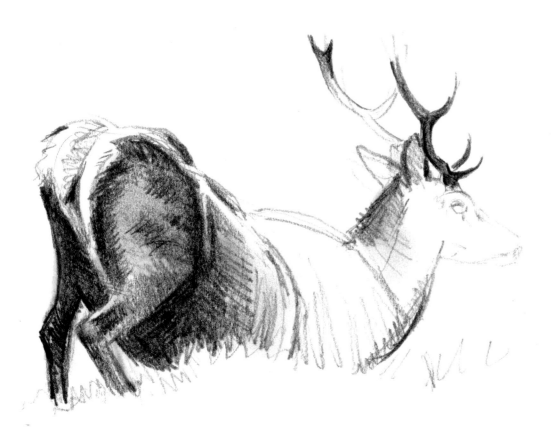

Right
HILL STAG
Oil

Despite the obliging broadside pose, sometimes the shot just cannot be taken.

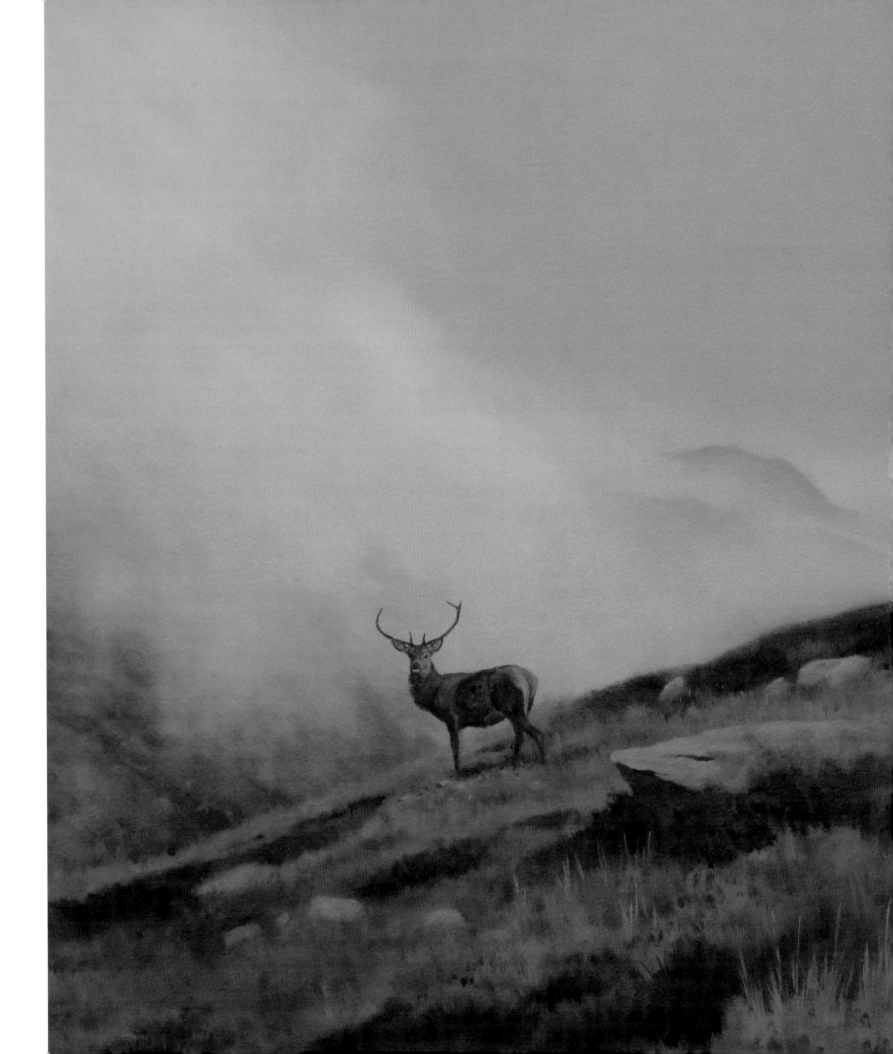

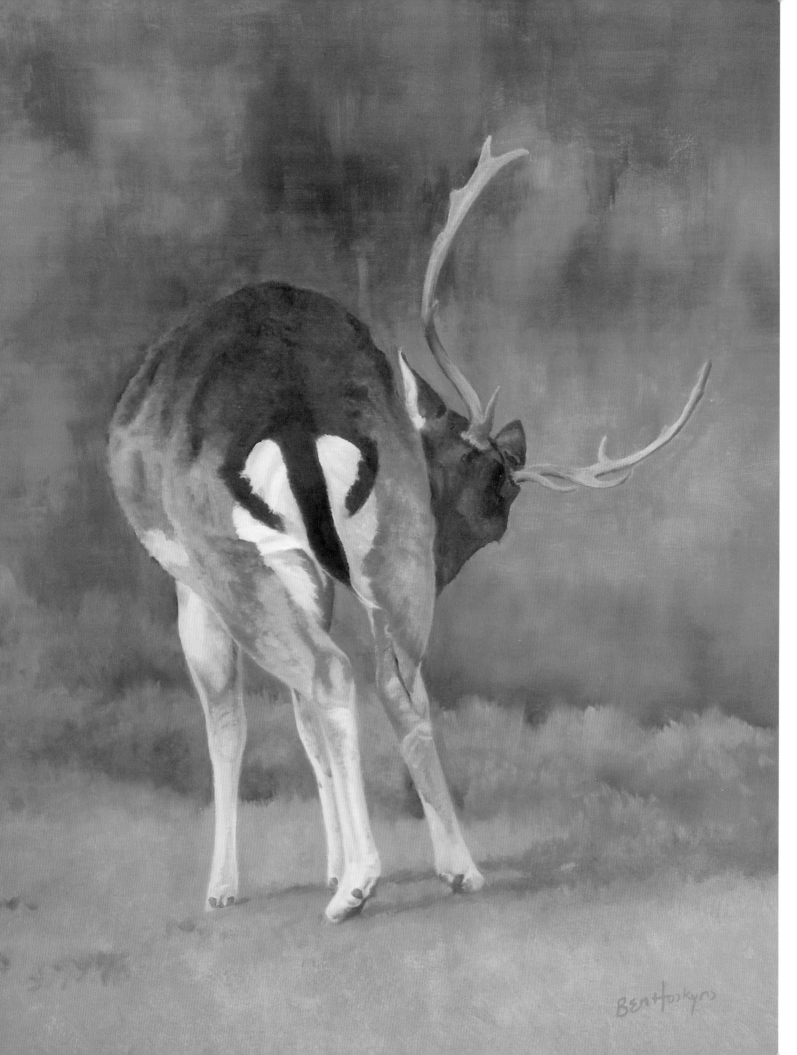

Stalking is ideally suited to the wildlife artist, far more so than game shooting. I try to capture the essence of the latter, the feel of the day, but a lot of the detail comes from the former. Fallow, in particular, are constantly on the alert for danger and if you are being unobtrusive enough to escape the attention of a group of fallow, you will be overlooked by a whole host of other wildlife.

Right
ROEBUCK
SKETCH
Pencil

Below
RED HIND AND
SUCKLING CALF
Pencil

I will often be out before first light and then sit camouflaged and, more or less, motionless for an hour, two hours, maybe longer and my attention will inevitably be drawn to the slightest movement whether it is a few inches from my nose or five hundred yards away. There's not a lot else to do and there's usually a lot of time for studying other wildlife or, for that matter and more often than not, deer that I'm not after that day.

But even when I'm on the move the process is so slow and quiet that I see far more than when I am just out for a walk. And whilst I try to focus on the task in hand, I often get distracted by something else and suddenly catch the flick of an ear through the trees and realise that a group of fallow are staring at me and ready to go.

Keeping quiet and hidden is obviously key to watching wildlife and, perhaps, more so with deer than anything else but sometimes their behaviour can be surprising. Fallow are very inquisitive and will often make a detour to a strange object out of curiosity – I have had them walk, albeit warily, right up to me even in good light and then bound away stiff-legged and barking before stopping and coming back for another look. I have sometimes come down from a high seat when it's too dark to shoot and looked up to find a fallow five yards upwind of me, having seen the movement and come to investigate. Even when disturbed and on the run, a loud shout can bring them to a sudden stop.

It seems remarkably difficult to approach deer with a rifle in your hands and yet you can sometimes stumble across the middle of a field and through a hedge and come face to face with, say, a roe doe and twins lying down forty yards away – their huge liquid eyes looking innocently gob-smacked at the sight of you – struck by the

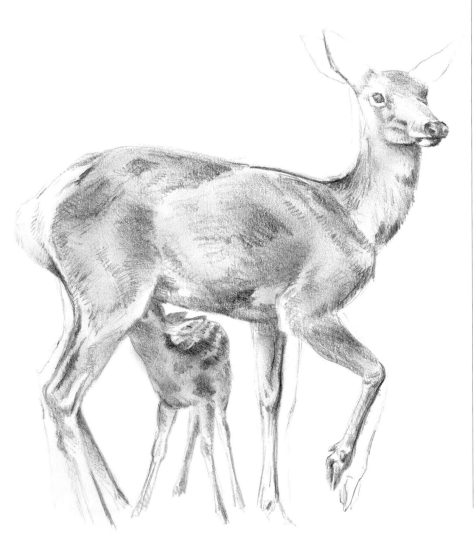

comical idea that such alert and timid creatures as they can be caught napping so easily. They are usually so bemused that, if you stand still, it takes them twenty seconds to get to their feet and another twenty to decide to ship out and even then they will probably stop for another look.

I once moved a large fallow buck whilst I was filling hoppers and watched him slowly amble off through a small stand of trees and up to a very thick hedgerow at the top of a bank. He knew I was there but had decided he couldn't be bothered to run away. He slowly edged his massive bulk into what seemed totally impenetrable blackthorns. The process took a full minute before he felt satisfactorily concealed although I could still see the tip of one antler quiver from time to time so it looked like he was giggling at the absurdity of his hiding place as I walked past him about fifty yards away.

A set of antlers can lead a deer into trouble and not just from those who only seem interested in sticking them up on their wall. I once found a poor roebuck that had become stuck whilst fraying the bark of a sallow and sadly died there. I wish I'd found him sooner and been able to release him or, at least, put him out of his misery as I did with another roe whose shoulder had been broken in a fight not long before.

I have only found two cast roe antlers and one from a fallow on my wanderings at home. A lot of animals (deer included, I suspect) will chew them for the nutrients and calcium so there's probably little left after a year or two. I once left a set of roe antlers in a pheasant pen and let the mice, rats and squirrels go to work and there wasn't much left after a couple of years. I suspect if badgers and foxes had been able to get at them, they would have disappeared rather sooner.

Whether I am out stalking or simply wandering with a pair of binoculars, I frequently come across deer of one description or another. Something catches my eye – the horizontal line of a back in a world of verticals; the flick of an ear; the switch of a tail or a pivoting head almost unseen through a mass of branches. Sometimes it is more obvious and we will both step out onto a ride at the same moment and there confront one another. There is something intensely intimate in that moment, our eyes locked not daring to move until, after maybe a full minute or more, the deer half turns its head, pauses, as if in puzzlement, and then trots unhurriedly away. The movement is always so quiet you

Left, from top
RED STAG TESTING THE WIND
ROE ANTLERS
ROE BUCK
Pencil

Right
ROARING STAG
Oil

Stags lose condition in the rut but this one is as fat as butter.

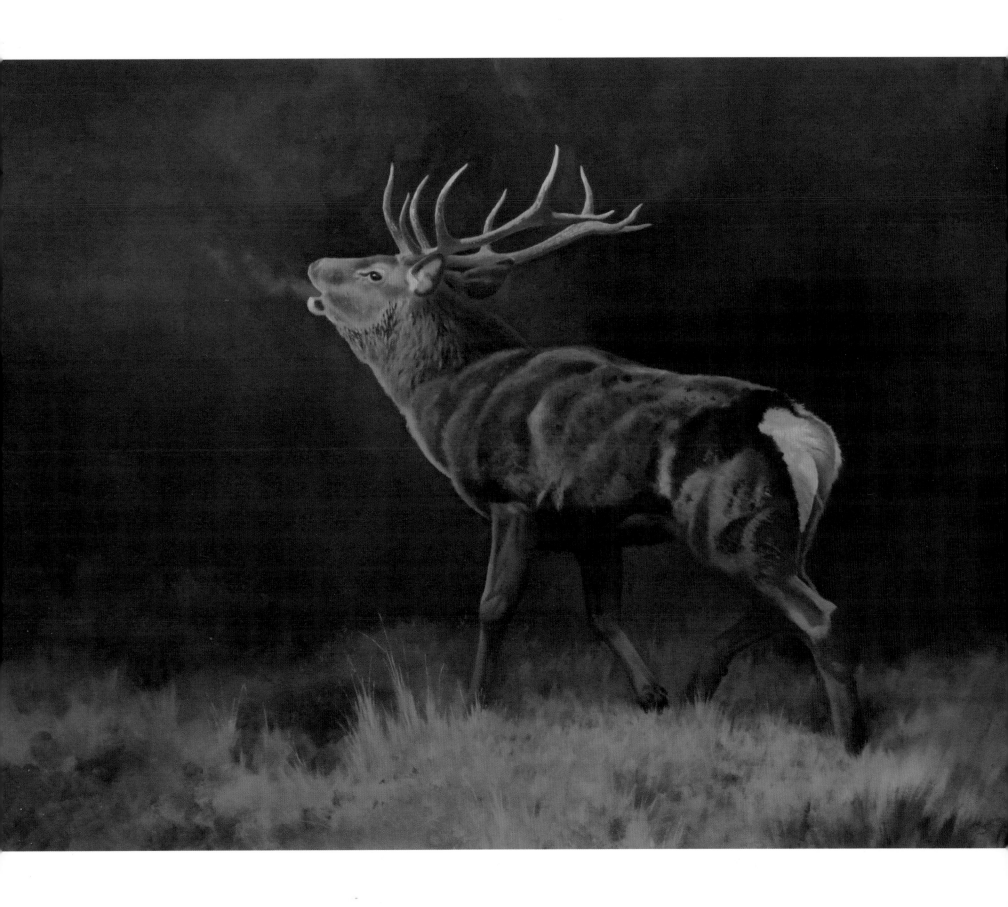

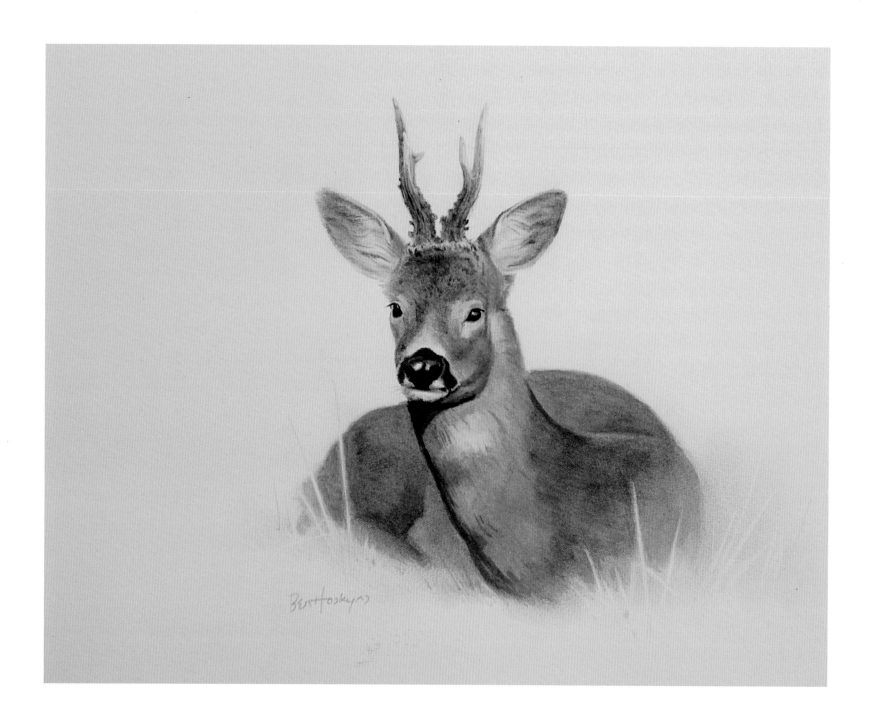

can hear the soft clicking of its hooves and just the occasional crack of a snapping twig. Even when a group of fallow is at full tilt through a wood the sound seems somehow hushed. These are big animals and, when the ground is wet, leave deep slots yet their passage seems to have little impact on thick brush and undergrowth unless it is a regular route.

But these quiet, serene moments are very different from the intense power of a large buck in the rut. In the autumn, we can hear the fallow belching from their rutting stands when we let the dogs out last thing – an eerie sound echoing across the valley. There are usually two such stands within half a mile of the house and a few years ago we had one about 150 yards away in

Left
ROEBUCK
Pencil and watercolour

I often come across roe lying down in woodland or along hedges. You can see them weighing up whether it's worth getting up.

Right
RED HIND
Oil

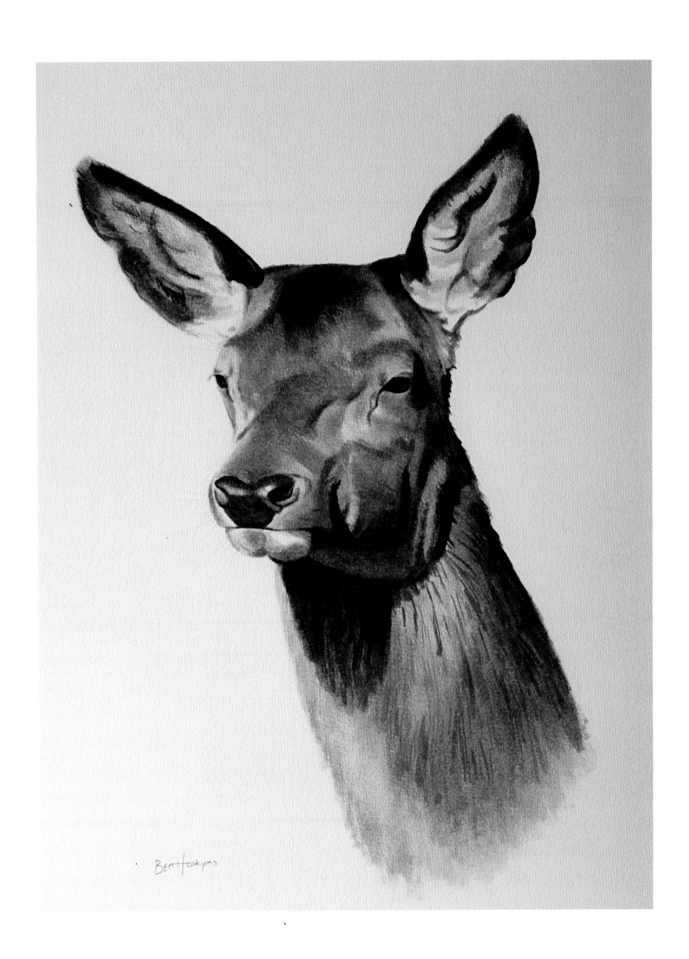

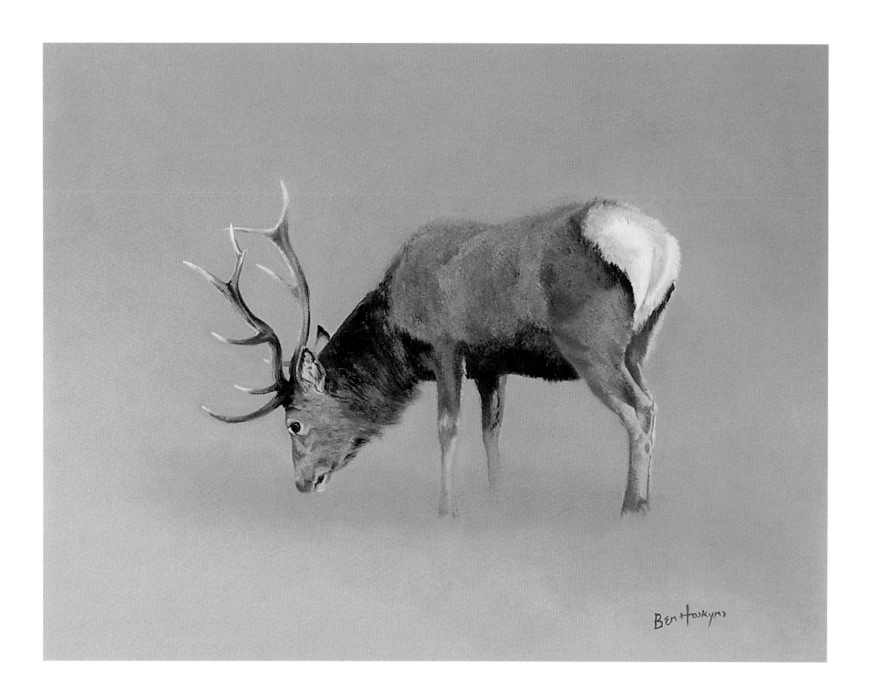

an old overgrown orchard. It is late October as I write this and a buck is back there again. I crept up with my binoculars to watch him and came across two lesser bucks (one with only a single antler) mooching about nearby whilst the big boy strutted back and forth along the rides cut through the brambles. Although I spooked the younger beasts, they were clearly keen to stick around and I caught odd glimpses of them along different rides every now and then, sometimes hurriedly doubling back because the big boy had seen them. One can feel quite vulnerable tip-toeing towards such a menacing and powerful sound (especially when the buck's mind is on other things) and there is definitely good reason to stay well clear of any tame deer during the rut. If a deer has no fear of humans, he may well see you as a threat and decide to have a go.

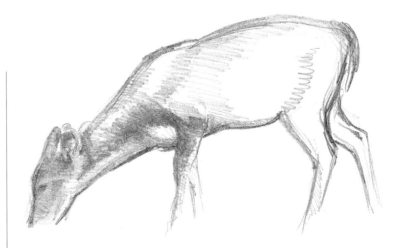

Left
FEEDING STAG
Oil

Right and below
MUNTJAC SEEN
FROM THE STUDIO
Pencil

Noises in the night are part of living in the country and, I guess, just a different set of noises to those in towns and cities. I can sleep through most of them but not the incessant barking of a muntjac which can go on for an hour or more. Even in pitch darkness, you feel a little foolish running round the garden, shouting at the bushes in a pair of pants. The barking stops, you come in, lock up and get back into bed. Gradually you calm down and just as you begin to drift off, the barking starts once more.

We have tried to keep deer out of the garden – once trying electric fencing with little effect. Both the fallow and munties come and strip the rose buds just as they are about to open and I have often seen a muntjac doe with a fawn, no larger than a rabbit, gambolling by her side from my studio window during the day. The roe, however, seem to be more timid and I don't remember ever seeing them in the garden although I know they are partial to the odd rose. My wife calls our garden the 'Happy Eater', on the highway between two large woods on either side of us.

But it is remarkable how the fallow have adapted to live alongside us. Where they feel unthreatened they will tolerate me walking past daily within forty yards, so long as there is some cover between us. They know me and the spaniels by scent, presumably, and will often stay put although they keep an eye on me as I pass. If I stop, they will usually move, setting off purposefully but stopping short of actually leaving the wood. After a while, once they are sure I have moved on, they will double back and end up, more or less, where I first disturbed them.

The roe are perhaps more cautious once they've seen me, but are usually found in roughly the same place each day and, as this is often tucked up against a hedge, it is easier to go out specifically to observe them, albeit from a distance. By contrast, the fallow are so alert that, even if I am quietly walking around on my own trying to find them, they often see me before I see them.

And the muntjac don't usually stop for long enough to study closely. As far as shooting them goes, in my experience, if the tail is down there's always the chance of a shot but if the tail is up, it's unlikely to pause for long enough. Occasionally they seem totally relaxed and amble lazily across open ground but, more often than not, they are somewhat furtive and timid, ready to run at a

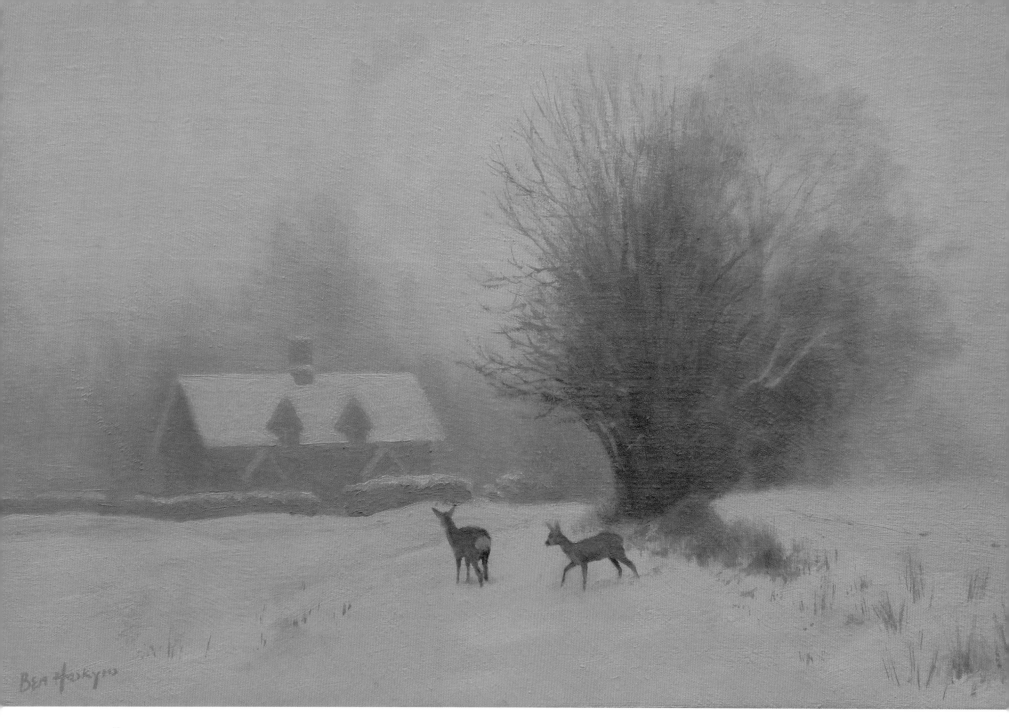

Above
ALL CLEAR
Oil

*I passed some roe near these cottages every
morning whilst doing the school run.*

Right
ROE FAWNS
ROE DOE
Pencil

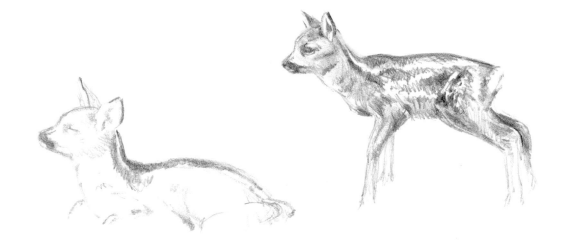

I had seen a woodcock feeding near these trees in the half-light one morning, when I was out stalking, and made up the rest although it is a very believable narrative. I am always intrigued by the interaction between different species.

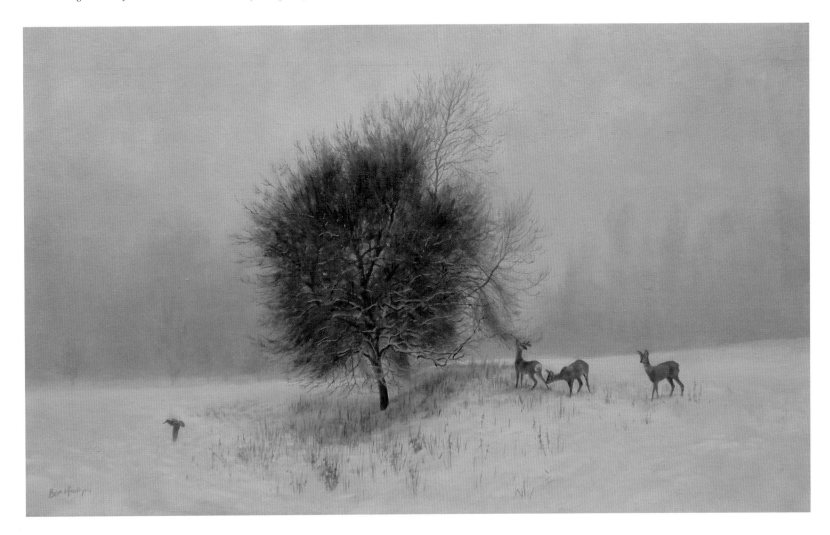

moment's notice. They sometimes come face to face with the spaniels but don't seem to be unduly alarmed by them. Our dogs have never chased them so they generally stand and stare for a bit before moving off.

There is something quite magical about coming across deer of any description – these are large animals that are anything but predictable. Even when you are specifically looking for them, there is always that moment of surprise that they are there but I grab any opportunity to observe them and very rarely turn away before they do.

How such elusive beasts have managed to live alongside man for so long, extending their range and numbers year on year is quite remarkable.

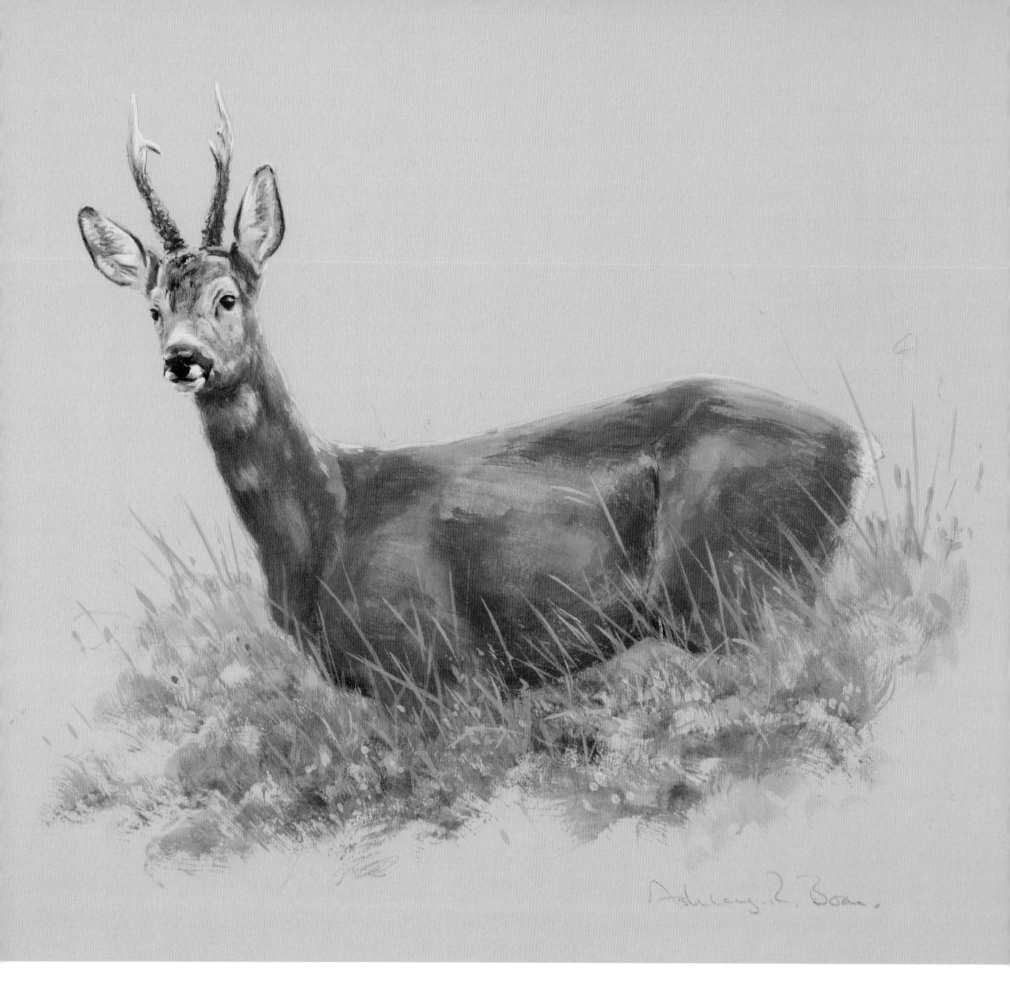

Ashley R. Boon.

Ashley Boon

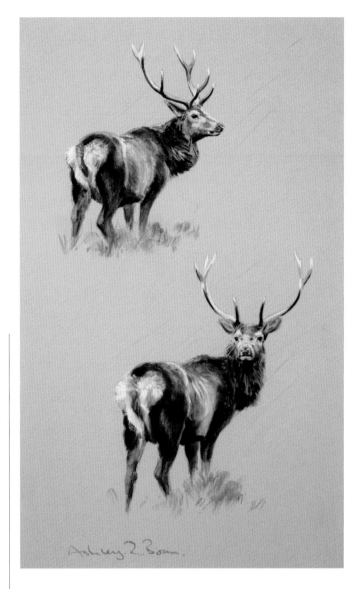

As the sun clears the fell top behind me and the first real light of the day seeps into the little valley, I stop to spy the slopes again looking for a roebuck. Actually I'm looking for an individual buck, skinny with spindly excuses for antlers, a good cull beast. Willow warblers and chaffinches sing from the scrubby thorns and then a stonechat ticks at me from the bracken that I push through. The light grows steadily warmer, the light breeze in my face, as I slowly make my way deeper into this secret place. Then there is the shape I've been looking for, half hidden by the gorse bushes on the slope ahead of me. Using a thorn as cover I creep forwards and the rifle slips quietly into the crossed stalking sticks. The cross hairs find the deer as it moves more into the open, still with its head down feeding. I can see from his rear end that he's a buck. About eighty yards off, the way he's moving he'll soon give me good broadside target and I move my thumb to the safety, only to pull it away as he shows me his head for the first time. Fine featured, slightly grumpy looking, a fine set of antlers, he's not the one I'm looking for. He's too good to take; he must leave his good genes in this little bit of wild Cumbria. I am content to watch through the binoculars as he restlessly browses, scratches an itch and then frays a small birch tree as he marks his territory. I'll leave him today and keep looking for his poorer relation.

Above
RED DEER STAGS IN RAIN
Watercolour

Opposite
MOORLAND ROE BUCK
Watercolour

Stags, hinds, bucks, does, calves, fawns, prickets, switches, royals, hummels, beasts, harts, slots, singles, fewmets (remember *The Sword in the Stone?*), our language is filled with references to deer. Pub names such as 'The White Hart', 'The Stags Head', or maybe the 'The Roe Buck' remind us of a time when some parts of this land were greener and an interest in hunting and the animals hunted were of a greater preoccupation to more people. It is not surprising that deer excite us as much as they do. They are the largest mammals that we regularly see in our country.

To many people they are a fleeting shape that crosses the road in front of them, or disappears in a moment whilst walking the dog. How excitedly the less observant will tell, 'We saw a deer!' But why be so surprised? They're all around us, and with a little patience can easily be observed.

Muntjac

I grew up in rural Northamptonshire, not so very far from Woburn Abbey, from where the now well established muntjac deer escaped. As a boy I spent many happy days wandering the fields and woods near my home looking for birds and other wildlife and on these solitary wanderings I often saw muntjac or barking deer. The muntjac does not display the same ethereal 'faery' grace that the roe does, nor the elegance of a fallow or red deer. It is actually more reminiscent of a small pig. Hunch-backed, head low, small and stocky, this diminutive beast nonetheless has its own charm. I loved to watch them trotting down a hedgerow on their dainty toes or walking up a forestry ride. I remember one occasion in a favourite local wood when I was able to stalk to within a matter of feet from a little muntjac doe as she browsed on brambles, until a change in the breeze sent her dashing away with indignant dog-like barks.

My life has got more interesting as I've got older. Amongst the other great pleasures of my life I now joint-lead annual safaris to Botswana, and I recently led my first trip to India. India is a wonderful place full of colour and some spectacular wildlife. However despite the great excitement of seeing my first tiger, I was a little disappointed not to see wild muntjac in their true native habitat in those dense jungles rather than a Northamptonshire field!

Being keen on natural history I was always interested in deer, but when I had the chance to hunt them, my interest was given a greater focus.

My sporting mentor in my early twenties was my great friend Steve. After much badgering he finally took me out to try for a shot at a muntjac. Morning after morning we were out at first light searching for a deer. Muntjac are great sport. They have excellent eyesight and can seemingly evaporate at will! I still have the skin and the trophy from the buck I finally got. If you ever have the chance do try Muntjac venison, it is very good. A word of caution though, if you can, get someone else to skin any muntjac you get hold of, it's glued on!

I shot a good muntjac buck one early morning

that, when I could examine him properly, had a face that looked as if it had been slashed with a Stanley knife. His head was covered in scars and he had broken the point off one of his antlers. I'm sure that a few of the younger local bucks must have had an easier time after such a bruiser was taken out.

Below
MUNTJAC BUCK
Watercolour

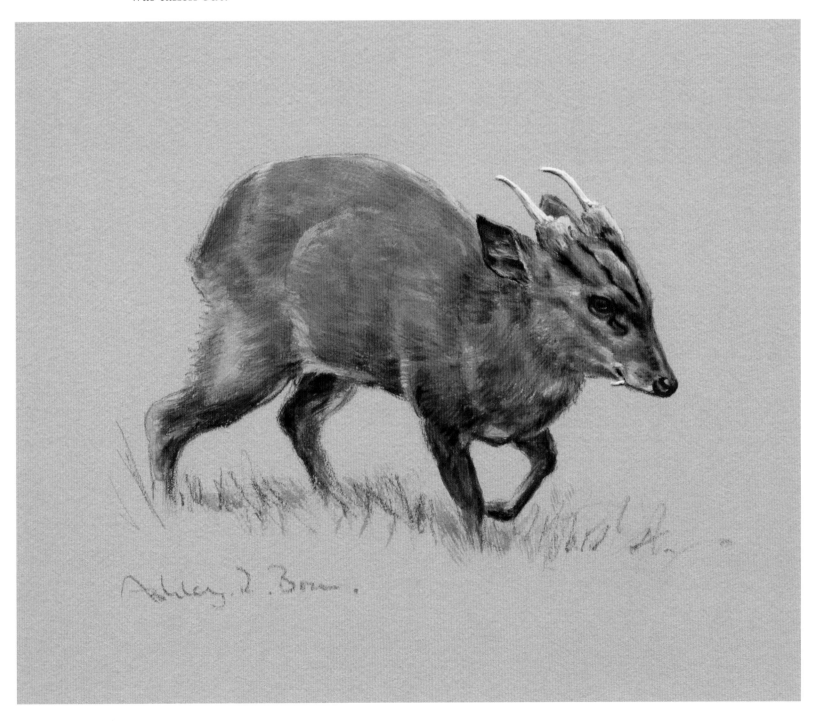

Fallow

I met Nick about thirty years ago. An exhausting, delightful man Nick is an avid enthusiast for all aspects of fieldsports and natural history, and if he does it, he does it well. His enthusiasm is only exceeded by his generosity.

It was with him that I made my first outings after fallow deer in Devon. I got my first fallow under his guidance and although it was only a pricket I still look at the trophy with fond memories.

The rutting call of a red stag is a glorious sound echoing around the Scottish hills, but the deep throaty calls of fallow bucks in the rut is just as impressive. Those deep harsh roars make those forests a thrilling place at first light. The buck's calls, the crashing chases and hard clacking of their antlers bring the forest an urgency and vigour for this brief spell.

I haven't had many chances at fallow, but I was told expressly by a great farmer friend in Northamptonshire who let me stalk muntjac on his land, that if I saw a fallow I was to shoot it without fail. They had moved into the centre of a maize field and were wrecking the crop.

At the time I had a Wire-haired Dachshund who was my constant companion, and despite the somewhat scathing looks that Siggy sometimes got from owners of more conventional sporting breeds, he was game for anything.

As I made my way up the side of one of the farm woods with Siggy at my heel, a fallow buck stepped out in front of us about forty-five yards away. Happily it was in a place I could shoot safely and I swung the rifle to my shoulder. The bullet struck him and he spun around and bolted into the trees. I sent Siggy on and as he reached the point where the buck had been, he too dived into the trees. After the sound of the rifle shot the silence was intense. I don't suppose it was anytime at all really but it seemed a long time until I heard my dog start to speak in that urgent way that told me he had the buck. I followed the sound and found the buck down, nearly dead but not quite, I had hit him too high. Every time he moved Sig seized him by the back of his neck. I dispatched the deer, made the rifle safe and started to drag the decent sized buck out of the wood and into the open. I have said he was decent sized, but it seemed to me that it was more of a struggle to drag him than I would have expected. As I glanced round the reason became obvious, my dog was pulling on the carcass as hard as he could, but in the opposite direction to me!

Right top
Roe buck
Pencil

Right
Bolting roe buck
Watercolour

Roe

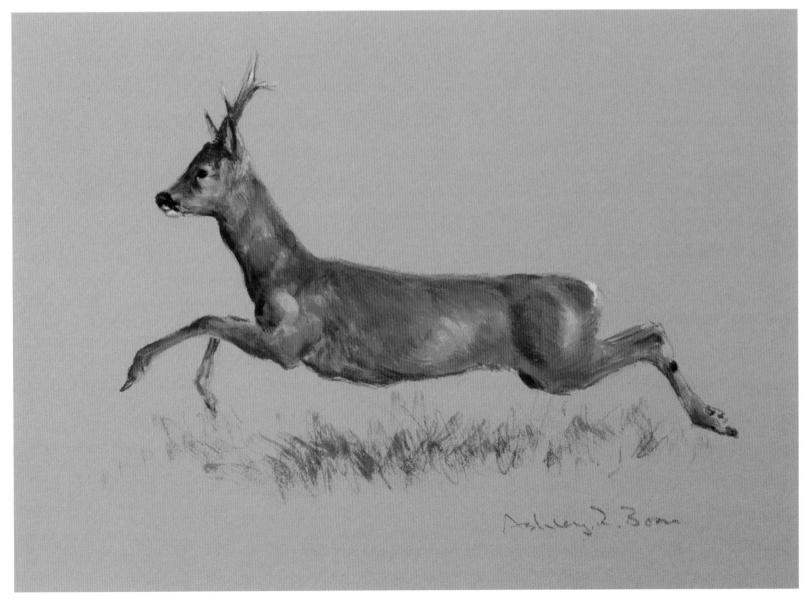

I am resentful of disturbances when I am painting in my studio. But then there are those disturbances that are more easily forgiven. The hares and the red squirrels that live by my house are welcome distractions, and so too are the roe deer that are so plentiful in our valley here in northeast Cumbria. My studio windows are only feet from the field behind our house and I have often paused whilst painting to sit and enjoy the pleasure of having these delicate, elegant, and at times frail looking creatures grazing a matter of yards from where I sit at my work desk. On occasions I have had bucks fighting less than

twenty feet from the windows of my studio.

Of all our native species roe deer are my favourite. Those spindly legs, those round dark eyes and that misleading air of vulnerability, an impression that is, however, soon dismissed when you see them fight. Roe are arguably our most beautiful deer, and a good six point buck in his new summer coat is smart as paint, red as a fox with a neat black and white muzzle. His slender neck and elegant antlers add to his neat lines, but don't be fooled. In the rut they can be ruthless.

From my studio I once had my afternoon's work interrupted by an ongoing conflict between a young and an old buck that appeared in view as I worked. The older buck pursued the younger relentlessly over several hours, first showing off his superior stature and antlers until, after a bit of halfhearted fighting, he got stuck in properly and eventually went into a full blown chase. I have never before, or since, seen

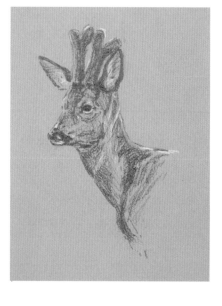

a wild animal look as scared as that young buck; he fled. But even though he had conceded defeat, the older of the two gave the younger no quarter and pressed him again and again. The younger buck ran in panic, weaving right and left, seeking some line of escape. He crashed into fences, slipped and fell, then finally appeared to escape his tormentor. He had good reason to be afraid. A day later when walking my dogs I found the young buck again. He was dead. His corpse was up against a wire fence where he had finally been cornered, and he was pierced so many times by the antlers of his opponent, that I would not have been able to lay my hand on any part of him without covering at least one wound.

When I moved to Cumbria and found myself surrounded by so many roe, I was keen to get some roe antlers to join my muntjac and fallow trophies, but I actually got my first roe on an annual sporting trip to Caithness. That yearly expedition was mostly after grouse and trout, but there were a lot of roe on the estate that we were allowed to try for, and they assumed a greater and greater importance in my mind as the journey north loomed. The first buck I got wasn't anything to write home about, nor was it a great hunt, but I was very pleased

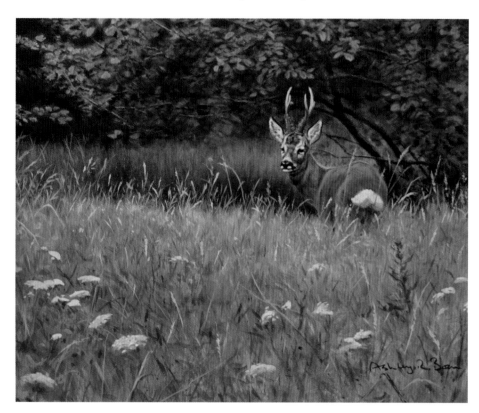

Clockwise from left
THE OLD BUCK
Watercolour

ROE IN VELVET
Pencil and watercolour

SPOOKED,
ROE BUCK
Watercolour

to put his pretty antlers on my studio wall.

After that first one I managed to get a few permissions to hunt roe at home.

One area I was now able to try was a 'moss'; an area of birch and semi bog. I had a few expeditions to this new area before I got my first roe on my own. There were roe slots everywhere, and it was obvious that if I put in the hours I would have a good chance of finding a suitable buck to try for. These were my first outings stalking alone, and that added a new excitement as I made plans.

So it was that, heading for an old high seat, I crossed the fields at first light, early enough to flush several woodcock still feeding in the meadow. I climbed the high seat and began to wait.

Time spent waiting in the countryside is never wasted, there is always something to see or look at. The strange shapes in the fungus growing on the nearby birch, a spider's web hung with dew, a sudden break in the silence as a wren declares its territory (why is one of our smallest

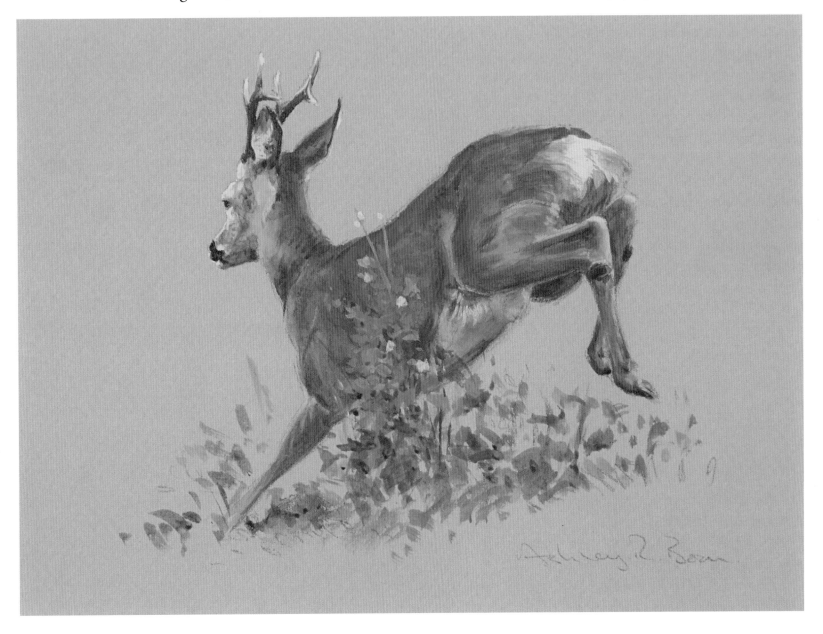

birds blessed with such a strident voice?). Hares, treecreepers, wood pigeons, a tawny owl still out before its return to its daytime roost. The time slips by. One's eyes and ears seek for a movement, a rustle, a sound. You move your head slowly and make all movements with care. And suddenly there is a buck, two in fact on that occasion. Two skinny yearlings, perfect.

I chose the smaller of the two and lined him up. Running the cross hairs up just behind his front leg, stopping not quite halfway up his body, I held steady, inhaled and as I slowly breathed out, squeezed the trigger. That sudden intrusion of noise into the still morning is a release in several ways. The spell is broken, your position revealed. Reloading immediately, the need for stealth is over and you can move those tensed muscles freely again. And there he is, down. His foot twitches a few times and then he is still. A careful climb down and a cautious walk to where he lies, dead as a stick. Your heart thumping as you make the rifle safe and prepare to gralloch him, pausing to run a hand over his coveted flank, enjoying that paradoxical moment of pleasure and slight regret. You were successful but he will not thread his way through these trees again.

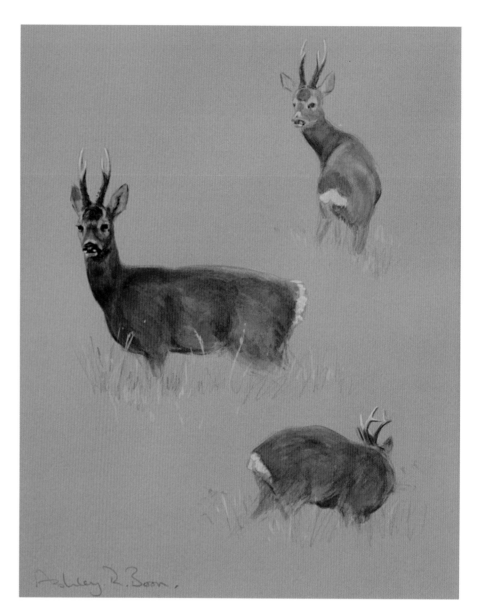

Red deer

My first foray after red deer was when my friend Patrick invited me hind stalking. The Scottish hills present a new stage for a new pursuit. If you've never been, they are as impressive and awe inspiring as you are led to believe. I remember the autumn colours and the cold air on our faces as we stopped to 'glass' the hills. I remember too, the distant roars of stags, their minds still on more earthy matters. One's eyes quickly learn to pick out the dun coloured shapes and it soon became obvious that there were plenty of beasts to try for.

Left
HOME BUCK
STUDIES
Watercolour

Below
RED DEER STAG
Watercolour

Under Bob the stalker's guidance we started off after a parcel of suitable looking hinds. This involved going up. Up, and up, and up and up and up. I got to know Patrick's boots well; they were at my eye level the whole way up that first climb. I remember the physical effort, the stunning landscape and a wee staggie that popped his head over a rise out to our side. But most I remember the hind and calf I shot under Bob's reassuring guidance. Unused to shooting over the distances involved on the hill, his quiet assurance put me at my ease and I am happy to say they both dropped dead after a brief dash out of sight. I was full of relief and elation when we found them both in a small hollow in the hill.

There followed that week more strenuous climbing, careful stalks, cold and rain, glorious sunshine, eagles and ptarmigan, and ravens that appeared from nowhere at the report of a rifle shot to gorge on the gralloch, and several more

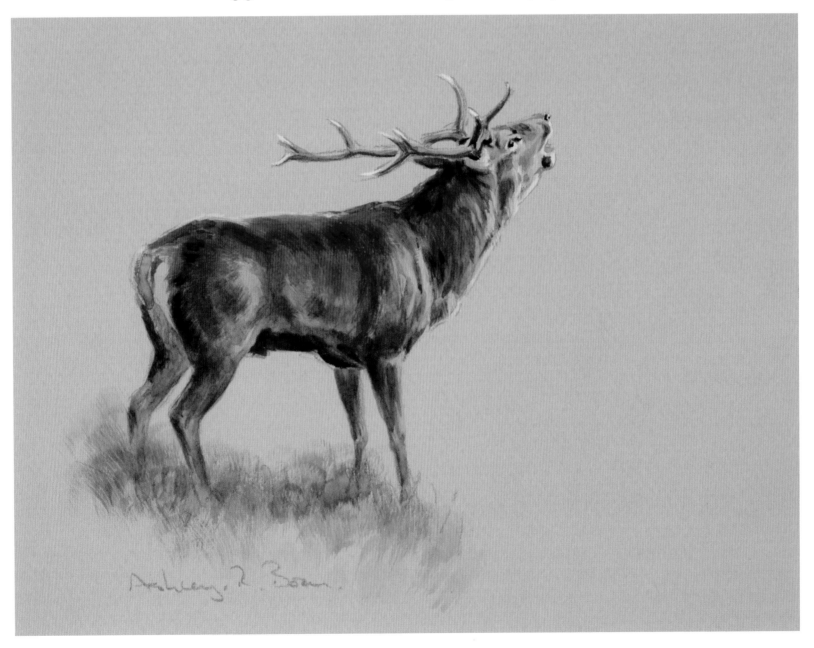

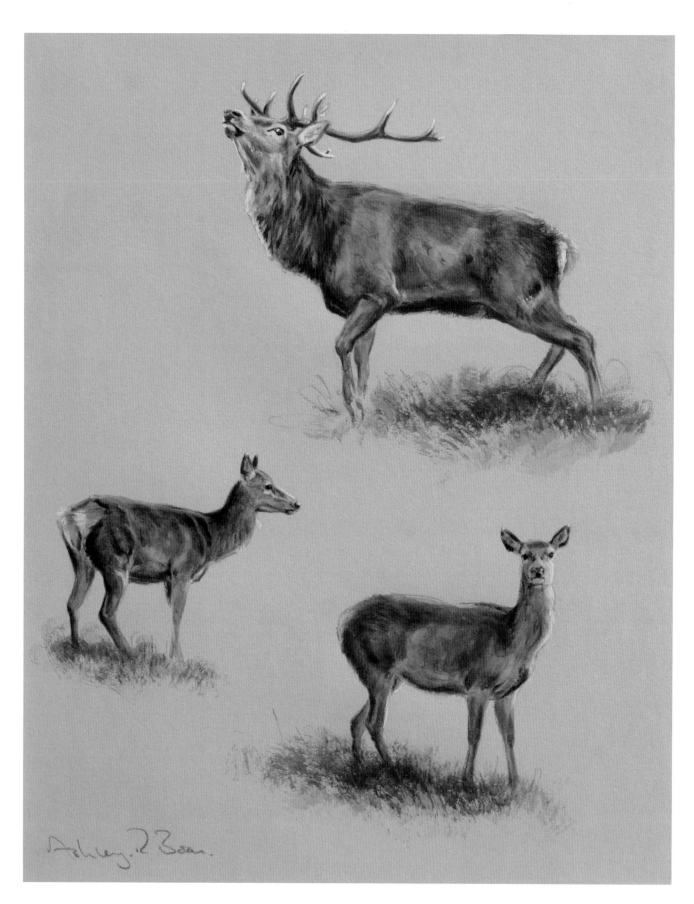

Left
RED DEER STUDIES
Watercolour

Right
MOVING OFF,
RED DEER STAG
Watercolour

beasts to be dragged off the hill. Days ending with a glorious bathtime whisky, reliving the events in the soothing peaty water and steam. The first experience of a much anticipated event is always the most intense, and that happy week is still a vivid happy memory.

I got my first stag when Charlie invited me to go up for the last week of the stag season. Not far from Pitlochry, the landscape was different though nonetheless impressive. We were taking it in turns with the rifle and all three of us had stags on the first day. I was spoiled with two stags whose fine trophies hang on the wall of our sitting room. They are good quality, better than I'd hoped for. I'd have liked all the six heads I shot in those three days, but it's easier to get the heads, than get them past the domestic authority!

A commission to paint a favourite glen took me north with Ross and Carol for the first time,

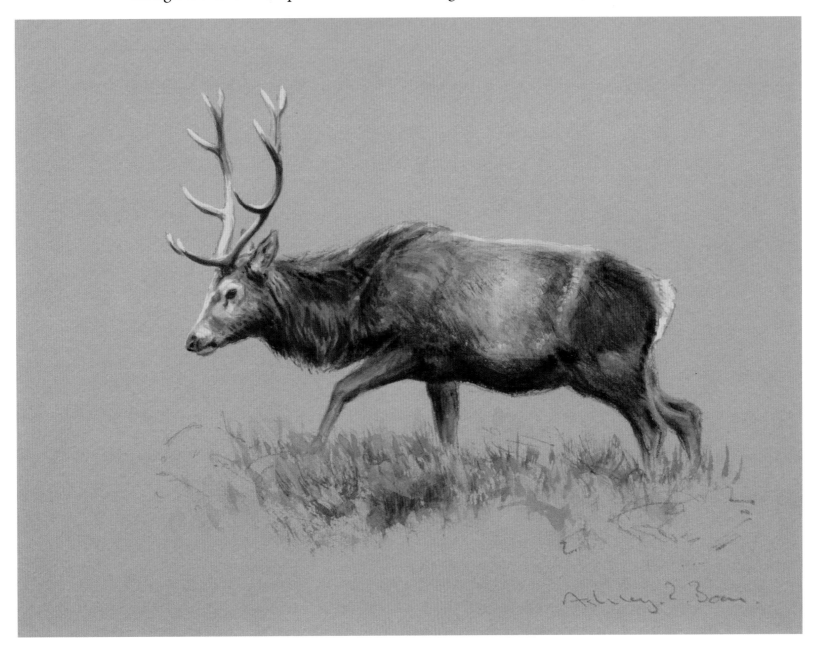

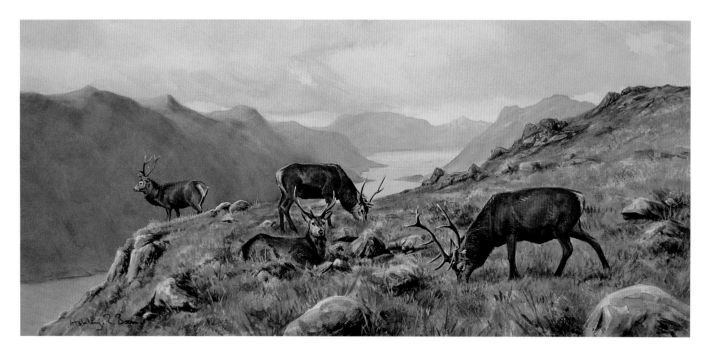

and another chance to stalk hinds. I took my longest shot there; successfully I'm pleased to say, under the quiet guidance of Donald the stalker. It is wonderful what confidence I got from his quietly whispered 'It's no too far, ya con shoot fine, jus tek yer time and squeeze'. And down she went.

Later as we sat eating our 'piece', I asked him if he thought that all our judging and choosing of beasts made a great deal of difference. I have never forgotten the answer that came after a considered pause; 'Well I don't think it does any harrem, but Nature's affy big, an she always keeps a few fer her sell!' We also discussed Scottish Country dancing, reeling, which we sometimes do in Cumbria. His comment was 'Oh you do the dancin' do you? I hope you do it properly mind, none oh that burling (spinning) and university nonsense!'

Of all my sporting friends who have a particular interest in deer, Tim is far and away the keenest. Fit as can be, he runs marathons for fun (I ask you!). Whereas, as I get older and spend more time sitting at my work desk, I get steadily less fit. I love to join him on his trips up to the West coast of Scotland, but it is always with a growing sense of unease at the prospect of physical effort in his company! Tim is highly selective, and cares deeply about taking only the right animal, so we have had a couple of trips that saw us driving south again with nothing to go in the larder. But as all true sportsmen know, it is not all about the killing of quarry. I have loved feeding off Tim's enthusiasm, the concentration of spying and judging the beasts we find, the planning of an approach, the wildness and the weather. I have loved the honest exhaustion of a day spent scrambling around the hills on his 'bit'.

The two of us went up to try for a hind at New Year a few years back. After a long day out not having found anything suitable, we made our way back to the 'Bothy' in the dark, down the steep path into the tiny bay in the sea loch. We lit the stove and opened a bottle as we prepared our dinner. Having eaten and with our tired bodies dry again and warmed by the stove, nearly overcome by sleep I asked if it wasn't time to raise a glass to the new year and retire. He

replied 'My dear chap, we can't possibly go to bed on New Year's Eve before eight thirty!' We woke on New Year's Day to a glorious prospect, looking out onto a view of the sea loch that was occupied only by two great northern divers in the bay and the charming antics of a bitch otter and her cubs on the rocky shore right outside our window. What a way to start the year?

Unfit as I may be now, I hope still to have the energy to keep trying for a long time yet. To pursue our different species of deer (not always with lethal intent), to enjoy the landscapes they inhabit and to be delighted by them in all their variety.

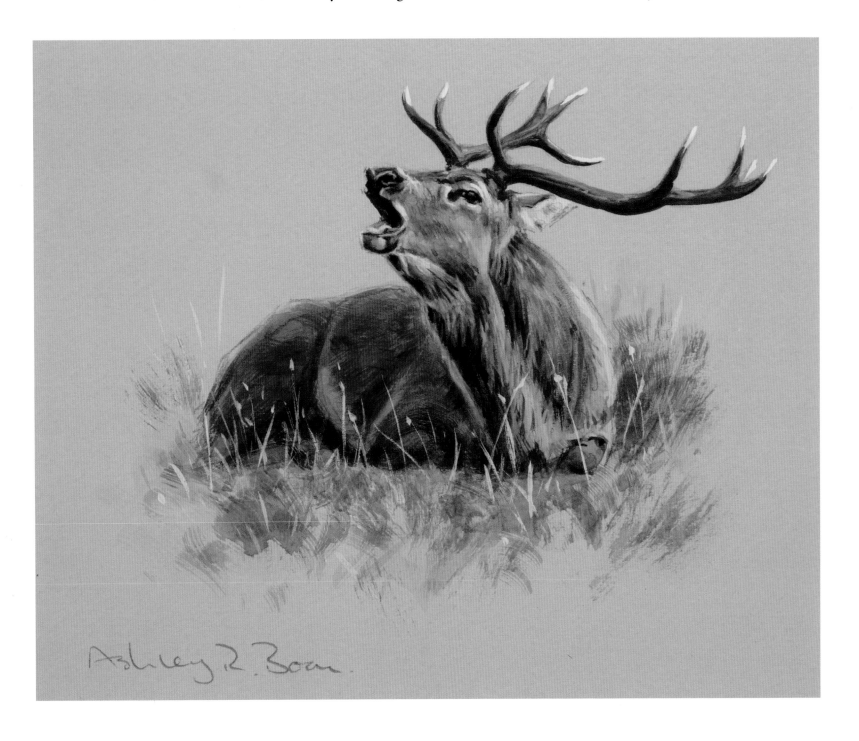

The Artists

Martin Ridley

Martin Ridley is a wildlife and landscape artist born in Liverpool in 1967. He now lives with his wife Jill and dog Skip in Perthshire, Scotland.

The bedroom of a nine-year-old boy, crammed with natural artefacts and walls covered with drawings of birds, were an indication of Martin's future obsessions. He joined a local art club and amongst a string of awards won the prize of free entrance to Chester Zoo for a year. From this early encouragement he eventually went on to further education studying an HND course specialising in wildlife illustration at the Carmarthenshire College of Technology and Art. He completed the course in 1988 and was awarded course, faculty and college student of the year.

Undaunted by the prospect of an uncertain income and with three years' studying behind him, Martin went straight into self-employment as an artist. At first, many of the artworks were created for illustration purposes, printed as greetings cards and calendars, but he soon realised that the creative freedom of painting original compositions was more rewarding and he focused on the sale of original paintings through exhibitions.

Strongly motivated to continue painting professionally, the first decade after Art College was a busy period in Martin's life. He exhibited widely, trying to establish his reputation as best he could. Regular venues included "Artist in Residencies" at Nature in Art, Twigworth Hall and John Noott Galleries in Broadway. Martin had two successful exhibitions at the Wildfowl 7 Wetlands Trust, Slimbridge and was elected an associate of the Society of Wildlife Artists in 1999. Works were also selected for the prestigious Leigh Yawkey Woodson Art Museum "Birds in Art" exhibition and Tryon Galleries, London.

Martin spent ten years in Gloucestershire, first living in a small hamlet on the banks of the River Severn and then in a village in the Cotswolds. During this time he studied badgers and foxes in depth, familiarising individual wild animals with his presence so that they followed him around in the woods, allowing close observation. The close proximity of the Wildfowl and Wetlands Trust, Slimbridge, the River Severn estuary and gravel pits provided excellent opportunities to study and increase his knowledge of birds. Formative experiences during these years gave him fieldwork strategies that he continues to use and perfect. These outdoor / fieldwork experiences have become the foundation of much of Martin's work.

Martin relocated to Scotland in 2000 and now lives in the rural village of Comrie. Before leaving England he set up a website (www.martinridley.com), an important element in his plan to work in a more remote location whilst maintaining contact with his customers and friends.

Martin prefers to base his paintings on real life experiences, often spending weeks at a time studying a single species in detail. Conceptual composition, attention

to animal behaviour, habitat detail and lighting are combined to create an accurate and yet artistic rendering of subjects. Compositional ideas, where the effects of lighting and the drama of weather conditions play a key role, are common as he endeavours to capture those wildlife encounters made all the more "magical" by the elements. His perfect day is observing wildlife outdoors in dramatic weather conditions and lighting.

Being based in Perthshire has facilitated easy access to some of the more remote and wild areas of Scotland. Whether dictated by the requirements of a commission or chosen for the landscape or wildlife, these experiences become the basis for studio paintings over the following months.

Martin would describe himself as very fortunate in having found a profession which allows him to indulge his interests so fully. From seashore to mountain plateau, bountiful natural treasures are fuelling him with creative inspirations and he is still as enthusiastic now about his wildlife encounters, the ribbons of mist and the final half hour of sunshine catching the grasses as he was as a youngster – although his style has developed over the decades. Not much has distracted Martin; he openly admits to being blinkered, single-mindedly directing his efforts towards improving his artworks and continuing to paint professionally.

The majority of Martin's original paintings are now either commissions or works sold directly from the studio or via the internet. In the summer, Martin exhibits at the annual Scottish Game Fair and opens up his home / work space as part of the September "Perthshire Open Studios" event. His home is open by appointment during the rest of the year, though he may well be out of reach in some remote glen when you first try to make contact.

www.martinridley.com

Owen Williams

Owen Williams spent his childhood years in West Wales where he enjoyed fishing for wild brown trout in the local stream and rough shooting on the family farm. His passion for painting came about through his desire to capture his experiences whilst out with rod and gun. In those early years his medium was pencil and pastels. Today, some 40 years after, as a professional artist, he paints exclusively in watercolour.

His pictures hang in many private collections of sporting art in the UK, Europe and the USA. In 2003 he was commissioned by the Royal Household to paint a picture as their 21st birthday present to His Royal Highness the Duke of Cambridge.

His love of landscape shows in his pictures, many of which are inspired by his regular stalking trips to the highlands.

He is a keen advocate of sustainability in shooting and in 2007 established the Woodcock Network, which works to study migration through ringing and tagging woodcock throughout the country.

www.owenwilliams.org.uk

Jonathan Sainsbury

Jonathan Sainsbury transforms wildlife and sporting subjects into contemporary art that wins places in open competitions in Britain and abroad. In 2012 his exhibitions were at: the Royal Scottish Watercolour Society; the Aberdeen Artists' Society; Birds in Art; the Woodson Art Museum, Wisconsin, USA, the premier museum for bird art worldwide; the Society of Wildlife Artists; and with Artists for Conservation Foundation in Vancouver. His work hangs in collections around the world.

Jonathan Sainsbury was born in Stratford-upon-Avon. He was passionate about nature and drawing from an early age and his mother, formerly deputy manager of the Royal Shakespeare Theatre, encouraged his interests. After studying Painting and Drawing at the Byam Shaw School of Art in London, Sainsbury worked as a scenery painter for the Royal Shakespeare Theatre for a year, where he learned to paint on a large scale. He visited Japan with the Company, travelling on his own through a country then quite unmodernised, sketching and photographing.

He graduated in Fine Art from Leeds College of Art in 1976. As well as developing painting skills, this was a time of experimentation – for his graduate show, Sainsbury built man-sized flying machines shaped like birds, which secured him a place in the Young Northern Contemporaries exhibition in Manchester that year. Concern for the environment was a strong theme in his work at that time. He painted a series of animals on the endangered list, he also painted fantasies of extinct creatures like the Dodo and the Thylacin, or marsupial wolf. Around the time of Carl Andre's "Bricks" at the Tate, London, he created an installation out of bricks, with tiger stripes on the outside, that weighed the same as the almost-extinct Balinese Tiger (in keeping with its message, this piece was donated to the World Wildlife Foundation and was subsequently lost!)

Then he returned to his native Warwickshire and began painting full-time for a living. Acquiring a Springer Spaniel, he learned the excitement of flushing game. He sketched constantly, building up the lifelong knowledge that would underpin his work. To this day, one area of his subject matter is British wildlife and landscape, He says, 'I paint very lovingly, things I really care about. My preferred subjects tend to be everyday scenes that have affected me personally so that I can convey the emotion of the scene. I want people to say when they see my work, "Yes, I've been there, I know that feeling".'

Soon his pictures attracted recognition and he established a name for himself in British Sporting and Wildlife art through the William Marler Gallery in Cirencester. He developed a new medium, fusing watercolour with charcoal drawing, which enabled him to work on a larger scale and in a more abstract manner. He also explored the Old Masters' techniques of working with oil, in layers of glaze and pigment over gesso ground to achieve luminosity.

This range of media that he employs for different ideas is a hallmark of Sainsbury's work; similarly, his choice of subject matter has always remained wide. To him, this is a consequence of being a wildlife artist in the twenty-first century, when photography and film can show so much factual information. 'Everything we are is reflected in Nature,' he explains. 'My aim is to create what art alone can do, with imagination and story-telling. Nature is too big for me to have found just one style, so I use different techniques, hoping to reflect something of its complexity and beauty.'

In recent years an interest in poetry has influenced him. 'A poem is like a painting: a frame into which an idea fits, whole and within itself', he says. His Square paintings were a conscious decision to abstract from reality, to illustrate the texture of fur and feathers, the colouring of creatures, typical gestures and poses, in an alternative format. 'I include as much of the subject as the design requires; my painting says as much about the genre of wildlife painting as about the creature itself'.

The painting "Apples", which was shown in Birds in Art, took the Square theme further, dividing the canvas into sixteen square arranged in a grid pattern. The overall

imagery comes from the poem of the same name by Laurie Lee: apples bursting and ripening, starlings stabbing the fallen fruit, in an arrangement whose interaction of different parts creates the movement the poem suggests. It was bought by a director of the museum.

Sainsbury never relinquished his concern for the environment. His 1997 piece for Birds in Art called 'Reciprocal Arrangement' showed oiled seabirds washed up on a beach. Here again we see the medium of the work adding its own comment, for the birds are drawn in charcoal, but the rainbow sheen of oil slick around them is achieved by using an oil-derived paint product, making the point that none of us can stand outside the environment where disasters and extinctions take place; we are all bound up in the complex totality.

Living for the last twenty years in Highland Perthshire, Sainsbury's work for the Deer book is informed by creatures and landscapes observed outside his front door. As well as wild deer, he has also been familiar with Highland ponies and the tackle and practices of bringing stags down the hill on deer saddles, and – when there used to be more grouse locally – the use of panniers to bring down the day's bag.

Jonathan is married and has two daughters and a son.

www.jonathansainsbury.com

Keith Sykes

Wildfowling as a youngster on the saltings and mudflats of Morecambe Bay provided the initial inspiration to paint and draw wildfowl and other quarry species; so began a lifelong passion for fieldsports and associated wildlife and sporting art.

From ancestral links back to professional punt gunners on the Essex coast, Keith's Father introduced him at a young age to a wide and varied selection of shooting sports including wildfowling, rough shooting, clay pigeon shooting, pistol shooting, as well as sporting and target rifle shooting. This deeply engrained family tradition and love of shooting has been passed to the next generation and inherited by Keith's two sons, Jack and Tom.

From his early twenties, and in parallel with other occupations in the construction industry, Keith continued to work as a semi-professional artist, but it wasn't until 2009 that he fulfilled his ambition to become a full-time "animal portrait artist". From leaving full-time education Keith took an unconventional career route, firstly training and working on site as a civil engineer for an international contracting company, followed by an office-based civil engineering design post for the local government. In 1981 he moved to the Estates Department of the National Health Service; this role involved architectural design, the production of detailed drawings, strategic planning and project management.

Keith became a member of the Redspot group of artists in 2003, he initially exhibited with them at the CLA Game Fair at Harewood House in the July of that year.

Combining his drawing board skills, an eye for detail and a passion for shooting, stalking and working dogs, he is now able to concentrate on the production of finely detailed black and white pictures for galleries and clients from the UK and abroad. Most of Keith's work still consists of dog portrait commissions with the majority of them being sporting dogs, but deer continue to provide many subjects for his portfolio. Keith has been privileged to stalk and shoot Red and Roe deer locally and enjoyed the wonderful experience of stalking and shooting Red deer "on the hill" in the Highlands of Scotland.

www.kjsykes.com

Rodger McPhail

*R*odger McPhail was born a very long time ago in Lancashire. He considers himself very fortunate to have been able to make a living from painting over the years without ever having to resort to a real job.

In order to do the research for his wildlife paintings Rodger feels compelled to spend a great deal of time on salmon rivers, grouse moors, pheasant shoots and chalk streams. His quest for authenticity in sporting art has led him to study the quail plantations of America, the bonefish flats of the tropics, the hunting consignments of Africa and the partridge fincas of La Mancha.

As this book demonstrates, he has also tirelessly researched the deer forests of the Scottish Highlands. His selfless dedication to his work is an inspiration to younger artists.

Over the decades Rodger has illustrated many books on many subjects and his work has been used to sell everything from whisky to Russian drama. His most recent book is a monograph on that popular reptile, the adder.

www.tryon.co.uk/rodger-mcphail

Ian MacGillivray

*P*ainting has been the continuous thread running through Ian's life and the light and colour of landscape has been the dominant theme of his output to date. Born in Inverness in 1964, it was the wild landscape of the Scottish Highlands that first captured the imagination of the child.

Upon completing a degree in painting at Maidstone College of Art in the mid-1980s, he returned north to paint the light and ever-changing atmosphere of the Highland landscape. Among the wildlife in these infrequently visited hills, and inspired by his many liaisons with Stalkers and Gamekeepers, sporting scenes became the subject to which he has continually returned.

Whilst painting extensively in the Highland hills, Ian's work began to attract the attention of collectors. One such collector introduced Ian to London's Tryon Gallery in 1992. A low output of completed work, combined with a tendency to collaborate closely with patrons, often on long-term projects, have determined a limited gallery exposure, typically exhibiting only two or three paintings in a year.

"Back from the Hill" in 1998 was Ian's first comprehensive accumulation of paintings. This debut exhibition took place at the Tryon Gallery's then Cork Street space, in the company of Balfour Browne, Landseer, Millais and Thorburn. Ian's deer stalking scenes formed

the linchpin of the show and included several depictions of stalkers and gillies attending to their daily work, including the gralloching of a stag. These paintings perturbed, and complaints were received by the gallery. The Romantic hangover was dispelled in an attempt to bring the genre up to date.

"A Year on the Hill". Tryon Gallery, 2009

At the heart of this exhibition were a series of paintings depicting the annual cycle of deer behaviour and habitat change over the course of four seasons. The series made the significant step of expanding the remit of the sporing artist beyond 'the season' to reveal the rarely depicted ambit of the quarry subject.

"Paintings from the Wild Highlands". Tryon Gallery, 2011

A growing interest in painting the sea informed a great deal of the exhibition, conveying wild coastal backdrops to spectacular stalking scenes.

Now at home in Cheshire, recent years have seen a growing development of Ian's plein air landscape paintings and colour study. This work forms the foundation of his practice and has facilitated a continual return to his sporting subjects with a renewed sense of purpose and vision.

http://ianmacgillivray.co.uk

PHOTO: GLYN SATTERLEY

Ben Hoskyns

Ben Hoskyns became a professional artist in 1988 after a brief spell working in the insurance industry. His deep fascination for birds and animals, nurtured from an early age, forged the inevitable path he would take. His work shows a passion for the countryside and a remarkable observation of wildlife.

In recent years he has developed more as a landscape artist: 'When I first started painting, the background was of little importance to me – all I wanted to paint was the bird or animal, preferably on a white background.

'But, gradually, I began to understand the significance of the habitat as my interest in conservation grew. Where the birds live is why the birds live – or, for that matter, don't live. Quite simply, if you don't have the right habitat, you won't have the wildlife and it has become just as important to convey that in my paintings as to get the subject right.'

The studies of birds and animals are still there but they are often part of a progression towards his larger pieces. The smaller landscapes, themselves, are usually part of that same development so that there may be several different versions of a particular view – a change of angle, subject, light or narrative – but each instilling that feeling of 'being there' and capturing the very essence of the British countryside, without being photographic.

'To me, a painting is as much about what you leave out as what you put in. There needs to be some ambiguity to allow the viewer the freedom to see what they want to see. When a roebuck steps silently onto a ride in front of you, you don't see every leaf, every twig. What is stored in the memory is a feeling, the atmosphere. If I can capture that, I'm happy.'

Ben paints towards exhibitions between March and November and works on commissions during the winter months. He prefers painting under natural light so work is a slower process in the winter when it can be quite gloomy in the studio by early afternoon; but his commissions take him to some very beautiful places that often inspire many more paintings than the one he is there to paint. *The shooting season, itself, produces a mass of inspiration, so that he is itching to start painting for himself (exhibition work) as the days begin to lengthen.*

Ben painted the 2006 Wildlife Habitat Trust's Conservation Stamp, one of only a small group of artists to do so. He produced the illustrations for The Shoot Lunch *and* The Fishing Picnic *(both by Prue Coats) and* The Better Shot *(Ken Davies). He was one of the contributing artists to* The Butterfly Book *(Laura-Jane Foley) and wrote and illustrated Holland & Holland's* The Nature of Game *(Quiller Press, 1994). He has, more recently, collaborated with several of the country's leading wildlife artists to produce* The Woodcock: Artists' Impressions *and* The Grouse: Artists' Impressions.

http://www.benhoskyns.com

Ashley Boon

Ashley Boon was born in London in 1959, but grew up in rural Northamptonshire. He trained at Banbury School of Art and gained a BA (Hons) in Illustration at Bristol. He now lives in Cumbria with his wife and daughter.

Like many wildlife artists it was his love of natural history which came first, and his early paintings were mostly of birds and animals. He sold his first painting at the age of fourteen.

As a young man he rode to hounds with the Grafton Hunt, and when he was able he pursued his interest in falconry. As an art student he shared his Bristol bedsit with a goshawk. He is too busy these days to devote the time required to hawking, but he is a keen shot, stalker and fly fisherman. These interests are naturally reflected in his work and he was pleased to be described once as

an artist who 'practises what he paints'.

As well as enjoying painting our native wildlife, he has more recently been drawn to Africa, where a boyhood fascination has become a passion. He now joint leads annual safaris to Botswana and India.

His work has been used as Christmas cards for the Game & Wildlife Conservation Trust. He is a regular exhibitor at the CLA Game Fair. He has illustrated several books and part works including The Pigeon Shooter *by John Batley (Swan Hill),* Private Thoughts from a Small Shoot *by Lawrence Catlow (Merlin Unwin Books) and* Muntjac, Managing an Alien Species *by Charles Smith-Jones (Coch-y-Bonddu Books).*

www.ashleyboon.co.uk

The British Deer Society

The British Deer Society (BDS) was inaugurated at Woburn fifty years ago, in 1963. It was originally formed by a breakaway group of the Mammal Society in order to give its members the freedom to campaign vigorously for better understanding and management of deer. By the end of its first year the BDS had almost two hundred members, and had formed a number of committees covering research, conservation and control, and membership and publicity. The BDS had already been mentioned in Parliament during the second reading of the Deer Act 1963, a stalkers' register had been started, and the first edition of *Deer News*, the Society's mouthpiece, had arrived.

The first half of the twentieth century had been a bad time for British deer. Two world wars and their aftermath had resulted in the closure of many ancient deer parks. Some were converted to farmland for food production, others requisitioned for military or defence purposes, and yet more fell into neglect. Deer escaped into the countryside, establishing populations in surrounding woodlands and the resulting damage to farm and forest crops brought calls for their destruction. Deer have no natural predators so their numbers were increasing, and without an established tradition of humane deer management to control deer numbers in lowland Britain, and no close seasons, the snare and shotgun were used indiscriminately. The Society's remit was clear.

Much water has passed under the bridge since those early days of the BDS. Today the Society membership is made up of professional deer managers, stalkers, educationalists, scientists, photographers and deer watchers. There are over six thousand members and supporters, with sixteen area branches of volunteers across the UK.

The aims of the British Deer Society remain the same, to increase awareness and understanding of deer whilst ensuring their continuing place in the countryside in balance with the environment.

To achieve this the Society delivers a full programme of research, education and training in humane deer management working in partnership with other organisations. The defining message for government and the general public relates to the place of deer in the natural world and their benefits to the environment. However, the Society also educates on the issues of imbalance and the effects of too many deer, with the possible adverse effects on other species and the general landscape. It also promotes increased use of wild venison as a healthy food with the aim of ensuring that deer are considered as a valuable resource and that the carcasses of culled animals are ecologically and economically used.

At the core of our work is a robust deer management training system, developed by the BDS over three decades, first as the Woodland